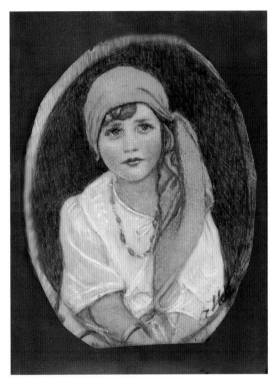

1927 | Painting of Little Edie, based on an earlier portrait
by unknown photographer.

This book is number **0698** *of a 2,000-copy limited edition.*

© 2008 Verlhac Editions
Foreword © 2008 by Peter Beard
Introduction © 2008 by Bouvier Beale, Jr
Other texts © Eva Marie Beale

isbn 978-2-916954-06-6

Layout: Verlhac Editions
Printed in China

Distributed in the USA and Canada by powerHouse Books, Brooklyn, NY

Verlhac Editions
41 rue d'Artois
75008 Paris, France
www.verlhaceditions.com
contact@verlhaceditions.com

Cover: 1951 | East Hampton, NY | Little Edie poses in an orange swimsuit and sarong with Spot in front of Grey Gardens. © Estate of Edith Bouvier Beale

Please visit:
www.edithbouvierbealeofgreygardens.com
www.greygardenscollections.com

COLLECTIONS™

By Eva Marie Beale

EDITH BOUVIER BEALE OF GREY GARDENS

A Life in Pictures Edited by Anne Verlhac
Foreword by Peter Beard
Introduction by Bouvier Beale, Jr.

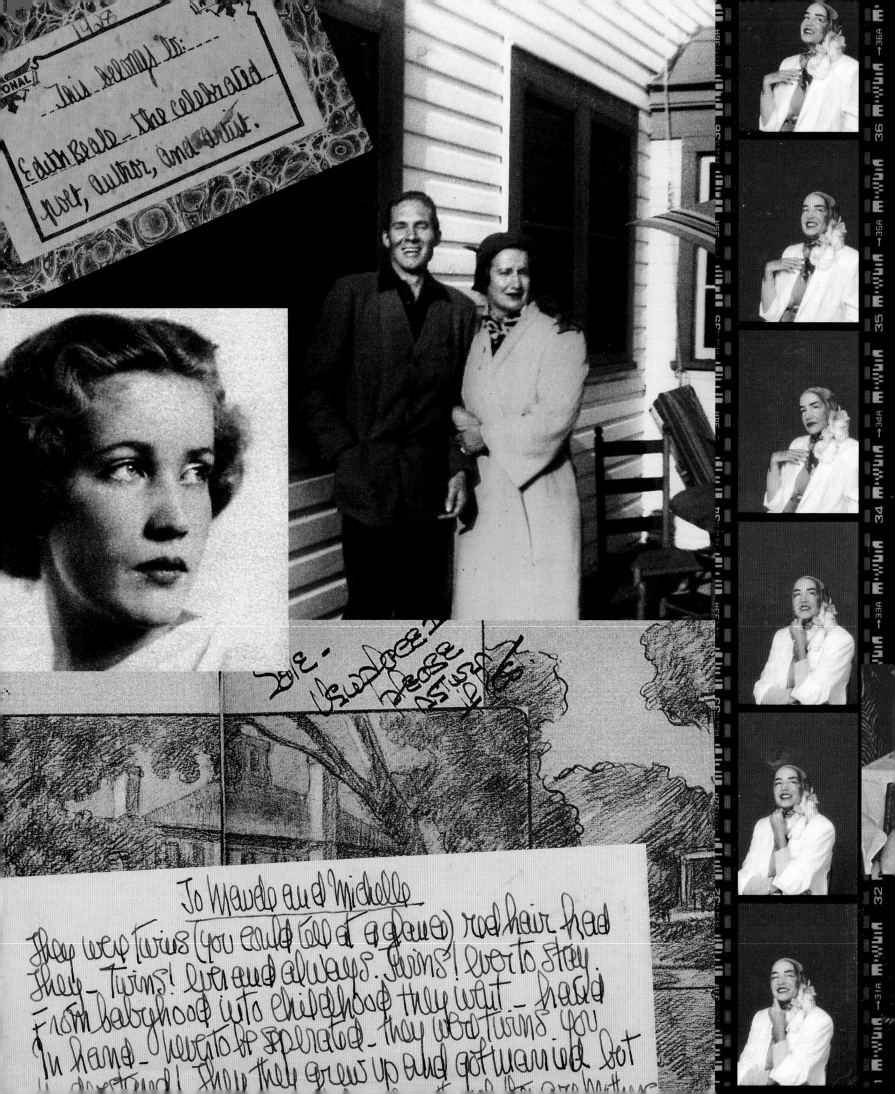

To Maudo and Michelle

They were twins (you could tell at a glance) red hair had
they – Twins! ever and always. Twins! ever to stay.
From babyhood into childhood they went – hand
In hand – never to be separated – they were twins. You

CONTENTS

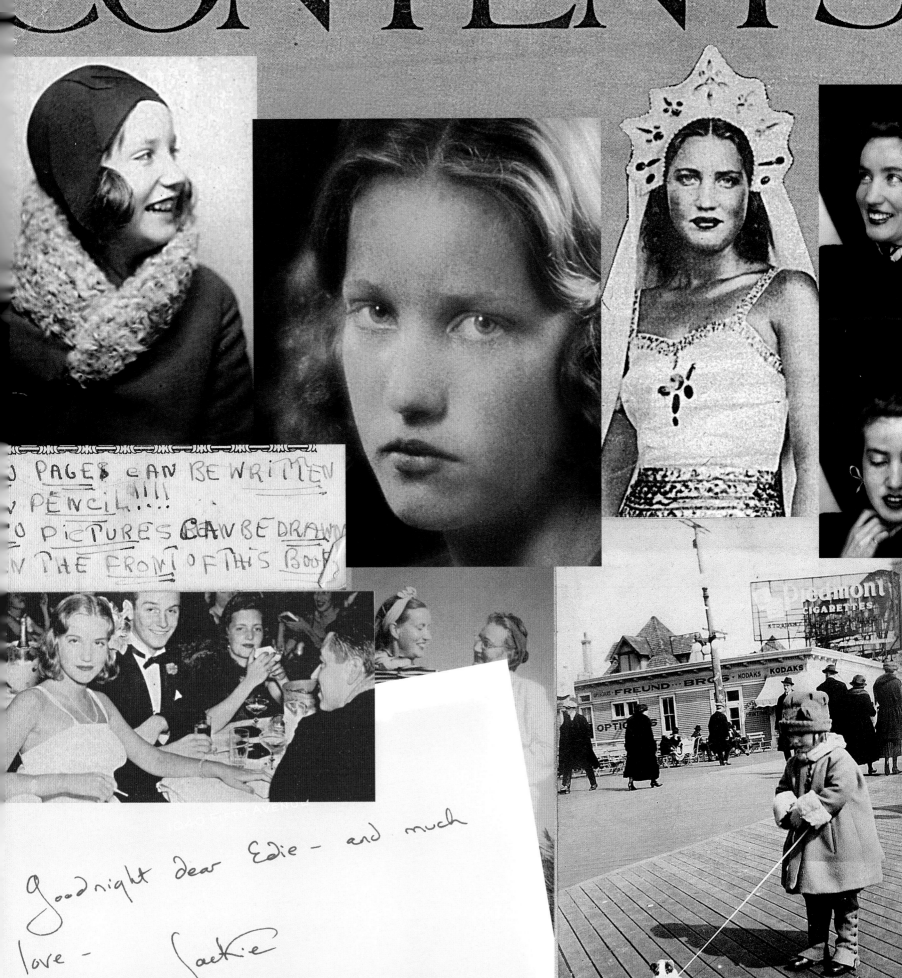

PAGES CAN BE WRITTEN

PENCIL!!!!

PICTURES CAN BE DRAWN

THE FRONT OF THIS BOOK

Goodnight dear Edie — and much

love — Jackie

THE BEALES By Peter Beard

Remembering back to the Beales' saga in the summer of '72, there was never an even-slightly-dull moment for all those afternoons and evenings. Not only was there the hysterical repartee of Big and Little Edie, but also the pathetic and perpetual intrusions of the East Hampton town officials. One time the whole fire department crudely broke in, and high-power hosed-down the first floor interior--totally illegally of course and for God-knows-what intent. I never knew and never asked if this sort of primitive demonstration—a barbaric intrusion—was even legal. No one wanted to talk to the scary-town weirdoes (a.k.a. the East Hampton town officials) without lawyers.

The middle of Gold Coast Lane--a primordial overgrowth of nature itself, a jungley bush of leaves and vines--boasted the abandoned-looking house they called "Grey Gardens". Throw in a troop of raccoons and around fifty-two cats (when they weren't having a die-off), and there you have the last stronghold of the Beales. Needless to say, it was beyond the tin-god patience of the town board, and they didn't like it. Lots of eccentricity and individuality inside and out. Genuinely genius-like personalities ran a rebellious, boycotting household that had just evolved along slowly. From what I've heard, it had been since the 1938 hurricane that they were ever more resentful of the goings-on outside. Rebels with a cause, Edie and Edie Beale: over the years, alone together, one-on-one, no one else, since the 1938 storm, all locked up in that house, considering it a better deal than what was going on outside.

I came from Kenya, a Mecca of the looming over-population horrors, into the summer-rush of the famous Hamptons. From the wasteland of "Starvo" to gluttonous consumer-ville; from the middle of 30,000 starving pachyderms, and the carcasses of rhinos and elephants (you could smell them from the airplane), to a summer sweltering mare's nest of Bloomingdales and Macy's relocated from Palm Beach. Right in the middle of it all, on the Gold Coast itself, were the two debonair die-hards.

I have to rush to say again that every single visit with Edie and Edie was every bit as interesting as anything I enjoyed in my wildlife years of East Africa: rhino-gorings, elephant-tramplings, leopards and baboons fighting, wild dogs hunting, spitting cobras, centipedes and scorpions, whatever. Grey Gardens was anthropology 32-A all over again – amazing field trips! "Every time a coconut".

A quarter of a century of greeting cards on the mantelpiece – birthdays and holidays, Thanksgiving, Christmas and Easter cards addressed to each other, jammed all around the dilapidated fireplace, under the cracked and broken ceiling. Many with a cat's face (or once an opossum), peering down Chas Adams-style.

Life without running water. Two hundred bags of cat shit in the cellar (personally carried out by William vanden Heuvel and myself). A musty world like Dagoretti corner in the slums, just beyond Nairobi swamp, and beyond belief. Every square inch in magnificent disrepair, and these two elegant and above-it-all creatures lounging around in all of it. Young Edie probably posing or performing, Aunt Edie muttering Oscar Wilde-like sarcasms--probably about how the town of East Hampton had somehow decided to go down the urban-migration-drain ("loss of rural integrity", etc...), with a mushrooming catastrophe of H.L. Mencken-esque tin-god "bureaucraps" – all kinds of Kafka S&M dogma, and loads of it.

You've asked me to reminisce about Edie, but it was a whole world that had been created in there. And the most unforgettable, amazing thing was *getting in there*, – naturally the whole outside world had been padlocked out. Getting access, a foot in the door, breaking through the barriers, gaining entrance to this world of conscientious objectors--that was the mystery ticket. It was the most thrilling and difficult part of our project; friends at the local deli, phone numbers, rumors, codes, knocking at the back door, eye-witness accounts, so many delicious details, the research, the planning, the other relatives--the strategizing was epic. And finally, with Mr. vanden Heuvel and Lee Radziwill we got that foot in the door – we got in – the full inside visual! Going upstairs would have to happen later, "next visit".

This was how our best and most original summer began, all leading to Jonas Mekas and Al Maysles' first month of 16mm and 35mm footage (the working titles were *Paper Moon*, *Over a Cardboard Sea*,

etc). Of course it was more like the voyeuristic filming of a really good house cleaning; the first view of a thirty-odd year old eccentric, wild, aristocratic compost heap. This was a whole world within a world. While inches away was the cash-Hamptons Food Liner shopping mall, Bigga Burger, and the Chicken Colonel Sanders, here inside was what they called "Grey Gardens". Animals, fur collared costumes, songs at the drop of a hat, dramatic performances/monologues spilling over with dreams (mostly fantasies) – sometimes sad, often heroic – life enhancing dreams with family-history, 20's and 30's paintings leaning against the wall. The one thing missing was a Tom Wolfe, F. Scott Fitzgerald, Sinclair Lewis, or (the Gonzo journalist himself) Hunter S. Thompson to capture on paper the delight of my unforgettable summer vacation.

We wanted to do an environmental, Gore-Green, population-dynamics film about the barometer of change coming out of New York City, AND – as the Beales' lock-up date was around 1938 – all the changes around as perceived by East Hampton's hard-core, full-time drop-outs – the Boycotting Beales! Sealed off, as it were, from the galloping rot, the excesses and the excessive mismanagement immediately outside the door and everywhere you looked. Indeed, all the hideous intrusions of a city-town racing down the wrong highway, like veritable schmucks. Officials tried everything, but there was no beating the naughty Beale revolt. It was individualism with a sense of history and beautifully loony humor. The Maidstone Club world, wide expanses of authentic country freedom, cultivate your sea-side garden, dunes, waves, Potato Fields Forever, lots of oceanfront, long before the developers and the Beales' boycott.

"Well, one brilliant high-pressure hose-job should fix it all."

But no, the two Edies stood firm. Aunt Edie loaded with the quietness of experience and age; young Edie wildly confined within their chosen world. They stood upstairs and watched. Individual preferences and artistic taste won the day against the town board, the planning board, and the E.N.C.. Despite these intrusions, the Edies had many good moments for some days to come -- Non-fiction drama without end.

Thinking back, who – out of all the dinner parties, BBQ's, lunches and get-togethers – was more interesting than the two Edies? [Nobody] Every minute was new, insanely funny, poignant, wild, unpredictable and unmatchable. Who's to choose?--The overgrown, old-style Hamptons house on Gold Coast Road, or the pretentious chemical factories that were going up all around? When you see the downfall of a whole way of life all around you--strawberries, radishes, corn, ocean air -- and then suddenly everywhere you look subdivided Levittown suburbs nestled in tight at point-blank range. Density and stress, or more bluntly, Environazis and Jewish American Princesses living side-by-side in their glass and steel nightmare houses, each ruining the other's view (The Philistines of Hedge Row).

I'm sorry I cannot help but think of Edie and Edie together – so different and yet so bound together in their resistance to the horrors outside (fire department inside) amongst the raccoons, cats, and the mold. No running water, no help from outside. Just daily soap operas amongst themselves, the most original scripts, the most surprising true-stories, the most paranoid gossip, remarkably historical tales – totally fun, inventive, serendipitous, and most importantly always hysterical.

Of course the worlds of Maidstone and madness would have to collide. Should one try to sum up all this phantasmagoria – the full bouquet of Edie's memories and everything else – it would have to be called something like BEYOND WORDS.

A Final Thought:

Nothing I can say about young Edie could match the brilliant portrayal of her by Ms. Chirstine Ebersole in the *Grey Gardens* Broadway musical. Trudging as one does through the monotonous Long Island weekends, there are no memories that match those of the amazing Edies, and it was miraculous to see them come alive so authentically and ingeniously on stage before a large audience. In hopes that they go on to a one-of-a-kind movie, the rest amounts to inadequate words, words, words.

The End.

MY AUNT EDIE By Bouvier Beale, Jr

My Aunt Edie was born on November 7, 1917, the day the Bolsheviks stormed the Winter Palace of the Tsar of Russia, which initiated the biggest and most far reaching revolution of the Twentieth Century. This seems an apt metaphor and an appropriate starting point for the life of this extraordinary American woman. My Aunt Edie's life, which would span the rest of that century and beyond, was one that observed, participated in, and contributed to many of the seminal events and dramas of American life during that turbulent and creative time.

Born to wealth and privilege known only to a favored few, my Aunt Edie enjoyed an upbringing in which she was provided not only with the finest of all things—material possessions, educational opportunity, social contacts etc.—but also an extraordinary familial love and affection that we have partly documented in these pages via various photographs and writings. This side of the family, the Bouviers, arrived on American shores several generations previous, penniless refugees of Napoleon's debacle at Waterloo. Raising itself up on purely guts and gumption, my family became a leading player on Wall Street during the economic boom of the first part of the century. Their incredible affluence would tragically begin its slow decline that fateful day in October of 1929, when the US economy, too tied to Wall Street, began its long but steady downfall, my family along with it. The economic prowess that the Bouviers and the Beales had worked so hard to achieve was to become a dim memory. Real estate, valuable stock holdings, family-founded legal and securities trading companies, all fell by the wayside as the hard years between the crash and the war took their grim toll. However, through it all, the love that the family cultivated during the good times remained. It is here, in these pages, that we document the better times of my Aunt Edie's life.

Shortly after my Aunt Edie's death in 2002, at the age of 84, I found myself standing with my wife, Eva, in the white pebbled driveway of our family home in Amagansett, NY, not but four miles from Grey Gardens itself. Peering into the tops of an assemblage of several four-foot high, recently arrived UPS shipping boxes, we began sorting out, inspecting, and cataloguing an extensive Bouvier and Beale family photo and document collection that was started by my grandmother, "Big Edie" Beale, and conserved and saved for us by my Aunt

Edie. Part of what we discovered and learned during the subsequent weeks and months is displayed in this book and represents a stunning chronicle of the rise, fall, and rise again of a persevering New York-based family, as symbolized by Edie herself.

THE EARLY YEARS

My Aunt Edie, the only girl in her family, was raised, with no budgetary considerations or restraints, by her mother, Edith Ewing Bouvier Beale who my two brothers and I playfully referred to as "The Original Bohemian". My Grandmother, "Granny Beale", was a complete and total free spirit—an "artiste" of the first degree. Beautiful, talented, and professionally trained in classical opera singing by the best teachers that money could buy, she could, in the twenties and thirties, hold her own among the New York area artistic elite. Her hosting and unlimited budget, mostly sans husband, Phelan Beale, a hard working, hard drinking, and successful Wall Street attorney, was legendary among the "Andy Warhols" of the day for its musical and improvisational atmosphere, and particularly for its very, very late hours. Meanwhile, as the collection of letters shows clearly, my grandfather, of whom I have no memory, was supportive financially and emotionally to the two Edies right up until 1940, when he essentially ran out of both money and patience, and wrote one of his last letters to his family.

Some have said that my grandmother helped to found, or at least perpetuate, the early reputation of East Hampton at the turn of the century and though the twenties, as the exciting new bohemian artist's colony and retreat. Close enough to New York to find plenty of wealthy patrons, and coupled with an intense sense of nature's isolated beauty by the sea, East Hampton was becoming the "it" place to be. Even so, when my father, Bouvier "Buddy" Beale, spent summers at Grey Gardens as a child in the twenties and thirties, there were more cows than tourists or summer renters in the whole of the Hamptons. The family simply called the place "the country."

My Aunt Edie grew up during the stock market boom of the twenties, and subsequently became an unwilling eyewitness in 1929 and beyond to the direct hit on the family's wealth taken by the stock

market crash and its aftermath. Aunt Edie wrote extensively, in the only remaining copy of any of her diaries, of summers spent in East Hampton and the fabulous pre-crash winters in NYC, where she attended the top live theater productions and first release motion pictures of the day, and took tea at the Plaza Hotel with her mother and the movers and shakers of the NYC art scene. By the time my Aunt Edie grew up and went away to boarding school in Connecticut, she was far wiser than most art school graduates in the method and madness of the arts in New York.

ART AND FASHION: THE UNION OF OPPOSITES

One sure sign of a true artist is a demonstrated ability to create something of value out of practically nothing, particularly when in a new and interesting way. My Aunt Edie was a natural, producing new works of art almost constantly, whether in the way she dressed, her manner of speech, or through spontaneous singing and dancing performances. One of her most amazing and endearing feats was her ability to take two or more seemingly contradictory elements and somehow bring them together in a way that was fresh, innovative, and inspiring. A memorable scene from the documentary film, Grey Gardens, shows Edie answering the door to let the cameramen in for yet another day of filming. She greets them cheerfully with, "Come on in; we're not ready!" And so, in they came, and everyone, including the viewer, was delighted. Another example is found in one of my favorite of her poems, reprinted in full later in this volume, where she combines the humorous and profound, writing "It must be love/ He's not my type/ I'm sure at last I've got it right..." The movie also demonstrates Edie's now well known proclivity for creating offbeat, but sometimes knockout fashion originals by inverting women's clothing items, wearing them on the "wrong" part of the anatomy, or mixing and matching odd and unlikely fashion elements. Two things contributed to this success: her still perfect fashion model figure, even in her fifties, and, of course, the stark and realistic budgetary realities that were never in play back in the twenties and thirties. Limited in funds, she simply used whatever was on hand to create stylish and innovative outfits.

During the thirties, in and around the Maidstone Club in East Hampton, Edie was the local fashion model of choice for all of the fund-raisers, women's clubs, or other civic or social events. Although an amateur, her style, positive deportment, and absolute radiant beauty, as reflected by the photos in this collection, won the day every time. Although Bouvier/Beale family money had not yet run out in

the thirties, most sources of income were reduced or cut off ("belt tightening" was the quaint term used in those days). Although the good life was slowly being strangled, you'd never know it by looking at these photographs!

"POETS ARE PROPHETS"

The above words are a verbatim quote from one of my Aunt Edie's early grade school submissions, and foreshadow the depth and original thinking of her future work. And so, here for the first time we, the family and estate of Edith Bouvier Beale, release some of my aunt's most compelling poetry that has lain dormant for decades. We hope that through these writings, you too will experience and firmly grasp Edie's experience growing up. As she matures, her poetry starts to reflect her emotional needs, frustrations, and loneliness as a young woman. The family letters in the archives, an astounding number of which show poetry utilized as a common medium of communication between family members, reflect the elite educational background in literary arts that, in their privileged state, the Beales could afford. How charming, intimate and utterly different from today's emails and "Blogs"!

In a letter dated May 7, 1948 (five days after I was born!) written to her uncle, "Black Jack" Bouvier, Jackie's father, my Aunt Edie shows her prophetic qualities at a key turning point in American history. She writes, "We're entering a new age now–the Negro is going to sit at the same table with the white man. We're not going to fight Russia, we're going to assimilate some of her ideas. We have to...It's a new era and intolerance is out–The closed mind and the unseeing eye is out and judgment of others is out–the other fellow may be right and you may be wrong. Your father's era is over- but your mother's will never be over. She lived by the Golden Rule–Jack. Do unto others as you would be done by." The first half of the twentieth century was barely ending, with most of the world in tatters, and my Aunt Edie could foresee that for the human race to survive, some big changes were necessary and overdue!

THE FALL OF GREY GARDENS

In the summer of 1966, as a new college student, I visited my "Granny Beale" at Grey Gardens. I didn't know it then, but this was to be my last time setting foot in the place until exactly 40 years later. Edie had moved out awhile back (soon to return, however), and my grandmother could still get about fairly well. Even after the release of

the Maysles' film, along with other negative local publicity about the dreadful living conditions at the house I am still able to recall what I witnessed that summer during my college years; Grey Gardens was still a lovely property, both inside and out, simply needing a major dusting and mowing. I can still remember all of the furniture, household items, etc. to have been in perfect order and placement, with no unsightly garbage piled up anywhere, no fleas, no broken windows, and just a few cats lurking about.

And about those cats--on that trip to the east end of Long Island I learned inadvertently of a notorious, elderly "Cat Lady" that was the brunt of local kids' Halloween pranks. It was only months later that I realized they were talking about my Granny Beale. In a different day and age, my grandmother and aunt would have been given an award from the Humane Society! My aunt and grandmother, the two Edies, were totally "normal" people, even exemplary in the unselfish, loving way that they treated people and all of God's creatures. They didn't know how to say "no" to anything or anybody, and ended up being taken advantage of by hangers-on and others who thought they might gain some advantage thereby. This book partly tells that earlier story; the roots, the origins and the better times of my Aunt Edie, a remarkably beautiful and talented woman who couldn't make it in a "man's world" all alone, and eventually became a recluse, but all the while never stopped participating and creating.

EDIE AND THE OCEAN

My Aunt Edie had an intimate relationship with the Ocean evidenced in her choice of where to live, and also most notably in some of her better poetry. The 1975 documentary film by the Maysles Brothers shows Edie quite often referring to the nearby ocean, and even pointing out the upstairs view to the cameraman, who pans over to the ocean obligingly.

At the end of her life, my aunt was content, in relatively good health, and living alone in a modest Miami Beach ocean-side apartment. I would visit her at least once a year and take her out to lunch, always with an ocean view at her request. She swam every day in the ocean literally until the day she died. She obviously drew solace, strength, and inspiration from being in close proximity to the ocean, which undoubtedly helped her through some earlier difficulties. One of her last wishes was that her ashes be scattered following her death, off the coast of Long Island, in the Atlantic Ocean. As she writes in this stirring fragment of poetry on July 4th, 1983, "Bury me not in the

sandy loam/ Let the winds and the tide/ hold my bones."

A particularly poignant memory of mine was during one of my last visits to see my Aunt Edie. On the way up to see her ninth floor Florida place, I was admittedly a tad apprehensive, given the fact that the last I had seen any of her living conditions was via the old documentary film. However, to my surprise, as soon as I opened the door, I was greeted by a cool tropical breeze blowing off the intracoastal waterway seen through a set of open French doors that fronted a small balcony. Sunshine, sailboats, and palm trees were visible everywhere. Her place was neat, clean, and orderly, though sparsely furnished. But it is the wall decorations that really stick in my mind; she had hung dozens of Japanese woodcut prints depicting beautiful flowers and delicate maple trees set against a tranquil sea on the walls of her two-room place. In her last years, Edie had appropriately further surrounded herself by her beloved ocean inside and out.

THE MIRACULOUS RESURRECTION OF GREY GARDENS

Many people over the years since the '70's documentary have asked me, my father, my uncle, and many other family members "Why?" Why didn't the family "step in," financially or otherwise, to aid the seemingly helpless, reclusive old ladies depicted in the documentary?

The answer, as many can gather, is complex and convoluted. By the time the East Hampton Health Department attempted to evict the two Edies, my other relatives had been conducting a ten year battle of wills to get my grandmother, with increasing health issues and blindness approaching, out of a too big, expensive, cold and drafty, unwinterized home, and instead into a small, charming cottage to call her own in Florida. The sale of Grey Gardens, still a valuable property due to its location, would have brought more than enough to allow for my grandmother to retire very comfortably, with Edie at her side, as the dutiful and loving daughter she had always been. Despite my family's almost continual concern and active urging, the Edies steadfastly refused to leave what they thought of as their "palace."

As stated earlier, the family had no major investments or appreciable assets remaining from the earlier years, thus leaving everyone on their own. My father was a struggling young attorney, with college bills to pay and a life to live over 100 miles away. Nevertheless he tried to help his mother and sister by paying the property taxes when he could. My uncle, having moved away to the Midwest years earlier, lived very modestly himself and yet continued to correspond with and

financially support his family as best he could. Fortunately, Jacqueline Bouvier Onassis was eventually able to step in, her money coming exclusively from her two husbands, to help her aunt and cousin of whom she was very fond. She contributed just enough so that Grey Gardens complied with local health regulations, and was at least now safe and comfortable, though very shabby. Events moved swiftly thereafter, with the death of Granny Beale in 1977, the successful sale of Grey Gardens in 1979, and Edie's move to NYC and later on to Florida.

But what would become of Grey Gardens itself? Here is where it becomes possible to believe in miracles. The new owners, far from wanting to tear the old place down and erect yet another "McMansion," turned out to be well known journalists Ben Bradlee and Sally Quinn. After meeting my Aunt Edie, and cognizant of the amazing history of the place, they were enthralled by the whole look and feel of what remained. The Bradlees chose the more painful and expensive route, doing and spending whatever it took to totally rebuild and restore Grey Gardens to its glory days of the twenties.

Recently Eva and I were invited over for a tour by a very gracious Ben and Sally, almost exactly 40 years since my last visit in 1966. I was overcome by both awe and nostalgia in seeing my old family home restored. Furthermore, I was stunned to discover that the Bradlees had uncovered a trove of old furniture and other Beale family artifacts hidden in the attic. The Bradlees repaired the furniture, dusted off the old books and volumes, reframed and displayed a few old family photos that were even overlooked by Edie herself (who usually saved everything). The result today is a home dedicated as a beautiful time capsule to my family's glory days. Outside, surrounding the house, a complete restoration job has recreated the famous and voluptuous "grey" seaside gardens as stunningly as they once must have been. Even the tombstone of Spot, the beloved family dog, has been cleaned up and remounted!

GREY GARDENS, THE MUSICAL

My family and I, having always had mixed feelings about the sad state of my relatives as depicted in the documentary film, were understandably apprehensive upon getting news last year of a new Broadway play entitled "Grey Gardens, the Musical". What in the world could now, after all these years, be presented in a positive light about the two Edie's, let alone to a musical score?

Apprehension soon vanished as Eva, my brothers, their wives, and myself and several other close relatives attended the opening night of the play at the beautiful and historic Walter Kerr Theater on Broadway in New York, invited by the producer of the show, Kelly Gonda. Starting the moment we arrived at the theater and navigated through the throngs of people surging towards the door, lasting until several hours later in the early morning as we exited the celebratory post-party, the mood of the crowd was electric.

The early years at Grey Gardens, with my grandmother, Big Edie, holding sway, are depicted musically with all the expected opulence and bohemian eccentricities. The songs, with the subsequent Tony Award-winning best musical actress, Christine Ebersol, taking the lead as Big Edie, drew ovations from the enthusiastic at crowd every turn. The second act was patterned after the documentary, though thankfully skipped the more sordid elements of the film, and instead focused mainly on the fascinating relationship between the two women. The multi talented Ms. Ebersol, here switches roles to also play "Little Edie", complete with an authentic looking "we're not ready" wardrobe. Again, the crowd reaction was dynamic and did not let up for a minute! The family and I were absolutely stunned and moved.

The play went on to be a hit, and a multiple award winner. But for my family, and myself this was the artistic event we had hoped might happen, but never dreamed would come to fruition. Through this production we felt as though the two Edies had been somehow vindicated and truly appreciated, not as the victims they were depicted as later in life, but for who they really were and what they stood for. It was the crowd's reaction, and the love we felt as being directed towards Big and Little Edie, and ourselves, as their legacy, that we will never forget. As my Granny Beale once said to me: "If you stick around long enough, you're bound to see just about anything happen". How very true!

So now, on these pages, the real story of my fascinating and perhaps misunderstood 20th Century New York family, the Bouvier/Beales can begin to be told through my Aunt Edie's eyes, by those who loved her and really knew what happened. The photos, poetry, and writings are our and her gift to you, the reader. Enjoy!

Undated portrait of Maude Sergeant Bouvier, mother of Edith Ewing Bouvier, and grandmother of Edith Bouvier Beale. Found in family scrap book.

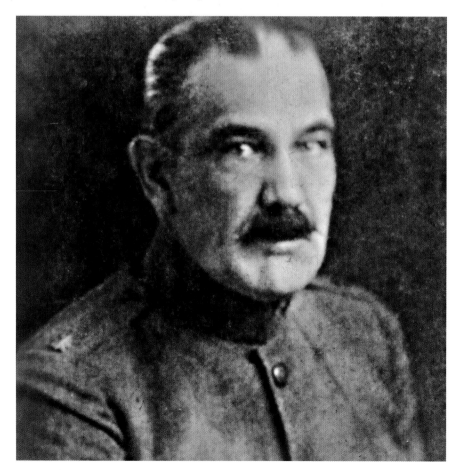

1914 | Portrait of John Vernou Bouvier, Jr. (1865-1948), father of Edith Ewing Bouvier, and grandfather of Edith Bouvier Beale, as Major Judge Advocate World War 1.

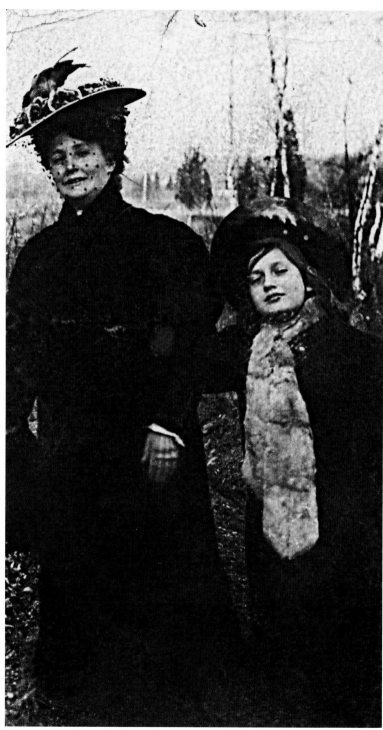

1907 | Maude Sergeant Bouvier with her daughter Edith Ewing Bouvier.

Opposite:
1907 | Bouvier Family Portrait. Clockwise: William Sergeant Bouvier, Edith Ewing Bouvier, John Vernou Bouvier Jr., John Vernou Bouvier III, Maude Sergeant Bouvier , the twins, Maude Repellin Bouvier, Michelle Caroline Bouvier.

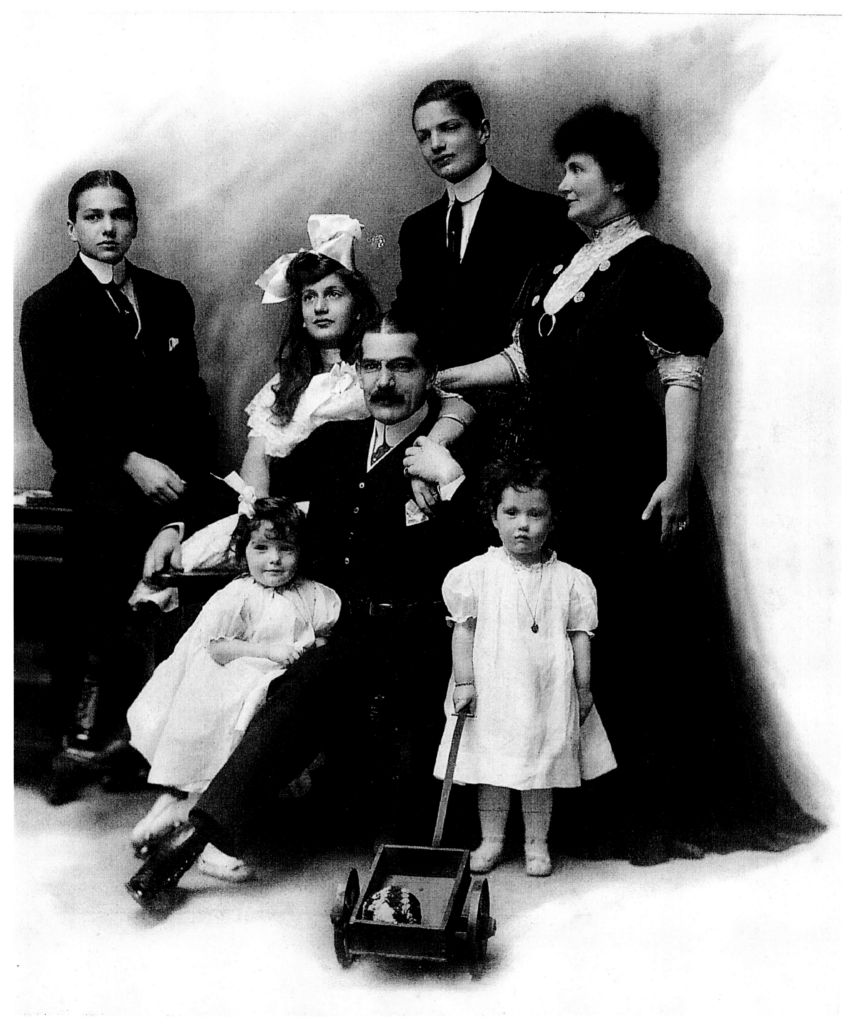

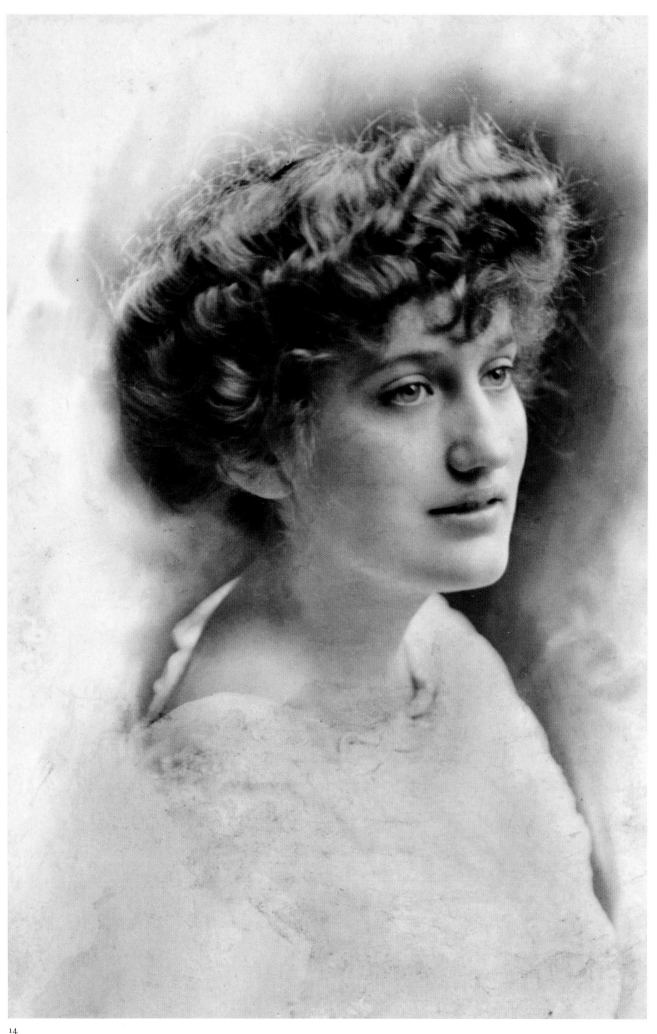

1910 | Edie wrote on the back of this photo: "Edith Ewing Bouvier, in her teens in Nutley NJ or East Hampton NY".

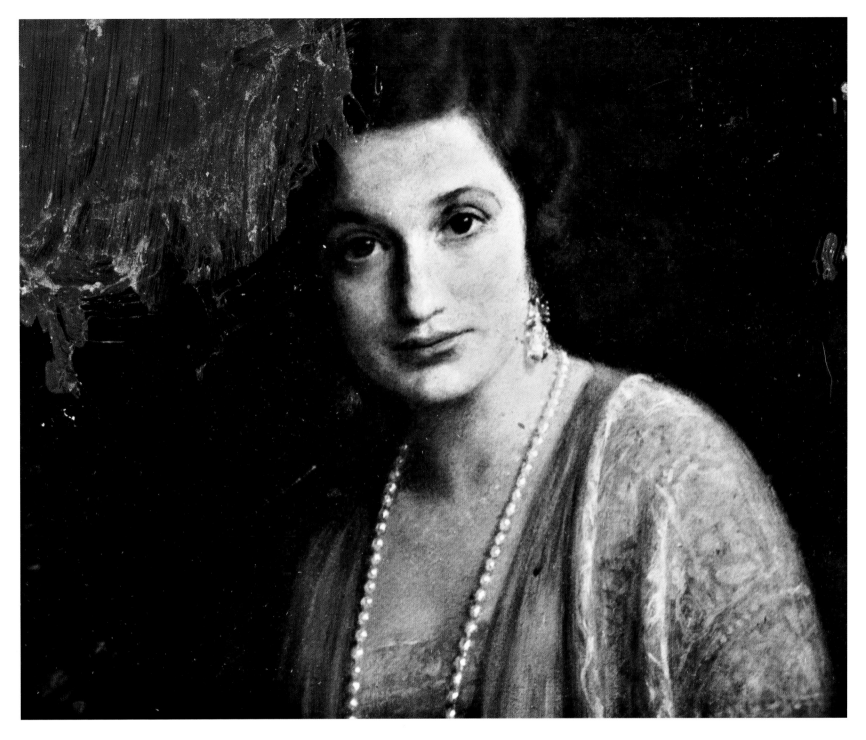

"This is my mother. There is british blood, maybe Jewish, I don't know. There is scotch blood - the Ewing, the Ewing clan's in here. But it's just a girl from a good french family. It's a very beautiful face."

Edith Bouvier Beale,
talking about her mother.

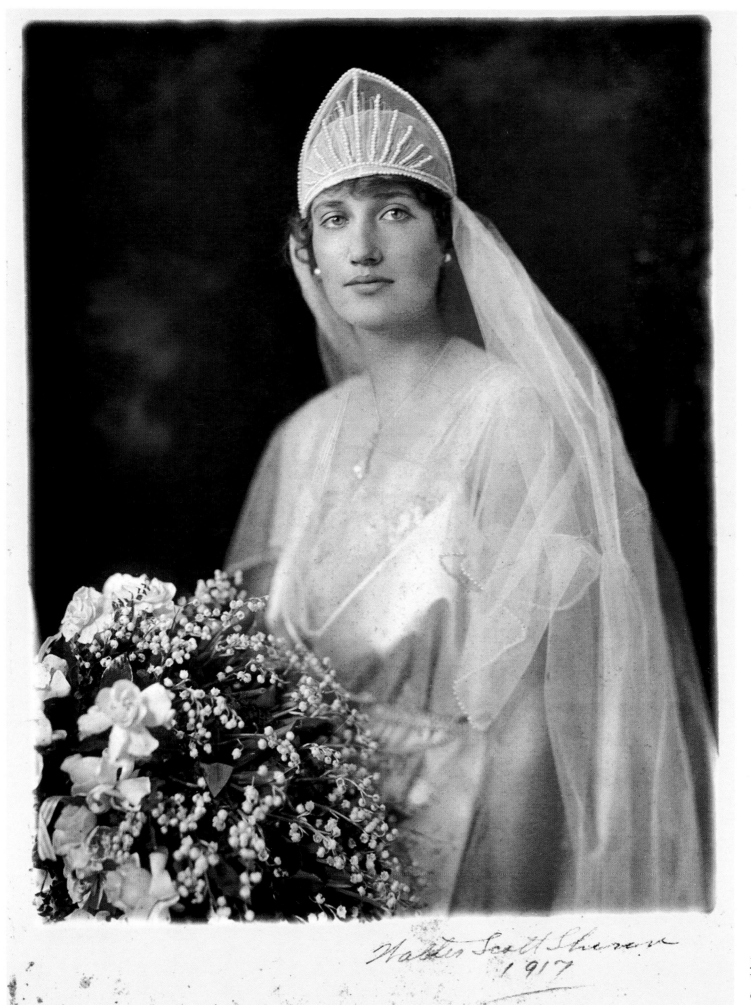

Walter Scott Shinn
1917

Jan 17, 1917 |
Wedding portrait
of Edith Ewing
Bouvier.

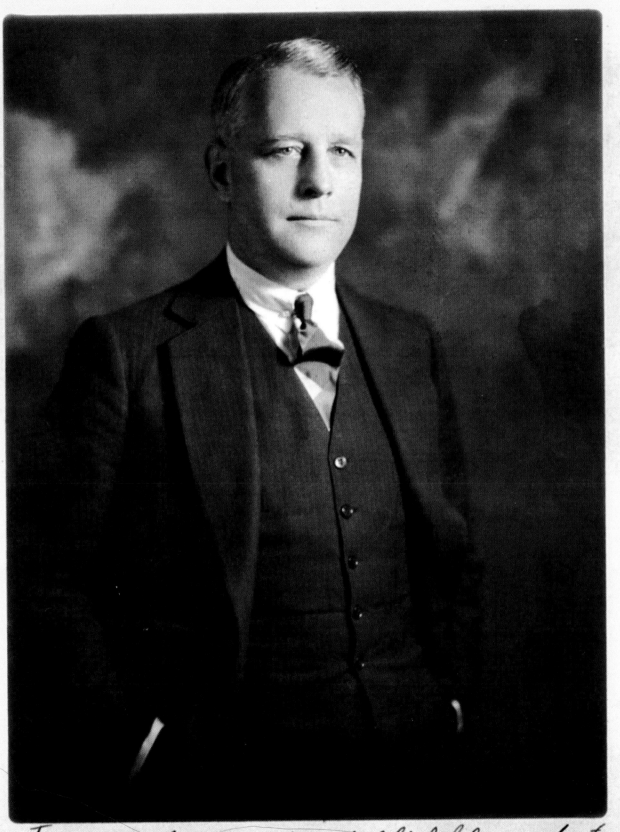

To my best friend and most delightful comrade; to my only sweetheart and wonderful wife, I tender the likeness of her husband.
Phelan Beale. 5/9/29.

May 9, 1929 | Studio portrait of Phelan Beale.

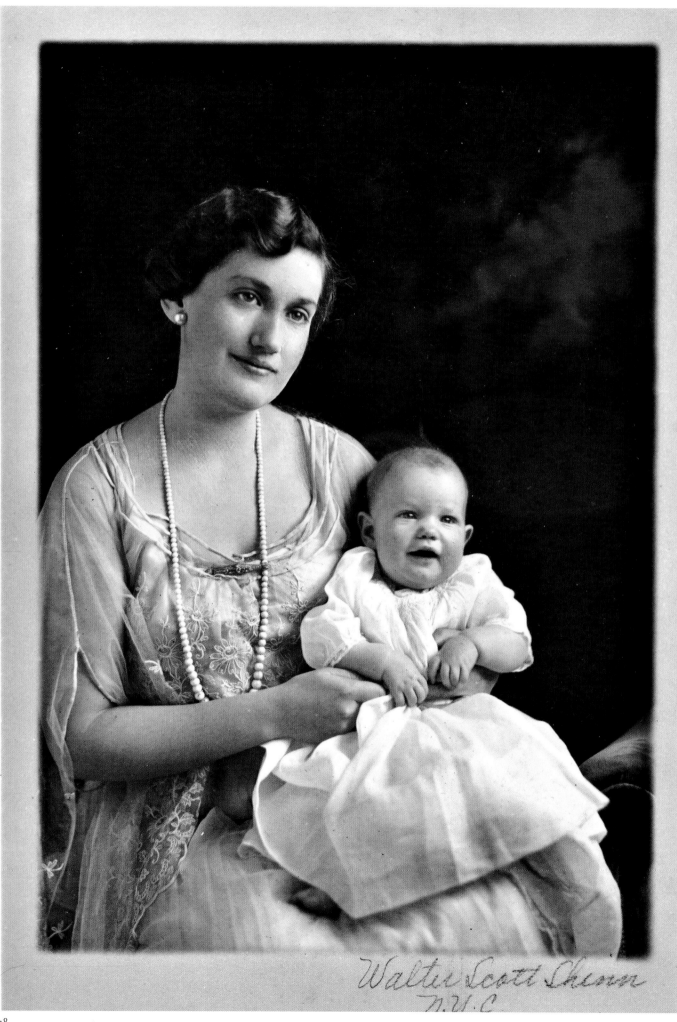

Walter Scott Shinn
N.Y.C.

1918 | New York, NY | Portrait of Edith Ewing Bouvier Beale with daughter Edith Bouvier Beale. This photo was found with attached newspaper announcement *"To Selma Friends:- Mr. and Mrs. Phelan Beale of New York City, residing at eighty-seven Madison avenue, announce the birth on November 7th of a beautiful little daughter who bears the pretty name of Edith Bouvier. Announcement cards have been received by Selma friends who are remembering the parents with cordial congratulations and the little heiress with gifts suitable to her youthful lady ship."*

Opposite:
1918 | East Hampton, NY |
Little Edie, pictured in her
baby carriage, between her
two twin aunts, Maude and
Michelle Bouvier.

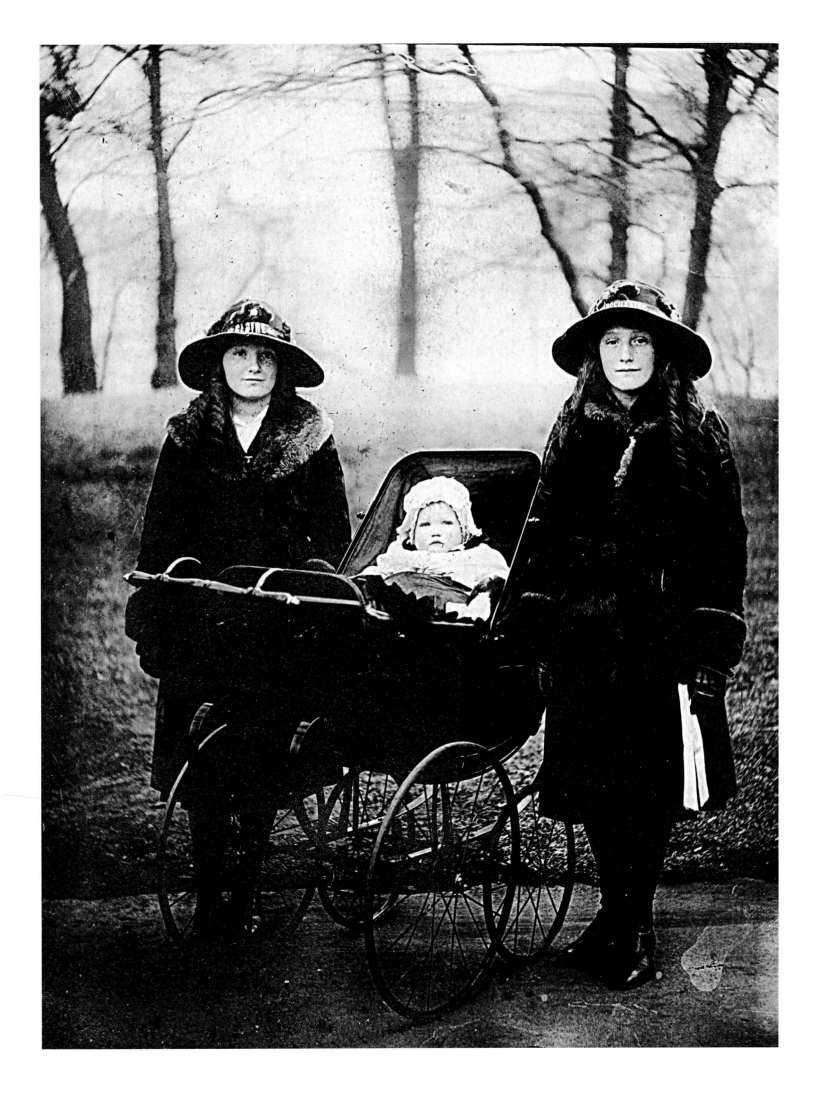

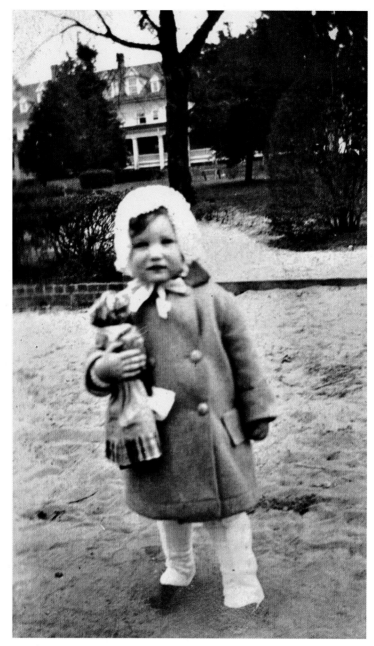

1920 | Nutley, NJ | Little Edie, pictured at age three.

"Once upon a time it rained over the week-
end in Dutchess County on the Hudson river.
That was a long time ago but that storm got
me born."

Edith Bouvier Beale,
speaking about family history

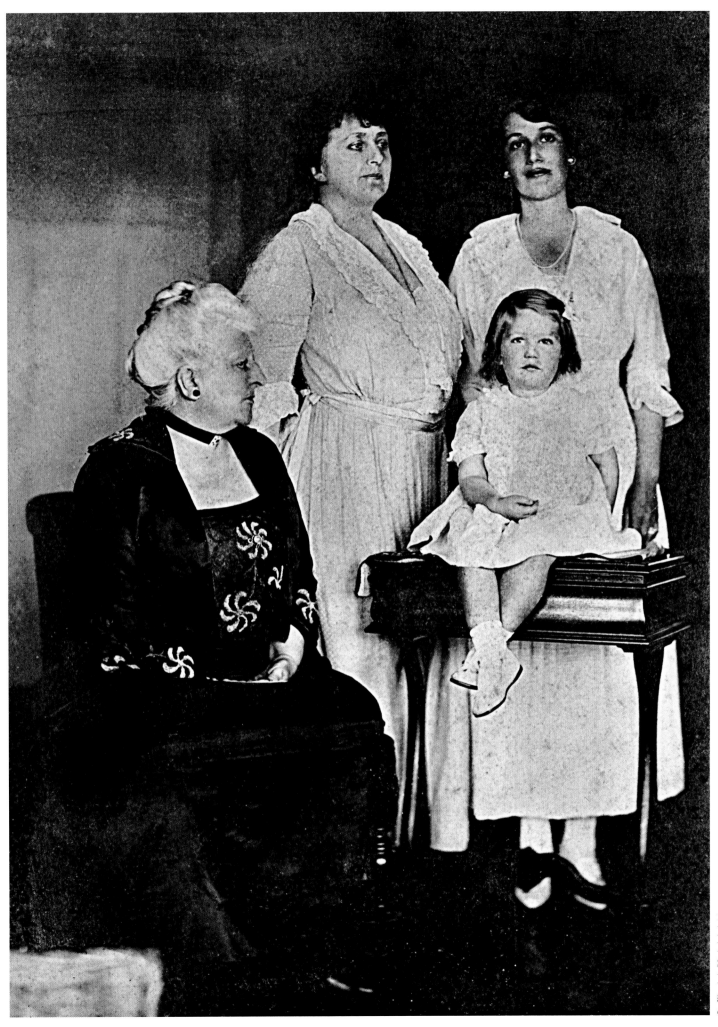

1920 | New York, NY |
Little Edie, Edith Ewing
Bouvier Beale, Maude
Sergeant, and Grandma
Precious (Marga), the four
generations at a fundraiser
on Madison Avenue.

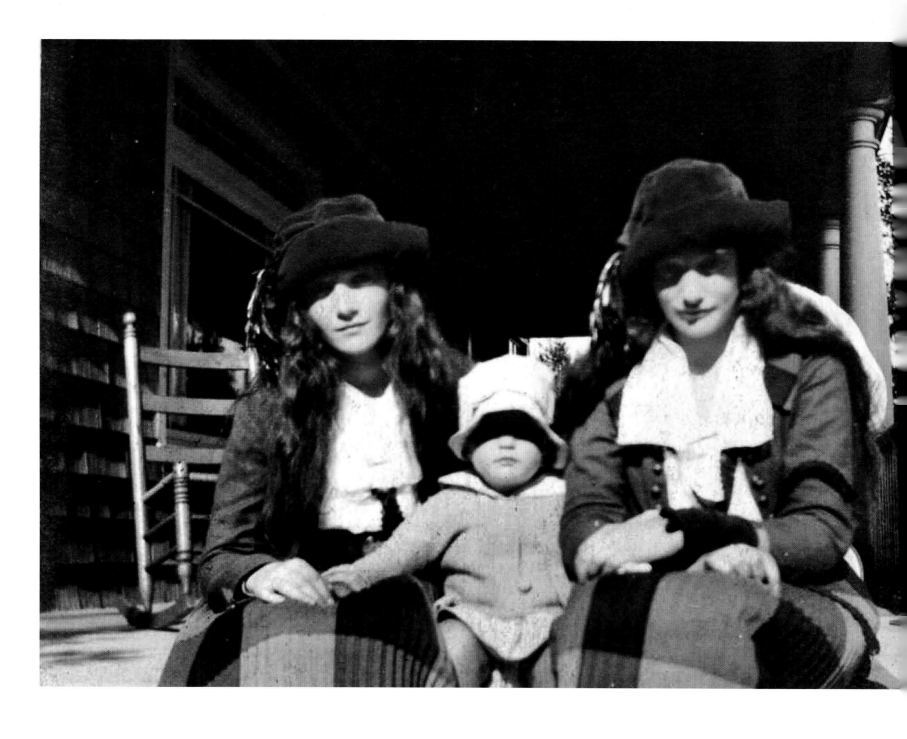

1920 | Nutley, NJ | Little Edie at age three, pictured between her two aunts, Maude and Michelle Bouvier, in front of her mother's childhood home.

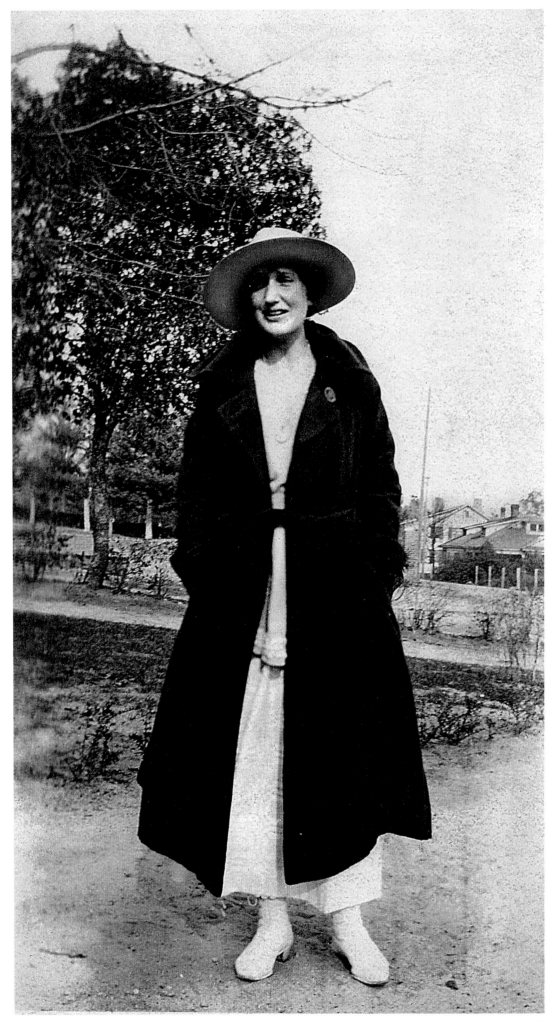

1920 | Nutley, NJ | Edith Beale Sr. poses
for a photo in front of her childhood home.

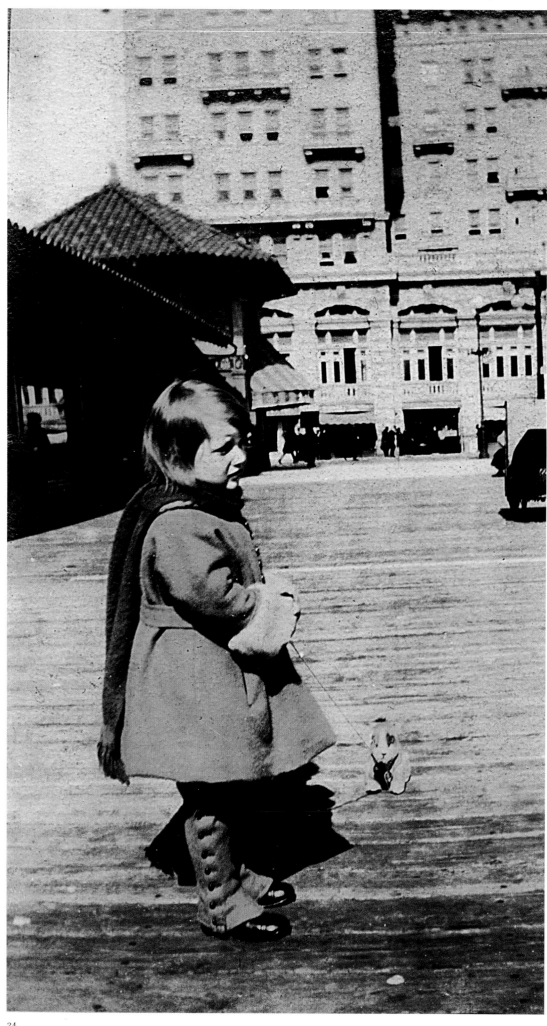

1920 | Atlantic City, NJ | Little Edie, pictured at three at the Boardwalk in Atlantic City with toy dog.

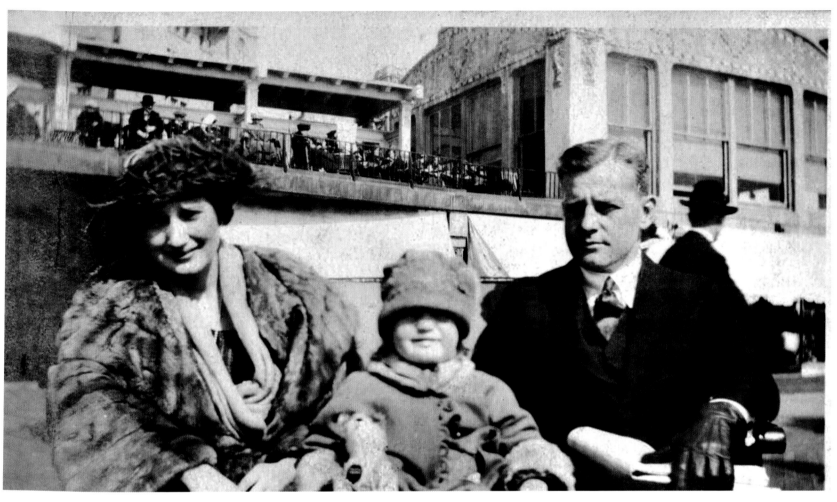

1920 | Atlantic City, NJ | Little Edie pictured between her mother Edith, and her father Phelan, at the Boardwalk enjoying family time together.

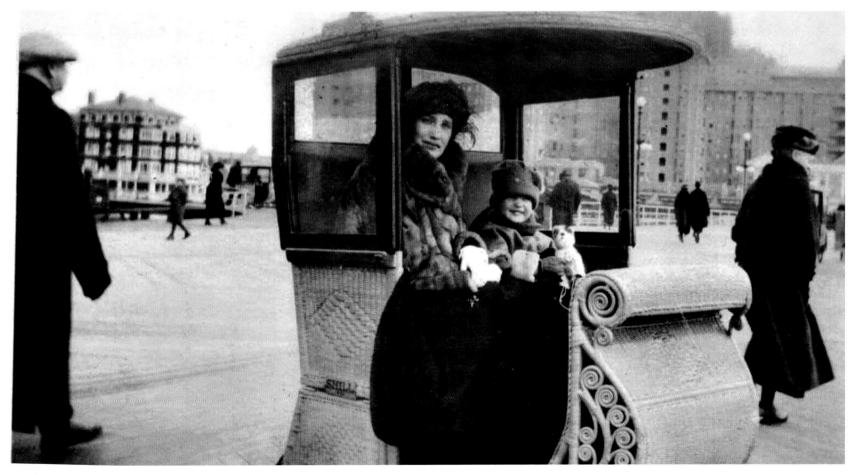

1920 | Atlantic City, NJ | Little and Big Edie pictured in a carriage at the Boardwalk in Atlantic City.

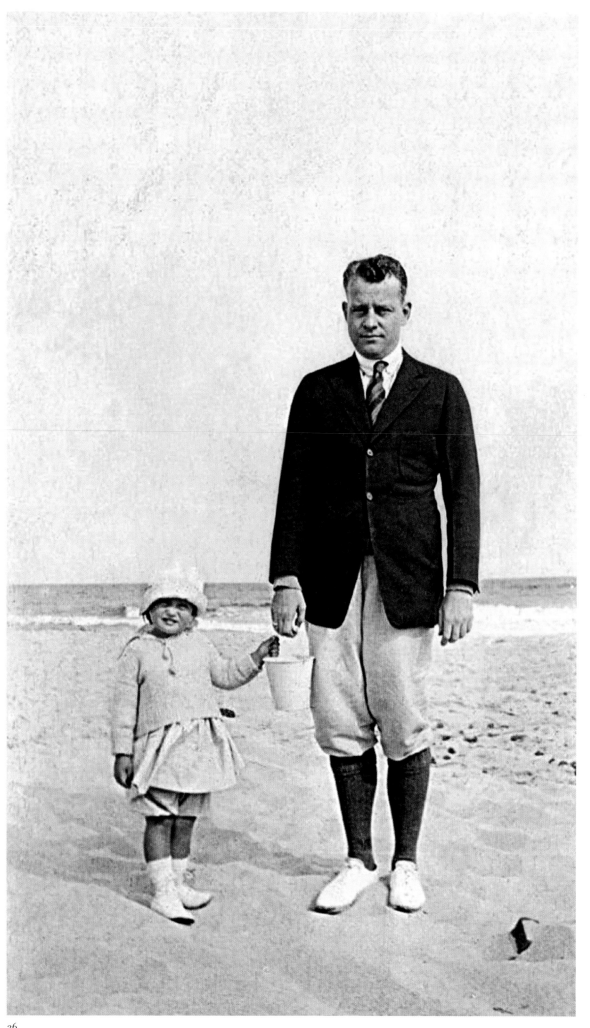

1920 | Atlantic City, NJ | Little Edie at age three pictured on the beach with her father, Phelan.

Opposite:
1920 | Pastel-colored photograph of Little Edie.

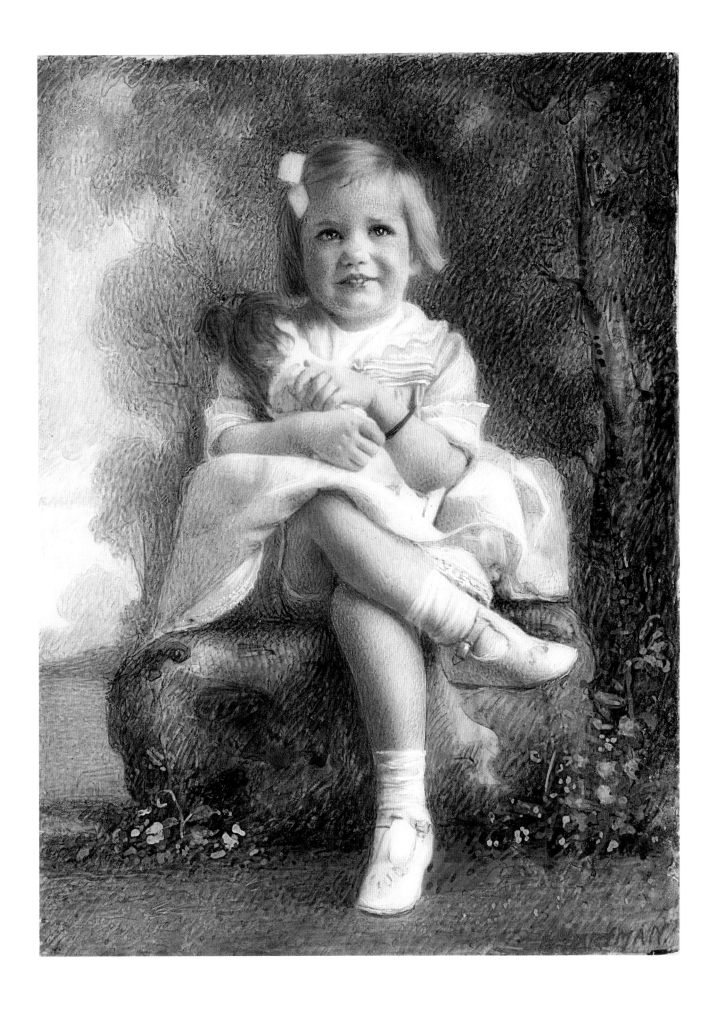

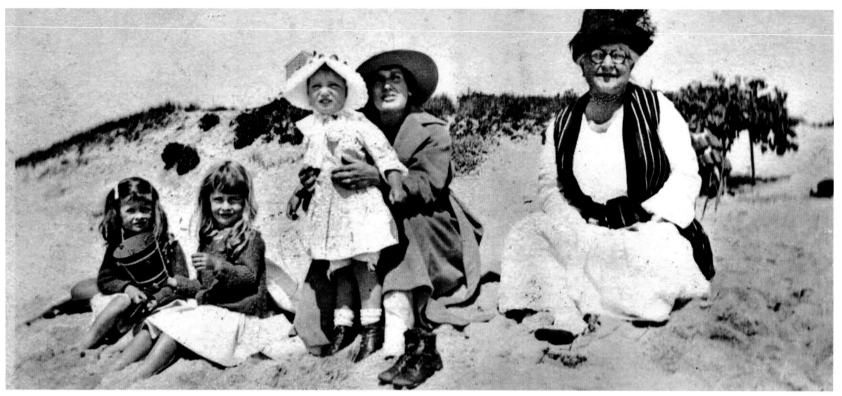

1920 | East Hampton, NY | Little Edie at age three pictured at the beach with her mother, "Grandma Precious", and friends.

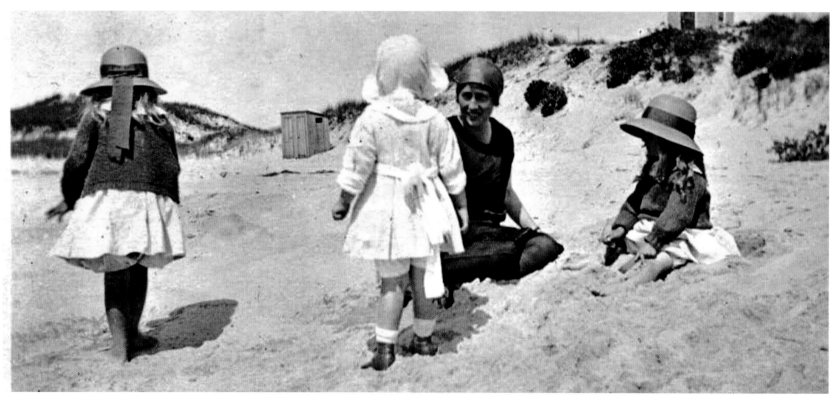

1920 | East Hampton, NY | Little Edie at age three pictured at the beach with her mother and friends.

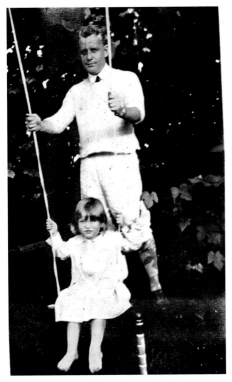

1920 | East Hampton, NY | At Wildmoor, or "The Little House," owned by John V. Bouvier from 1915-1925, on Appaquoge road, Little Edie at age three pictured with her father, Phelan Beale.

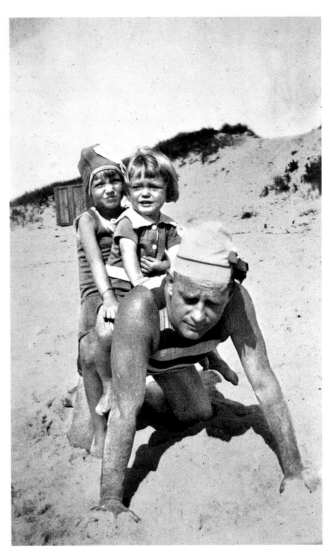

1921 | East Hampton, NY | Father Phelan lovingly plays with his children, Little Edie and Phelan, in the sand of the East Hampton shore.

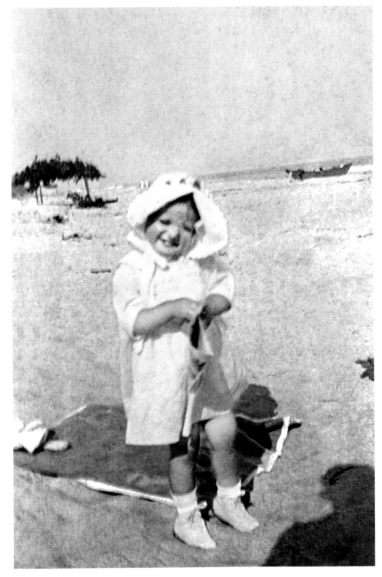

1920 | Boardwalk, Atlantic City, NJ | Little Edie at age 3 pictured on the beach.

"Loving you"

"I cannot count the grains of sand
That lie upon the desert's wastes
Nor trace the story ancient man
Left in stone enfaced
The air that held the golden songs of Greece
I cannot summon back
In silence of the years
Their beauty lies enwrapped
A pyramid constructed to a star
And built alone by man
I cannot divide its plan
Sand and stone and star
All these infinite are
What pen explains a star?

In loving you - I cannot write of love."

Edith Bouvier Beale

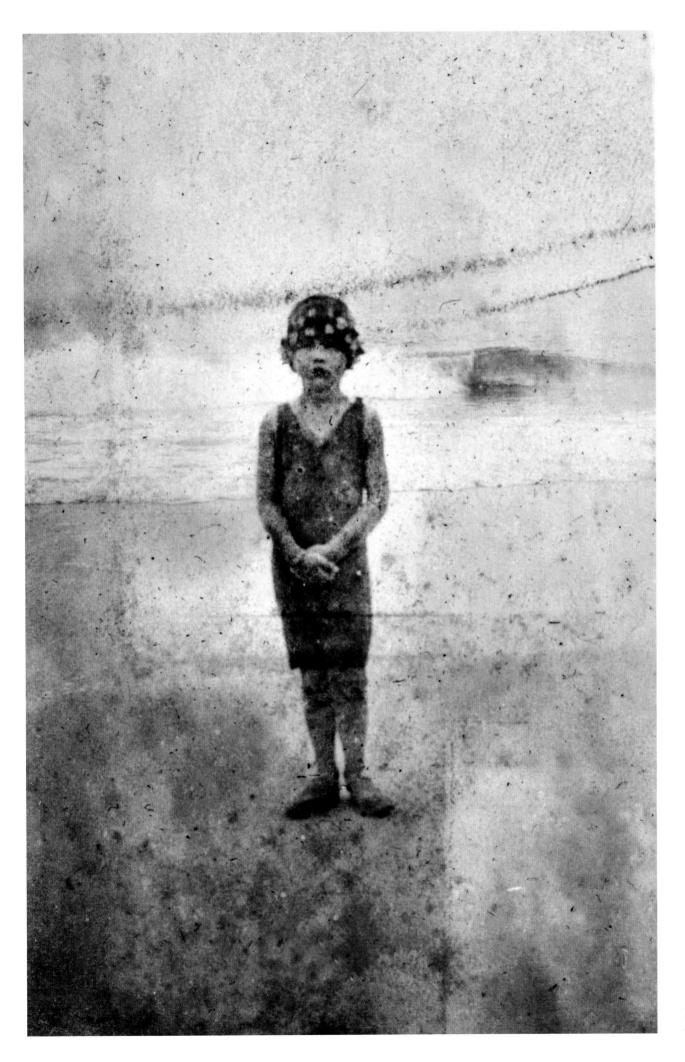

1922 | Georgica Beach, East Hampton, NY | Little Edie, pictured at age four, wades in the tides of Georgica Beach.

"Mother's Day."

Wishing momzie all the happiness in the
world ——— and the most joyous "Mother's
Day" she ever had,

with ladles, and ladles of kisses,
love, and hugs,
your - ever-precious, ever-
loving- and ever-darling ———
kissable
Edes.

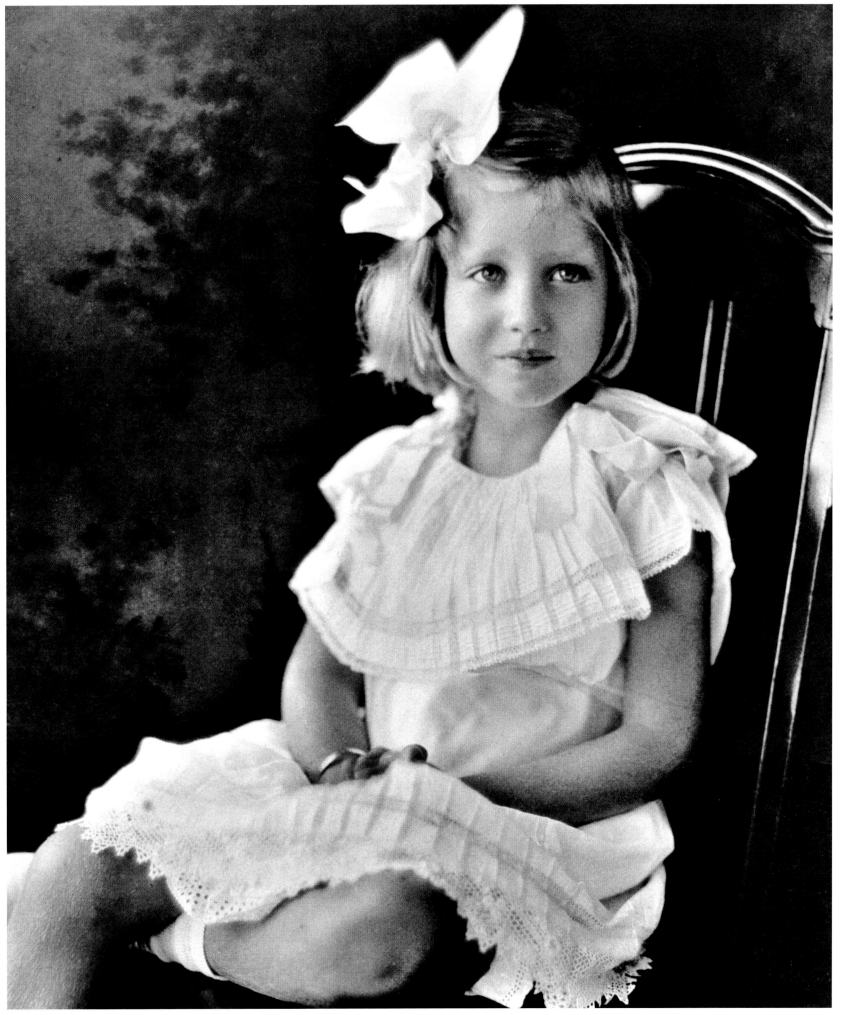

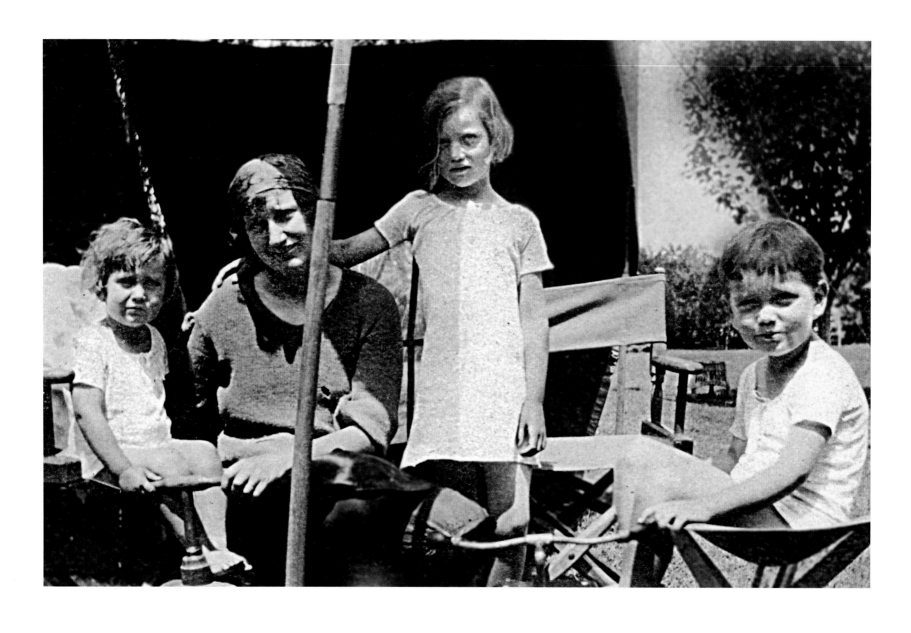

1923 | East Hampton, NY | At Wildmoor, or "The Little House," owned by John V. Bouvier from 1915-1925, on Appaquoge road, Edith Beale, pictured with her children, Little Edie, Buddy, and Phelan, during their summer vacation.

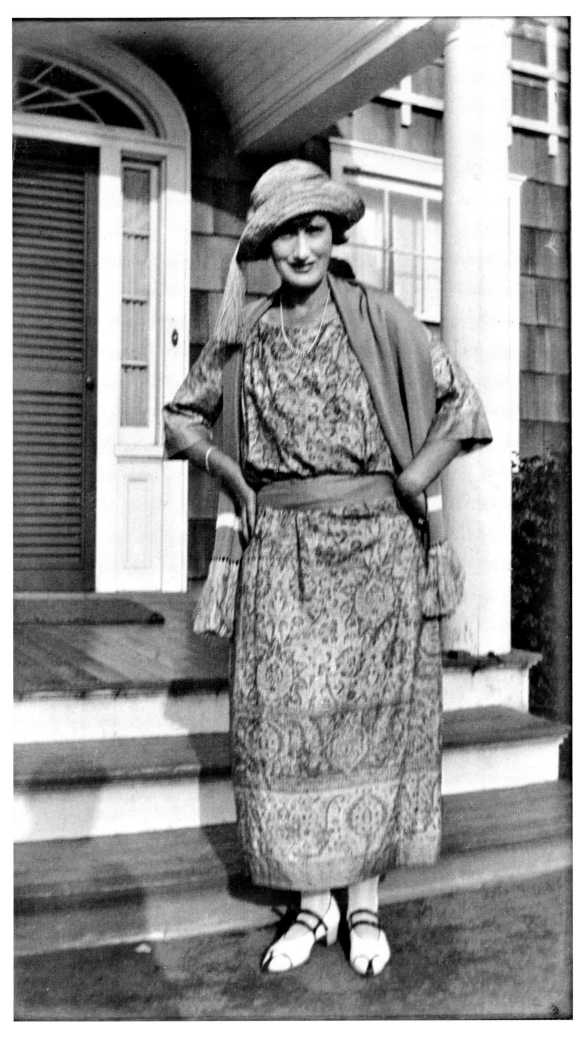

1922 | East Hampton, NY | Big Edie dresses in style on porch of "The Little House."

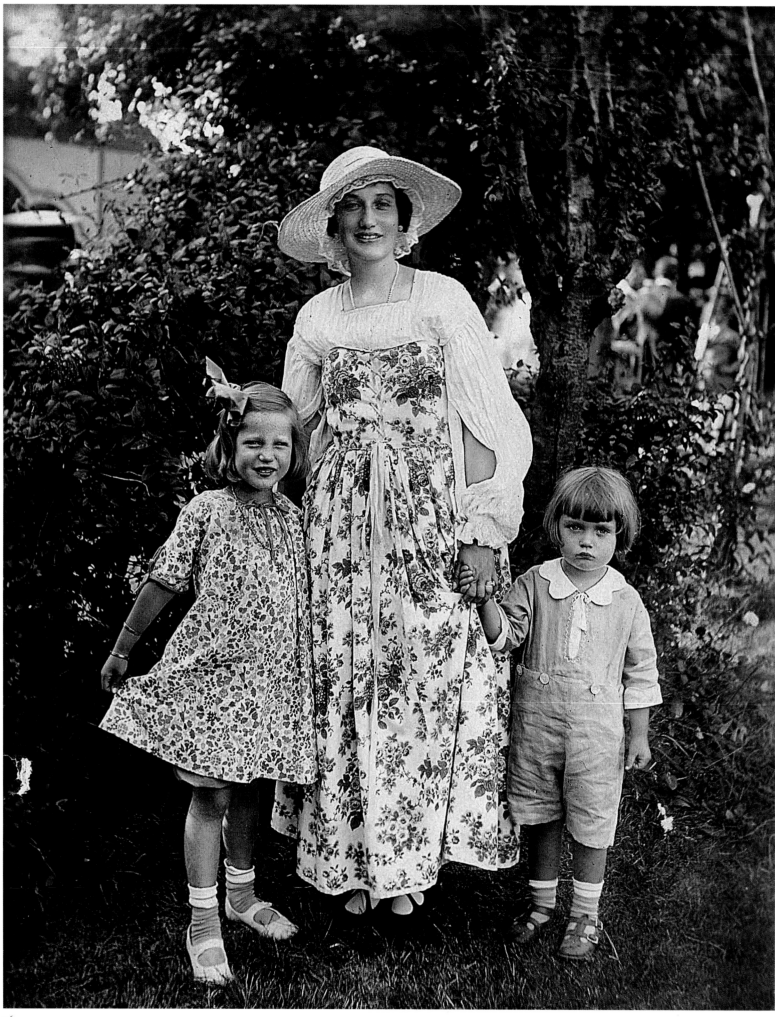

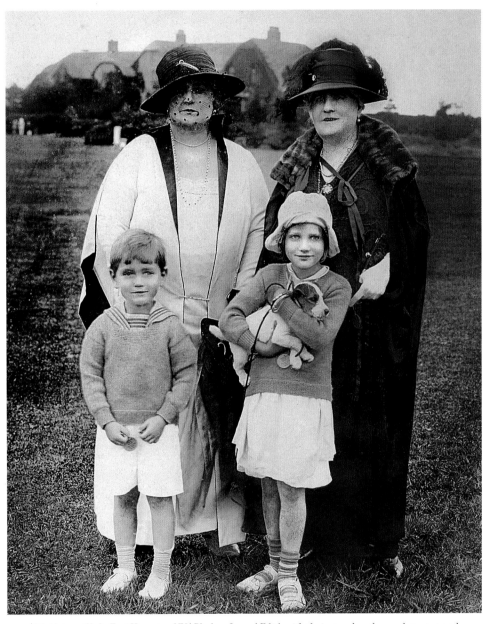

1925 | Maidstone Club, East Hampton NY | Phelan, Jr., and Edith with their grandmother and great-grand-mother. Edie happily clutches her first puppy.

Opposite:
1924 | Southampton , NY | Edie Beale with Little Edie and Phelan, Jr., at Southampton Fair.

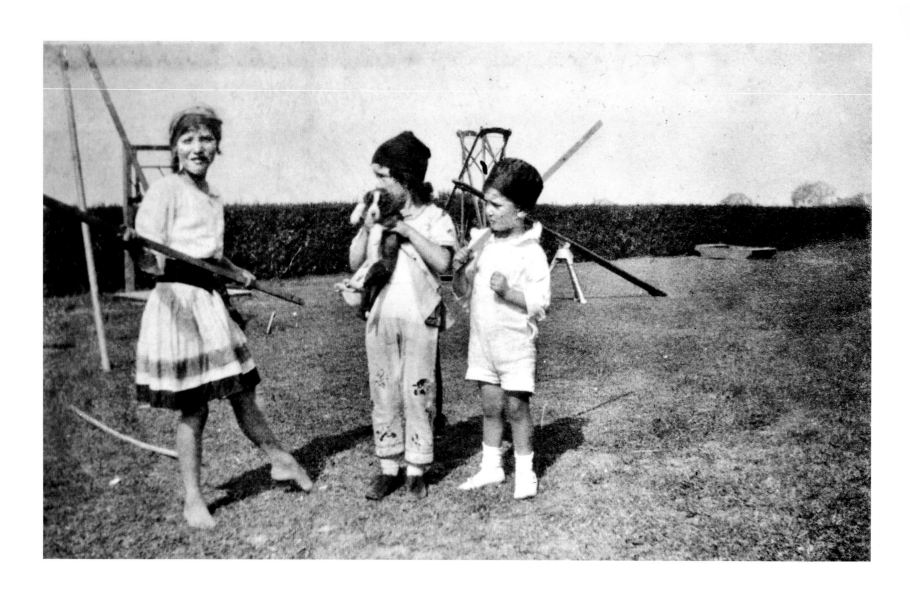

1928 | East Hampton, NY | Little Edie, Phelan Jr., and Buddy dressed in a gypsy costume and pirate costumes pictured playing together in the Grey Gardens backyard.

Opposite:
1926 | East Hampton, NY | Little Edie toe dancing or "bally dancing" which she wrote in her diary as her favorite thing to do.

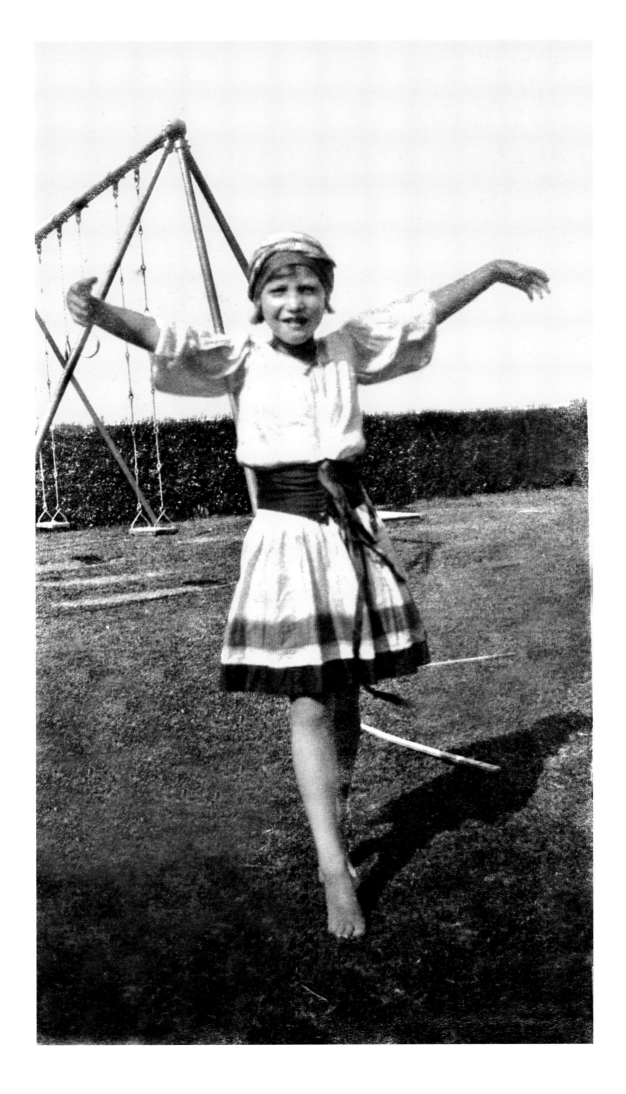

"It Must Be Love"

"It must be love
He's not my type
I'm sure at last
I've got it right
I go for blonds
With cury hair
Big blue eyes
Full of country air
He's short and fat
Likes his life
Drinks till four

Has had more than one wife
Gone is yesterdays ideal
Ushered out by something real
He's not my type-it's love all right."

Edith Bouvier Beale

1924 | East Hampton, NY | Edie posing with doll in the garden.

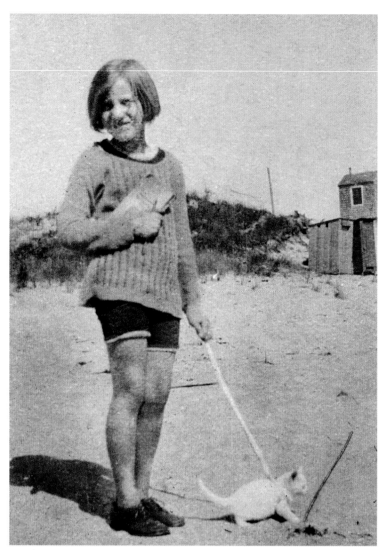

1926 | Georgica Beach, East Hampton, NY | Little Edie pictured with her pet cat on a leash.

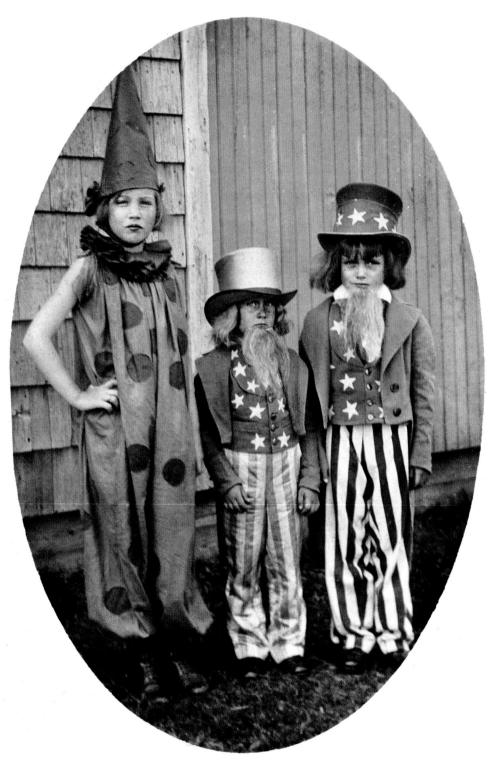

July 1926 | East Hampton, NY | Riding Club Pageant "America." The Beale family won 2nd place in the pageant.

East Hampton, NY | Little Edie,
Phelan Jr. and Bouvier (Buddy) sit-
ting on the steps of Grey Gardens.

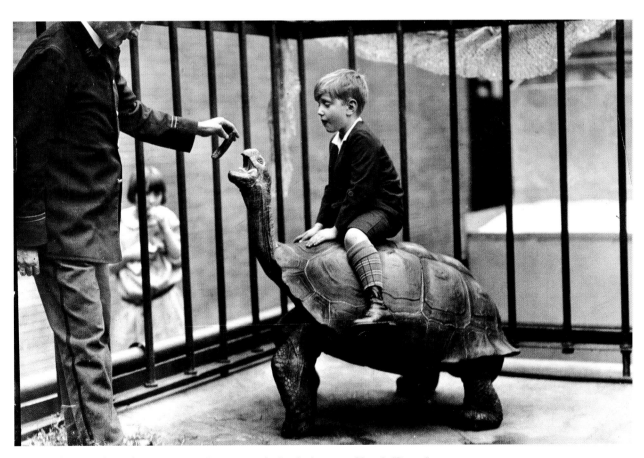

1926 | NY | Bouvier (Buddy) Beale visits the Bronx zoo and rides the 300 year old turtle "Buster".

"Edith Ewing Bouvier Beale is Moma's favorite, hates vegetables - adores meat - fountain pens - has six of them - high heels - short dresses - and is crazy about movies and sodas, pretty good at school - marvelous writer."

"Interviewing the Bouvier family" by Little Edie, aged 10

1928 | New York, NY | Little Edie writes an "Interview with the Beale family" where she writes about all the individuals in her family.

Opposite:
1928 | Grey Gardens, East Hampton, NY | Little Edie pictured with brothers Buddy and Phelan at Grey Gardens. 1928 was the year the Beales purchased Grey Gardens.

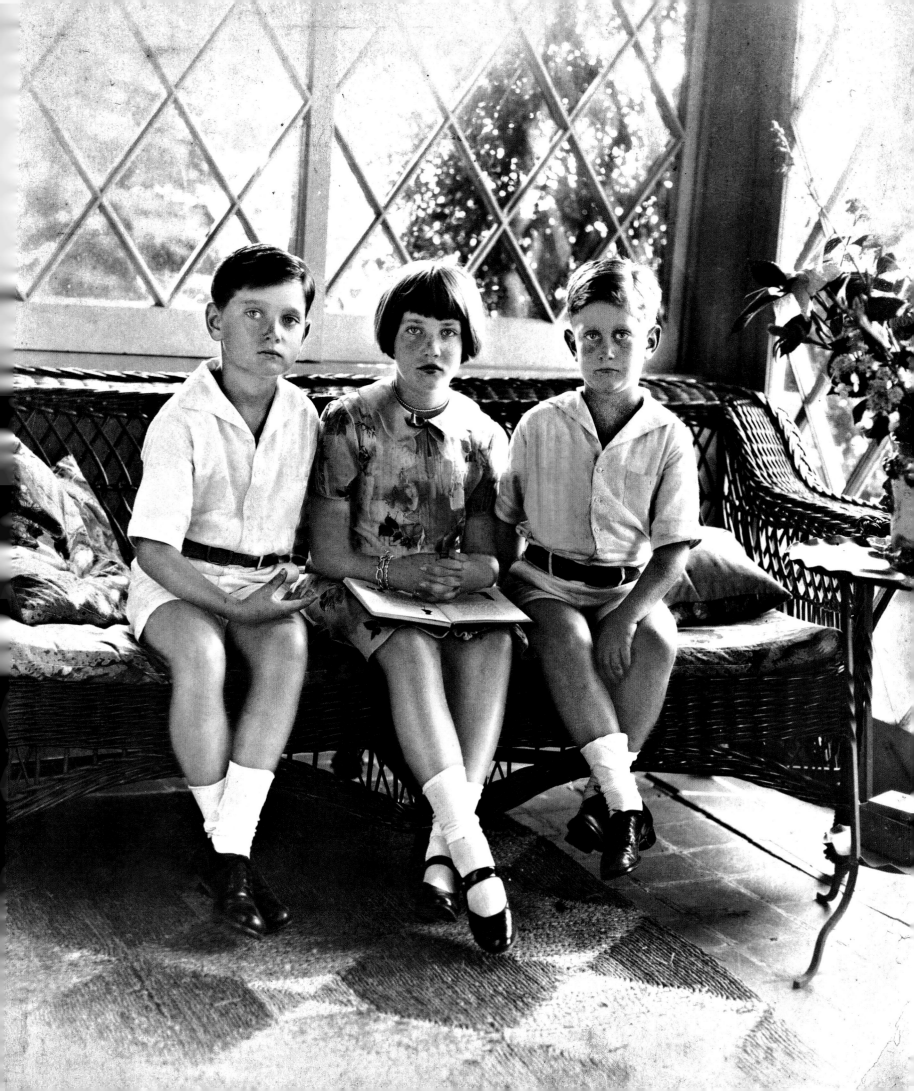

This belongs to Edie Beau

Edith Beau

E Edith ——— Beale

This belongs to:

Edith Beale

Edith Beale.

Edith

Red - Edith Beale

green - Edith Beale

Edie

Edith BSL

Edith BSL

Edith Beale

Edith Beale

E

Edith Beau

Edith Beau

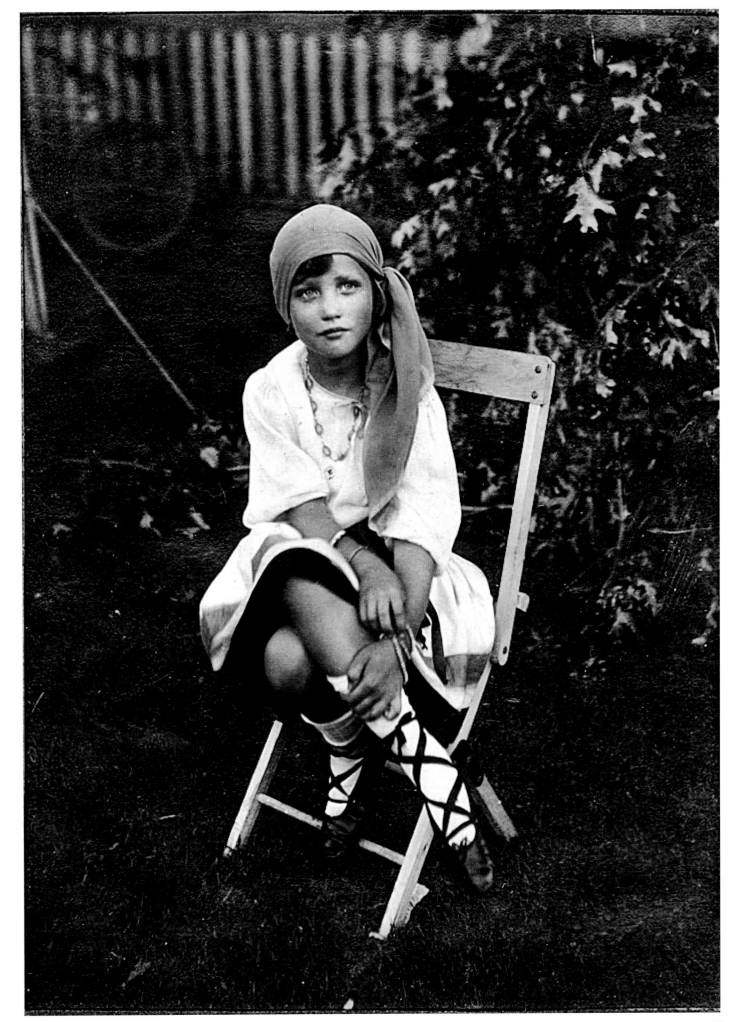

Opposite:
As found in little Edies
composition book dated
1928.

1927 | East Hampton,
NY | Little Edie poses
in gypsy costume by
unknown photographer.

New Years resolutions:

To improve her studies
To be a good girl
To get more fresh air.

Edith Bouvier Beale

1929 | Photo taken from Edies' scrap book.

1928 | Hand made folder decorated
by Edie labeled "Poems" on cover.

"to mother"

She is so sweet and
loving and neat —
that Person that I know.
and My! Oh My! doesént
this Person love her
So, She has other
admirers of course,
but you can see —
without a guess —
that I'm the Person
She loves best!

I hope you will
like this little book —
and now and then —
take a tiny look.

"When I'm Sick"

When I'm sick _ Ah _ Mercy me!.
the medicines and pills are
heaped so high _ I can
hardly see! there's a pill
every hour _ and a cough-
drop sour _ combined
with soda and water _ I
storm and I rage _ but all
in vain _ that doctor insists
on coming again _ be _
cause he says he oughta.
There rubbings and dubbings
and pokes everywhere
(OVER)

1928 | Copy of inside of handmade folder; enclosed
are poems dedicated to Edie's mother.

Following pages:
Signed drawings by Little Edie as found in her
journal/sketchbook.

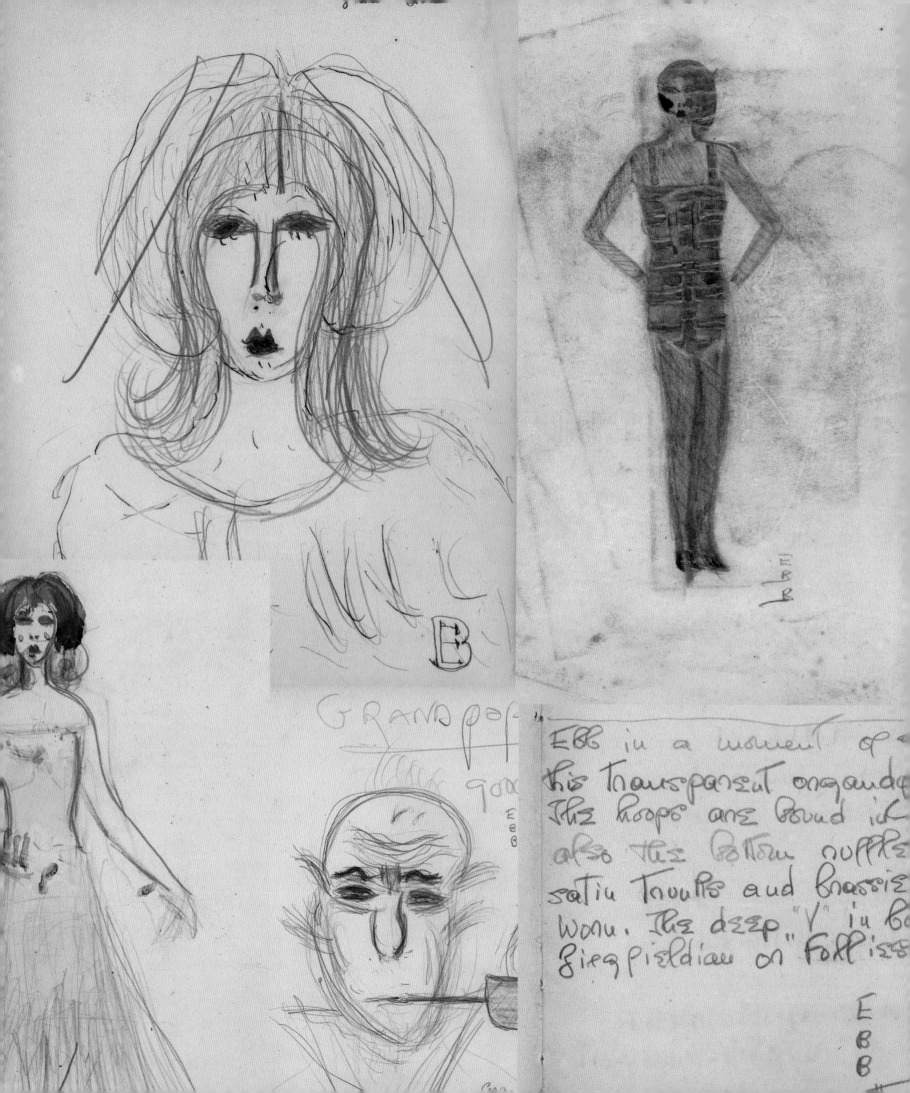

B

GRAND PO
go

EBB in a moment of
his Transparent organdy
The hoops are round it
also the Bottom ruffle
satin Trouves and Brassie
worn. The deep "V" in Ba
Ziegpfeldian on "Follies

E
B
B

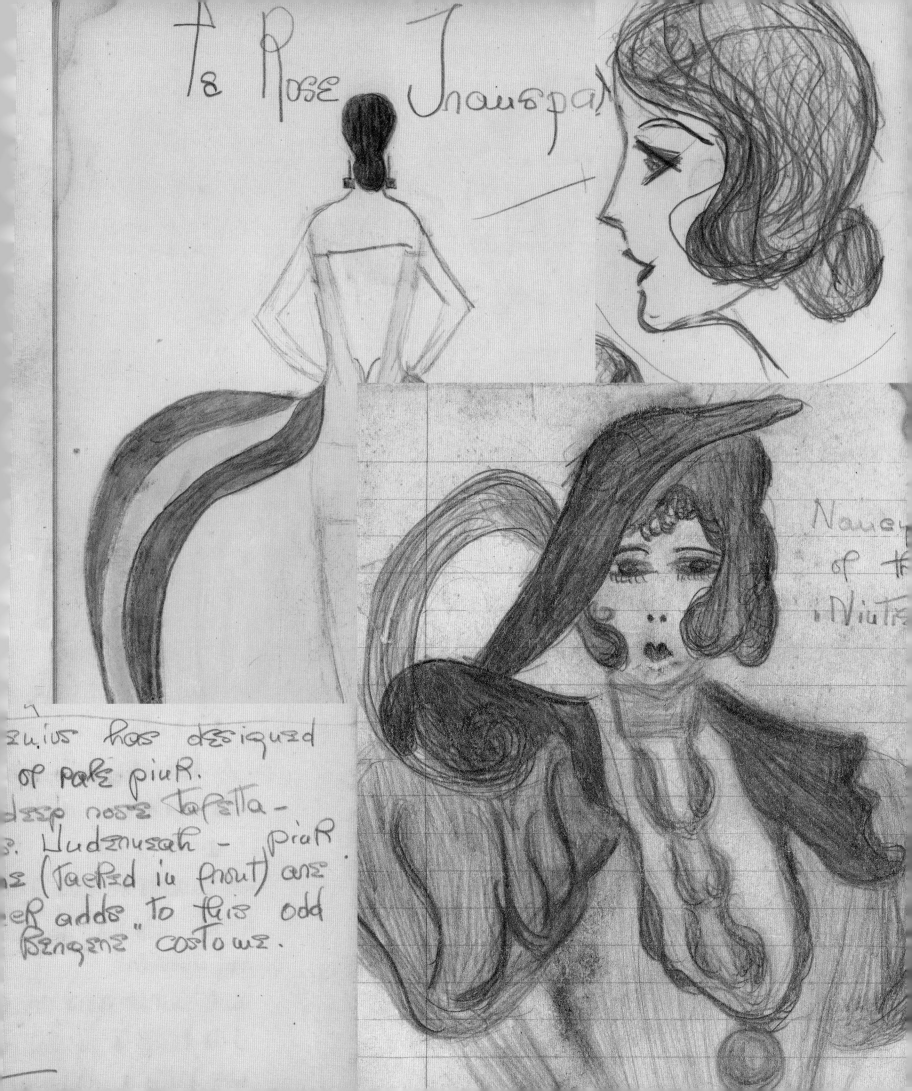

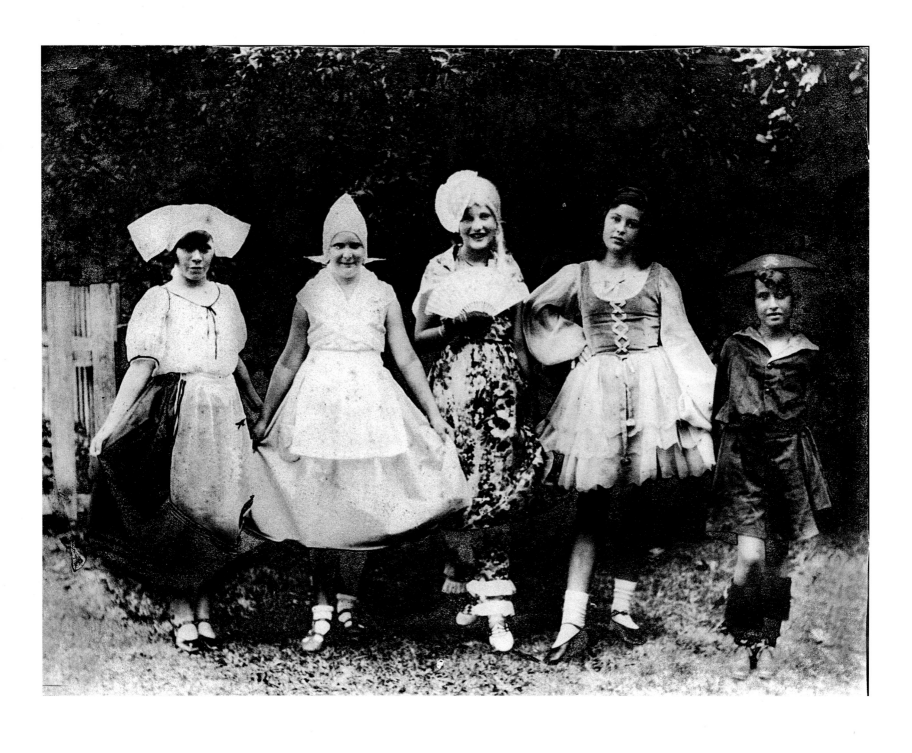

1929 | East Hampton, NY | Little Edie (third from left) pictured with friends at the Lady's Village Improvement Society in East Hampton (as referred to in Edie's 1929 diary).

Opposite:
1929 | East Hampton, NY | Little Edie poses, wearing a floral dress with a fan, at the Lady's Village Improvement Society in East Hampton.

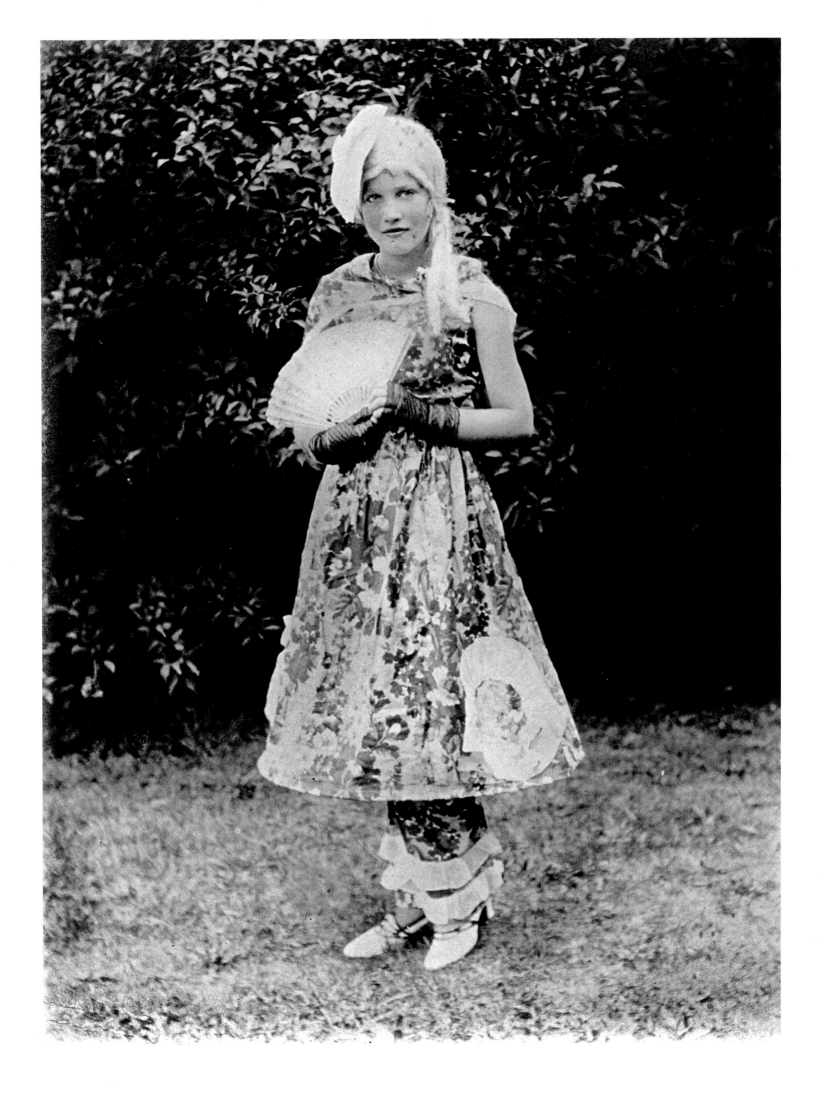

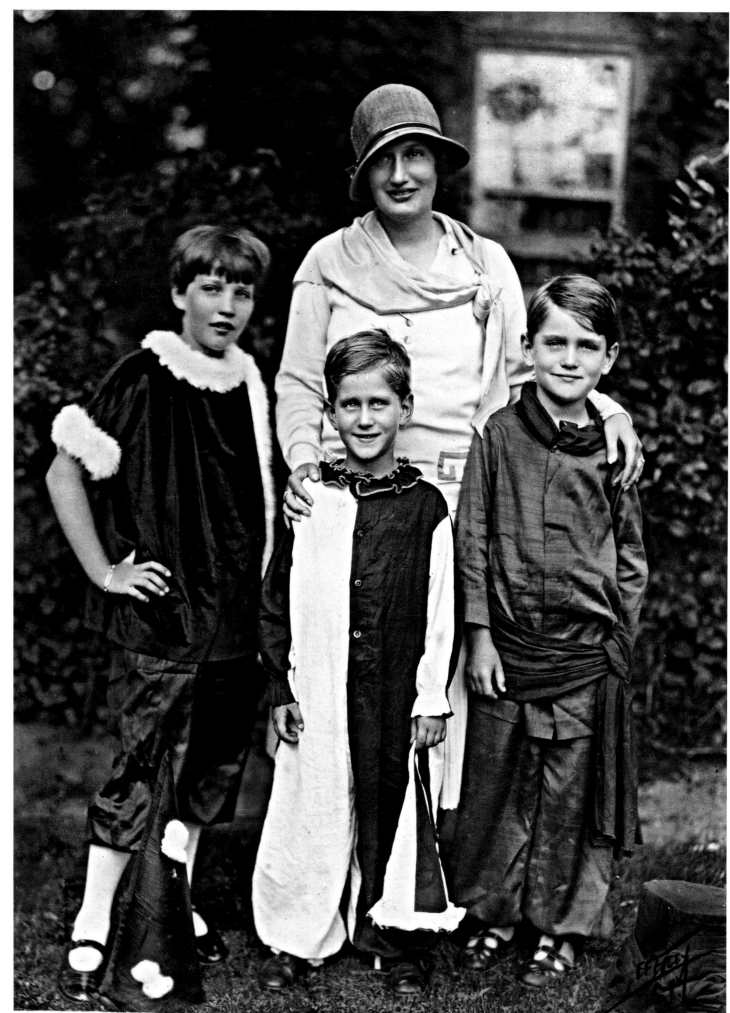

1930 | East Hampton, NY | Little Edie with brothers Phelan and Buddy dressed in costumes, pictured surrounding their mother, Edith, in the yard of Grey Gardens.

58

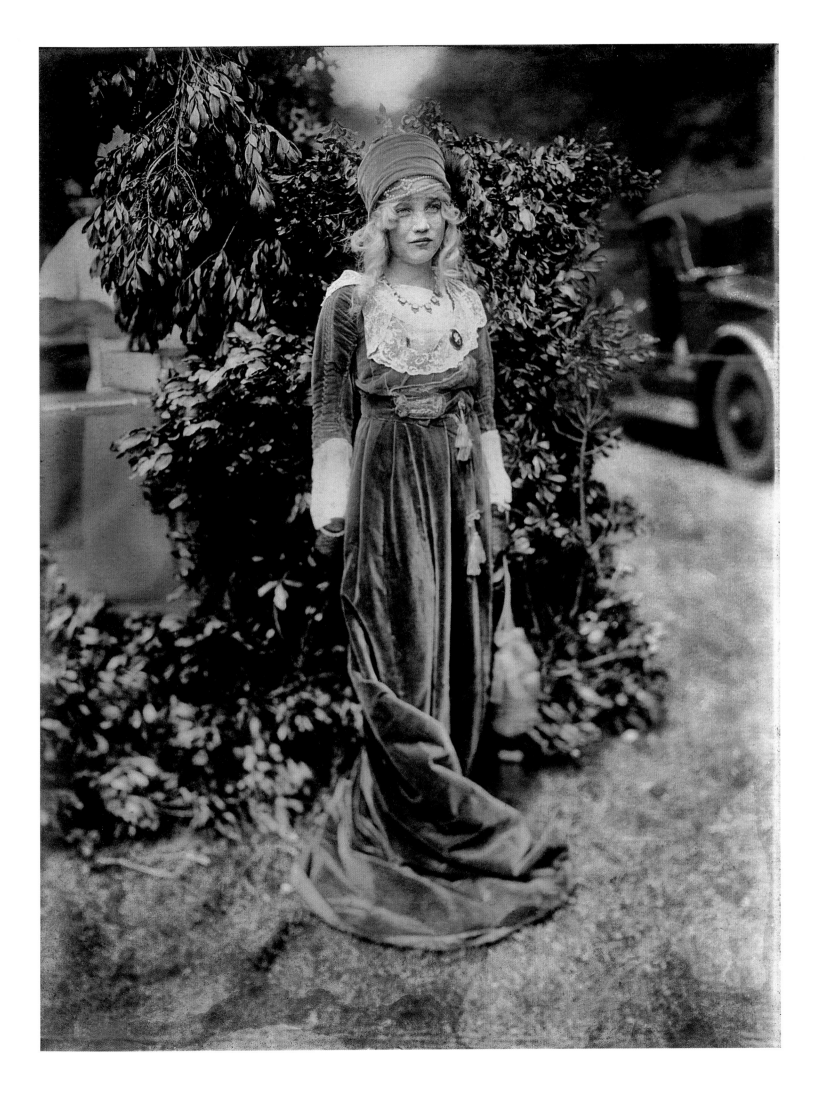

Undated photo of Edie posing in front of flowering bush at Grey Gardens house.

Opposite:
1928 | Copy of the cover of Little Edie's sketchbook "Edith Beale-the celebrated, poet, author, and artist."

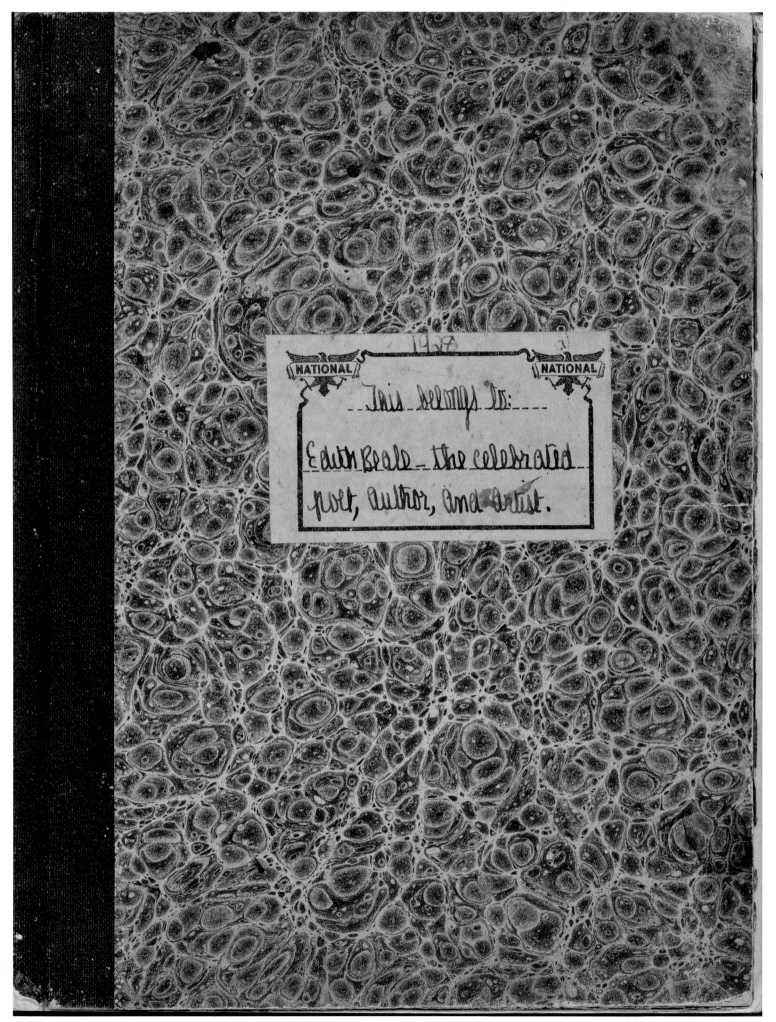

1957

This belongs to:

Edith Beale _ the celebrated
poet, author, and artist.

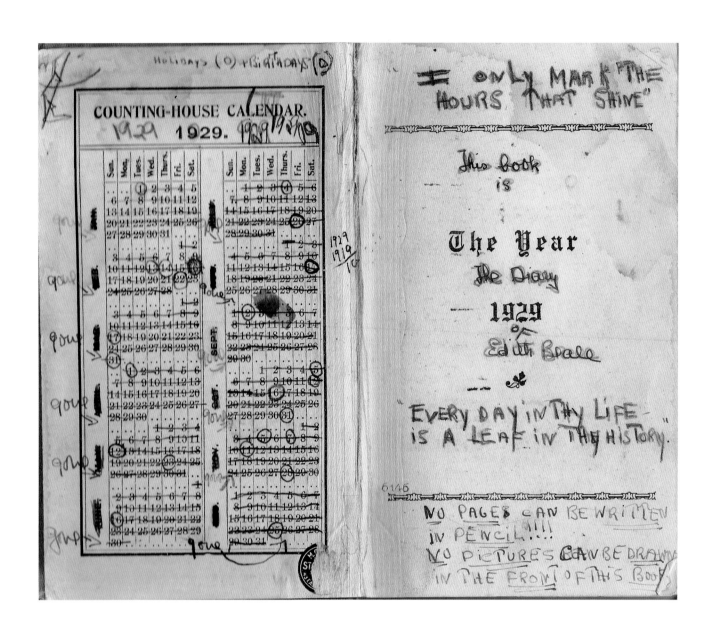

Transcription of Edie's diary:

"To-day is the last day 1929 has. A new year comes tomorrow. A year that holds our future in its hands, and all the sorrows and disappointments of the last year is passing slowly out of our lives. As I write this page I wonder what the new year holds in store for me. –but I do not know. All this winter there will be school, then commencement- then we start the summer at East Hampton. I think I hear the new year laughing at my guesses- perhaps I am guessing at the future in vain–for the new year like a pool of mystery lies before me. When I think of all the unhappiness of 1929 it gives me courage to face the new year and find happiness in it. This is the last page and the page that I will always remember. 1929 has brought two great sorrows, the passing of Marga and Buddy- they are celebrating the new year in a place different from ours- a place where we will meet themsomeday. Good-bye diary and good-bye 1929- 1930 is slowly coming and this is the end.

1931 | Grey Gardens, East Hampton, NY | Edie, Phelan, Jr., and Buddy pose together in the yard of Grey Gardens.

1933 | East Hampton, NY | Bouvier family portrait: top row, from left to right: Edith Bouvier Beale, Michel Bouvier, Bouvier Beale, Phelan Beale, Jr. Bottom row, from left to right: Henry Scott, Michel Scott, John Davis, Jacqueline Bouvier. Seated: John Vernou Bouvier and Maude Sargent, holding Lee Bouvier.

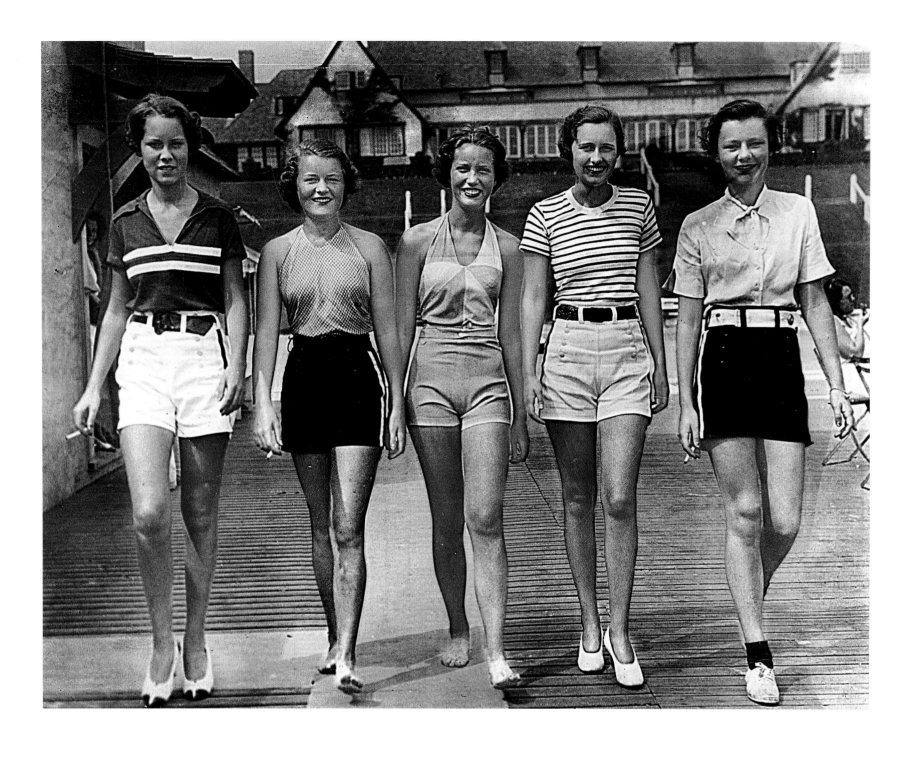

1933 | East Hampton, NY | Little Edie pictured at the Maidstone Club with her friends during summer vacation.

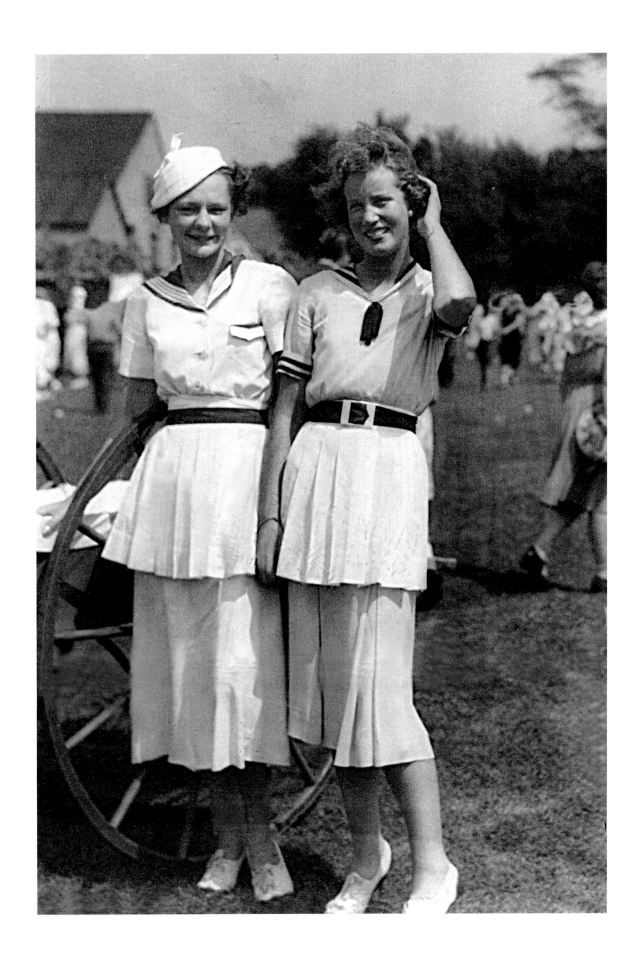

1933 | East Hampton, NY | Little Edie with her good friend and fellow society girl Eleanor Maloney.

"Dream"

"When I was young
I had a dream
So real it seemed
'Twas part of me
A waking, living, fantasy
Of my life and all I hoped t'would be
Of what I loved and wanted near
The sea, the sand, the sun and sky
Could anyone love them as much as I?
The wind through dune grass
As dusk came on
A whippoorwill's lonely song
The waning moon over the pond
A placid ocean beneath a summer's sun
A path through a woodland once begun
But never finished
I would live with these and never leave them
Till my life was done!
They say such dreams are finally cast away
But mine died a little
From day to day
Through loneliness
Yet I know now
What I never knew...
That it would live again in you."

Edith Bouvier Beale

1933 | East Hampton, NY | Black Jack Bouvier with daughter Jacqueline Bouvier, and cousin Michel Bouvier.

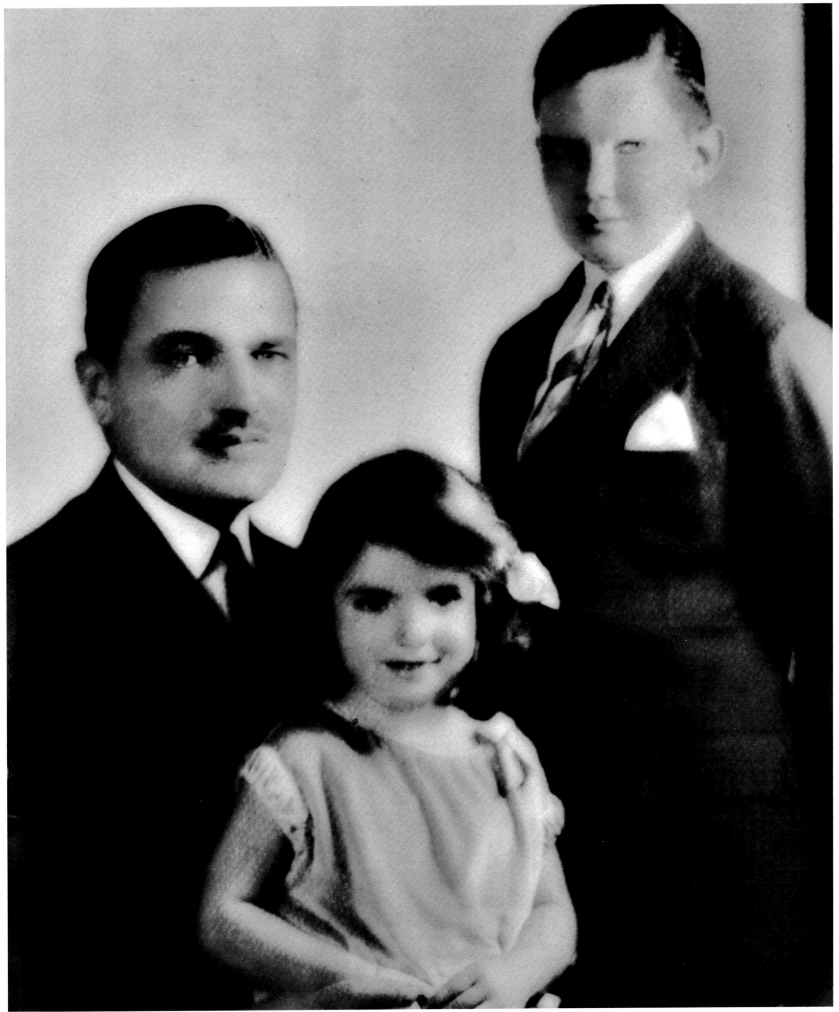

BOUVIER & BEALE
165 BROADWAY

CABLE ADDRESS "VERGERLIN"
TELEPHONE CORTLANDT 7-2425

NEW YORK August 22, 1934.

Mrs. Phelan Beale,
East Hampton,
Long Island, New York.

Dear Edith:-

 This is a difficult letter to
write, but nevertheless it must be done, so here
goes:-

 Since our marriage I have en-
deavored to provide you with every luxury, and
in this up to the date hereof I think I may say
that I have been successful. I will not enumerate
the generous gifts that I have made to you, be-
cause, after all, this is water over the dam, and
I will confine myself to the immediate present.

 Since the great crash in 1929,
we have seen many of our friends and acquaintances
suffer. Fortunately, this suffering did not come
to me until now. My law business has been largely
builded on that of an "Exchange Specialist", and
my income was almost entirely derived from this
source.

 The Stock Exchange legislation on
the part of Congress has so reduced the volume of
business that Stock Exchange houses are either
merging or retiring from business. Few, if any,
are earning their expenses. A number of annual
retainers that I enjoyed have been cancelled, and
I have been notified that others will be cancelled
on the first of the year. I am truly in a desper-
ate situation, so much so that Miss Maguire, one
of the girls in this office is being let out on
next Saturday. Major Norris goes on the 1st of
October. In addition thereto, Mr. Vincent who has
been with me for twenty years has got to go, for
the simple reason that I cannot afford to keep him.
Even Miss Mahoney, the telephone operator, who like-

Pages 74-76:

1934 | Letter from Phelan, Sr. to his wife Edith explaining the deteriorating financial situation. A turning point for the Beale Family.

wise has been with me for several years must go
through necessity. My three office boys I am re-
ducing to one. There may be other changes as well,
and in the same manner I am forced to retrench in
every possible way, which means that I cannot re-
turn the boys to Westminster School, and I am so
writing the Headmaster. To keep them there costs
me about $4,000.00 per annum. I can borrow on my
insurance sufficient funds to keep little Edie at
Miss Porter's School for the next year.

 I can well understand your bitter-
ness when you read this letter. You have not been
extravagant and you doubtless feel that if I had
curtailed expenditures, I would not be in my present
unenviable position, but as we say in the law, re-
gardless of what may have been, I am at this time
faced by a condition and not a theory.

 I am not giving up, although at
times there is a great temptation to take the
easiest way out. It will not be the first time
that I have met with a major catastrophe. When the
war broke out in 1914, all of my German business
was destroyed and I found myself facing a situation
similar to the present, although then it was not as
burdensome as I was unmarried.

 I do not intend to ask you to do
anything that I would not ask my mother and sister
to do. I must arrange for them to occupy less ex-
pensive quarters, even though it may mean a boarding
house.

 I am glad that you have the house
in East Hampton, because it is in tip-top repair
and may be occupied comfortably the year round.
The boys can go to the school in South Hampton.
It is possible that when I get the expenses of
maintaining my office cut to the bone, and I then
am able to give eighteen hours a day to my business,
free from financial worries that keep me awake at
night, I will stage a quick come back, wherefore,
your abnegation of remaining in East Hampton may
be short-lived.

 I do not intend to live in luxury
when I am asking you to make a sacrifice. I am

going to Washington this afternoon. On my return
I will move to more modest and cheaper quarters,
such as procuring a room at some bachelor hotel
for $50.00 per month.

I do hope that you will appreciate
that the contents of this letter should not be
broadcasted. You are at liberty, however, to show
the same to your mother and father.

I hate like the devil to deprive
little Buddy of the pleasure he gets in going horse-
back riding. Will you ask the boy to give up his
riding until next season. The bill from the riding
school came in this morning. It is $53.00. In some
instances the charge for his rides were $8.00 per
day, and in no one day was it less than $3.00. Do
not tell the children anything that will alarm them
in regard to my financial condition. They are so
young that their minds receive an exaggerated and
inflamed impression which may have evil effects of
a permanent nature. Offer some excuse to the kids
about remaining in East Hampton and attending school
in South Hampton. Make a game of it, so that they
will like the idea. Even with little Edie, you
should not confide in her, otherwise she may think
that we are headed for the poorhouse to-morrow, and
it will destroy all the happiness of her year at
Farmington.

There is nothing more to write just
at this moment, because I must leave in the next
five minutes to get the airplane to Washington. I
do hope that the machine crashes, because it would
be a pleasant exit of a very tired man -

Your husband,

Phelan

PB:CL

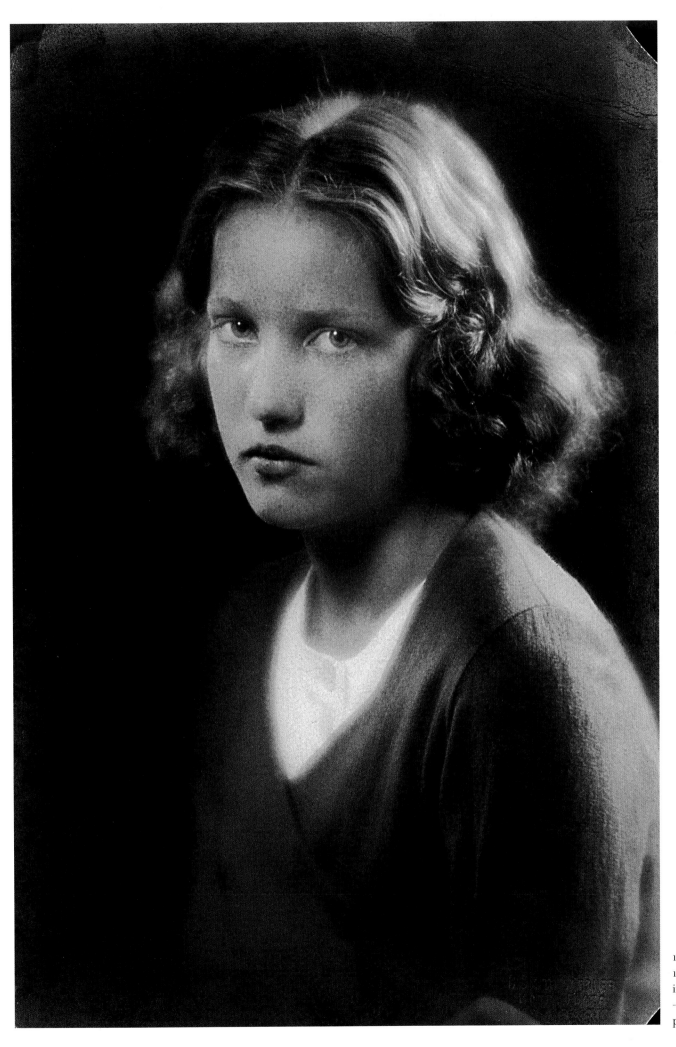

1931 | East Hampton, NY | "Summer 1931 (E.H.) Getting ready for Paris in the Fall. No More Spence School - N.Y.C." as quoted on the back of photography by Edith Bouvier Beale.

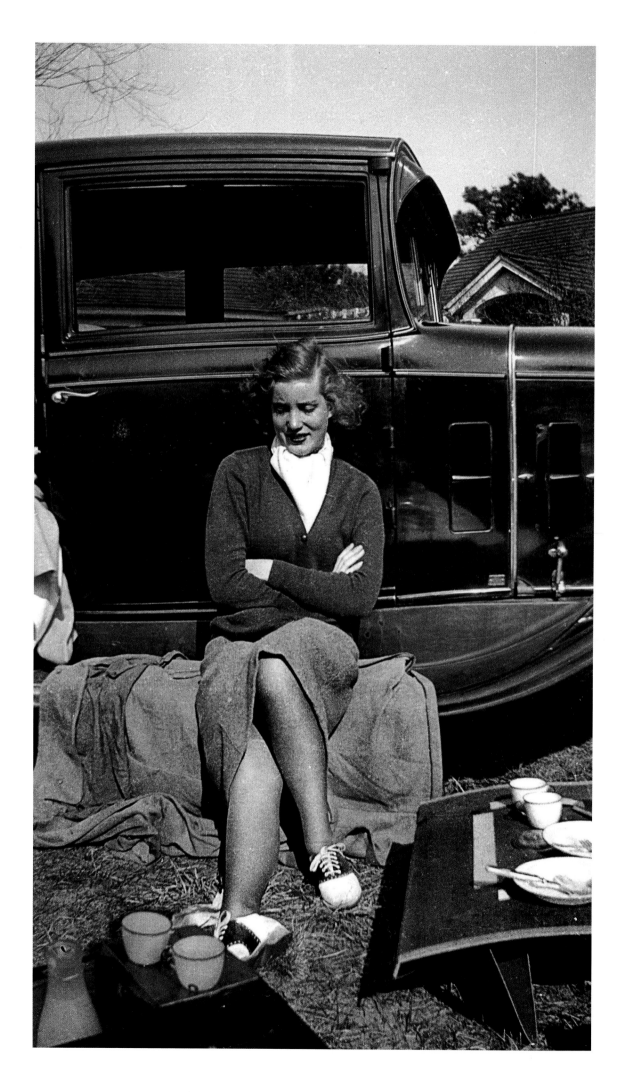

1934 | Grey Gardens, East Hampton, NY | Edie sitting
and enjoying early spring family picnic.

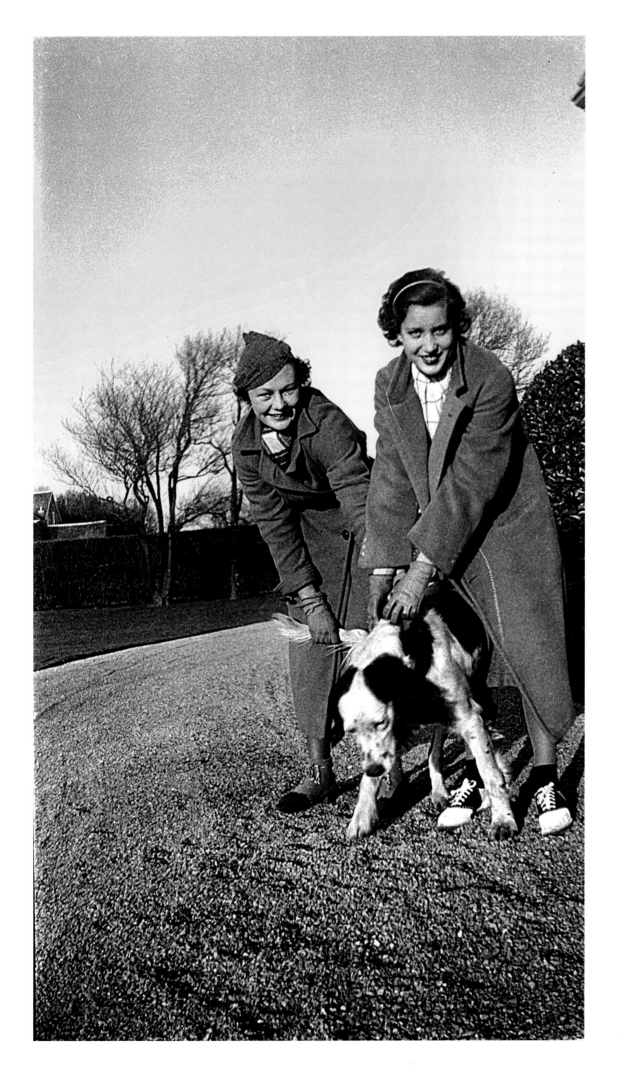

1934 | East Hampton, NY | Edie comes home from
Miss Porters and is seen with friend Eleanor and dog
spot at Grey Gardens.

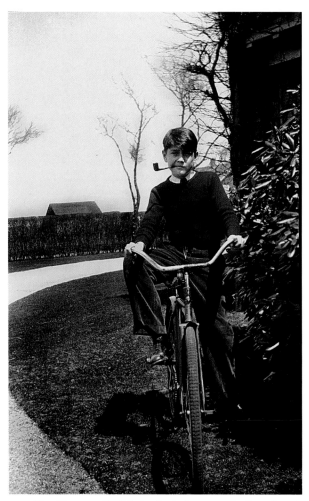

1933 | East Hampton, NY | Phelan Beale, Jr. pictured riding a bicycle in front of Grey Gardens.

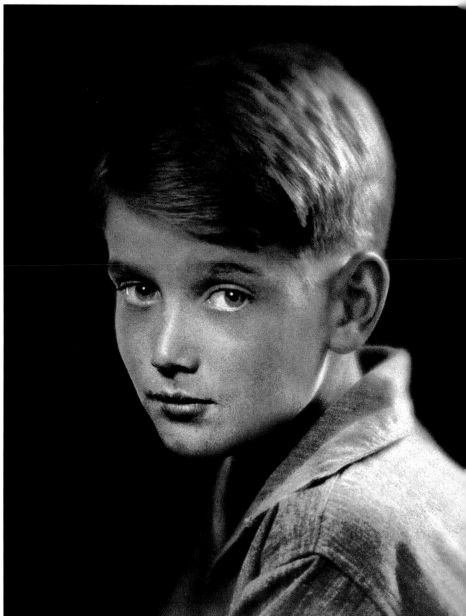

1934 | Portrait of Phelan Beale, Jr., Edie's brother.

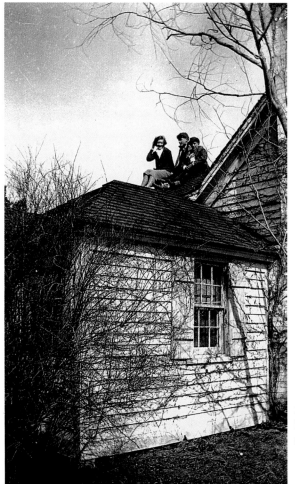

1934 | Grey Gardens, East Hampton, NY | Edie and her two brothers Phelan and Buddy sit on the roof together and enjoy the view of the sapphire blue ocean.

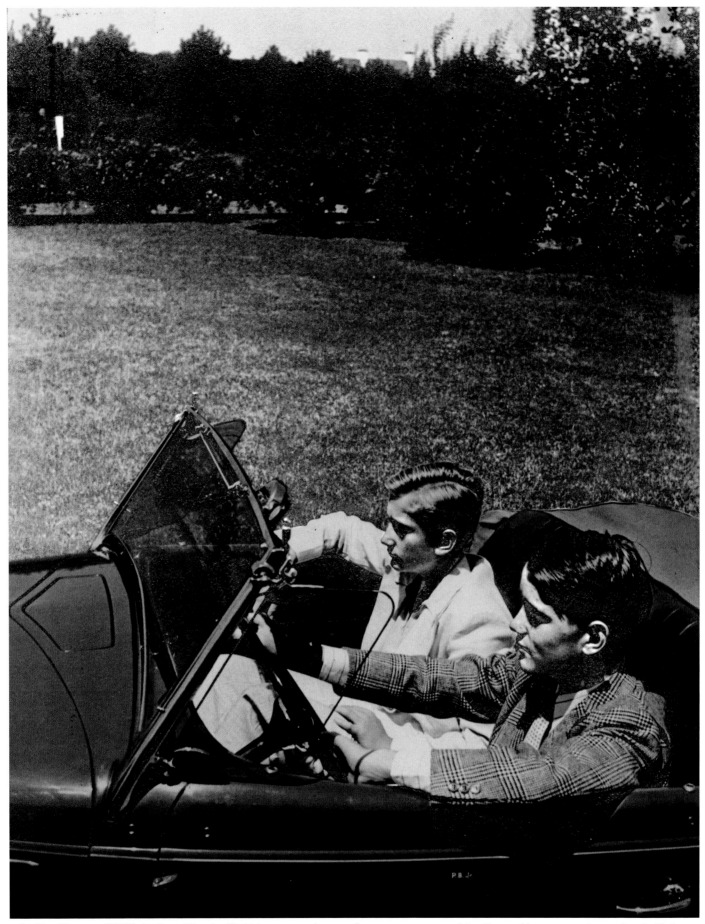

1939 | East Hampton, NY | Phelan Jr. and Bouvier (Buddy) prepare to depart on first ever cross-country drive. Convertible coupe was given to them by Phelan Sr. for this trip.

1935 | Cover of Miss Porters Year Book, Edie's third year.

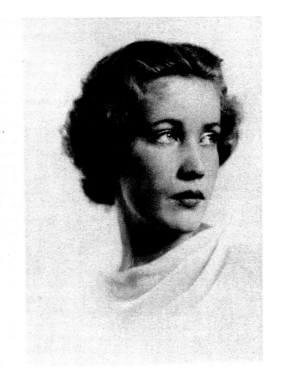

EDITH BOUVIER BEALE
NEW YORK CITY
"Edie"

1935 | Excerpt from the Miss Porters School's Yearbook. Edie seen in upper right yearbook photograph.

79

MISS PORTER'S SCHOOL
FARMINGTON, CONNECTICUT

THIS CERTIFIES THAT

Edith Bouvier Beale

HAS COMPLETED THE COURSE OF STUDY WHICH ENTITLES HER

TO RECEIVE THIS DIPLOMA AND IS HONORABLY GRADUATED

GIVEN AT FARMINGTON THIS eleventh DAY OF JUNE

ONE THOUSAND NINE HUNDRED AND thirty-five.

Robert Porter Kup
PRINCIPAL

WARDS-BOSTON

1935 | Farmington, CT | Edith Bouvier's Miss Porter's School diploma

Opposite:
1936 | East Hampton, NY | A relaxed Edie models a sun-suit and her favorite white shoes.

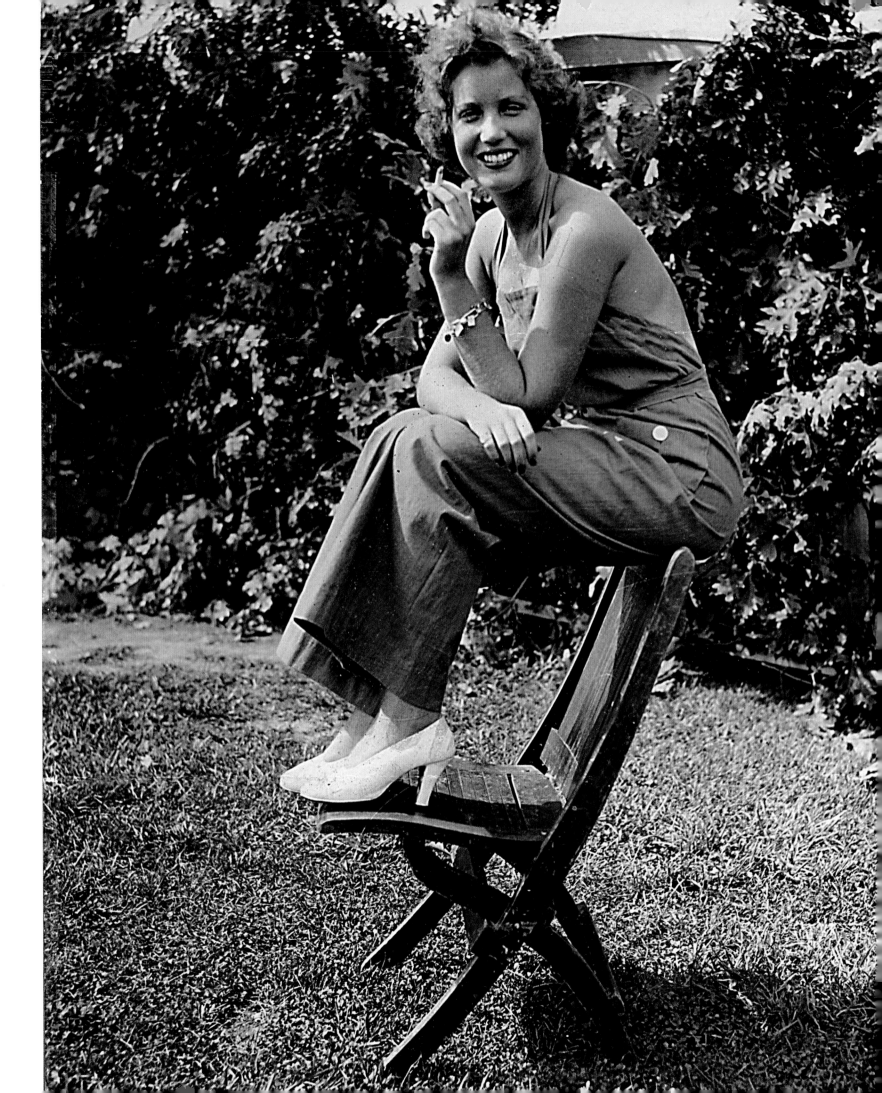

february eighteenth

EBB

Dearest Momsie,

I hope your having a wonderful time
and dont get lonely — its still snowing
here, and my wave is slowly coming out.
"Grama-Maude" and I went to see the musical
comedy "funny-face" this afternoon and
had loads of fun — the tickets were awfully
expensive, but the dancing was wonderful!
My new shoes came to-day — their a
perfect fit and I wore them out —— but
with my goloshes.
I wish I was with you — getting all
dressed up and going down to the dining
—room, but when you come back we can
have a wonderful time by our selves,

Above and opposite:
Letter written by Edie to her mother in her early years.

Following pages:
Two pages from Edie's scrapbook.
82

this is'nt a long letter — because I have'nt a thing to
say — exept — please come home soon — and don't
forget to pretend to say good night to your
"Tootsie Tootsie" Edies when you go to bed, and also
kiss everyone of these crosses ___ and hearts,

with all the love a "darlingest"
daughter could give her
"Darlingest" mother
Your,
"Edie babe Edes"

D.M. (dearest mom) please read my little poem —
its not very good but its cute —
love
Edesse.

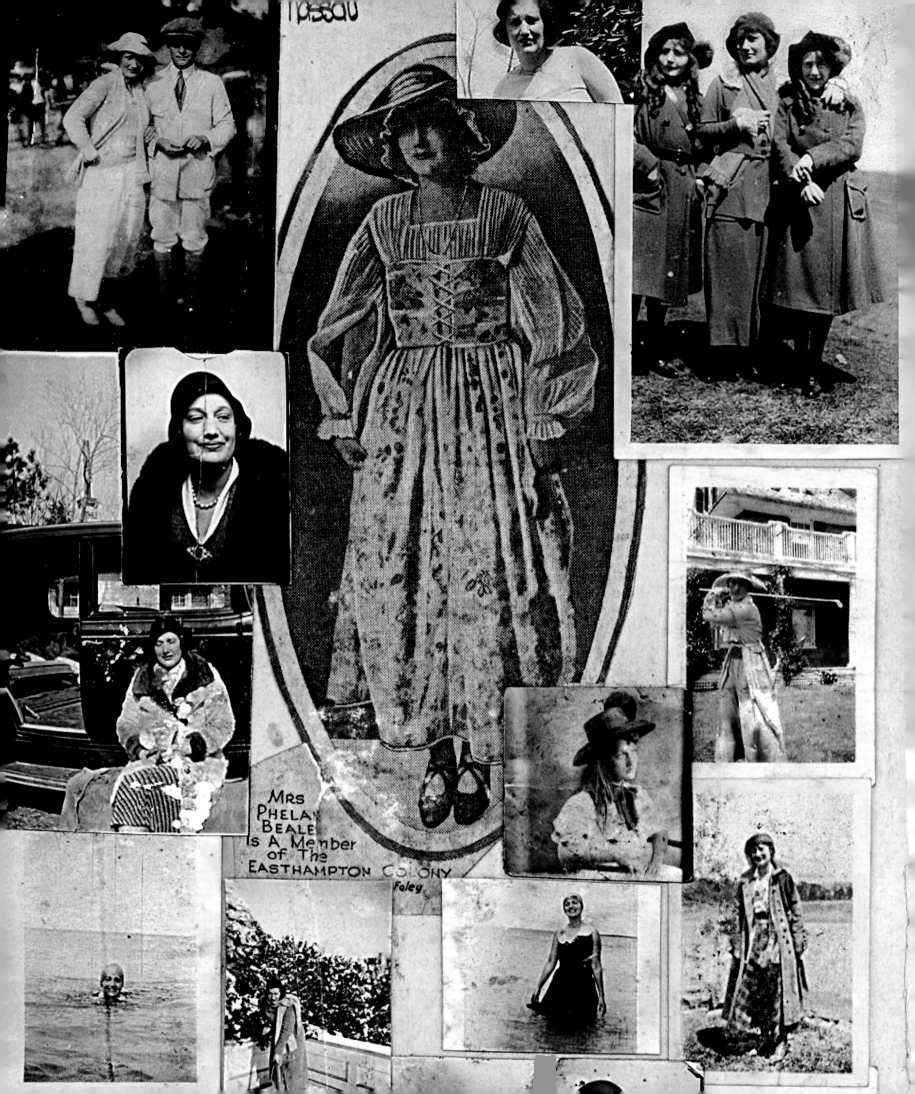

nassau

Mrs
Phelan
Beale
Is A Member
of The
Easthampton Colony

Foley

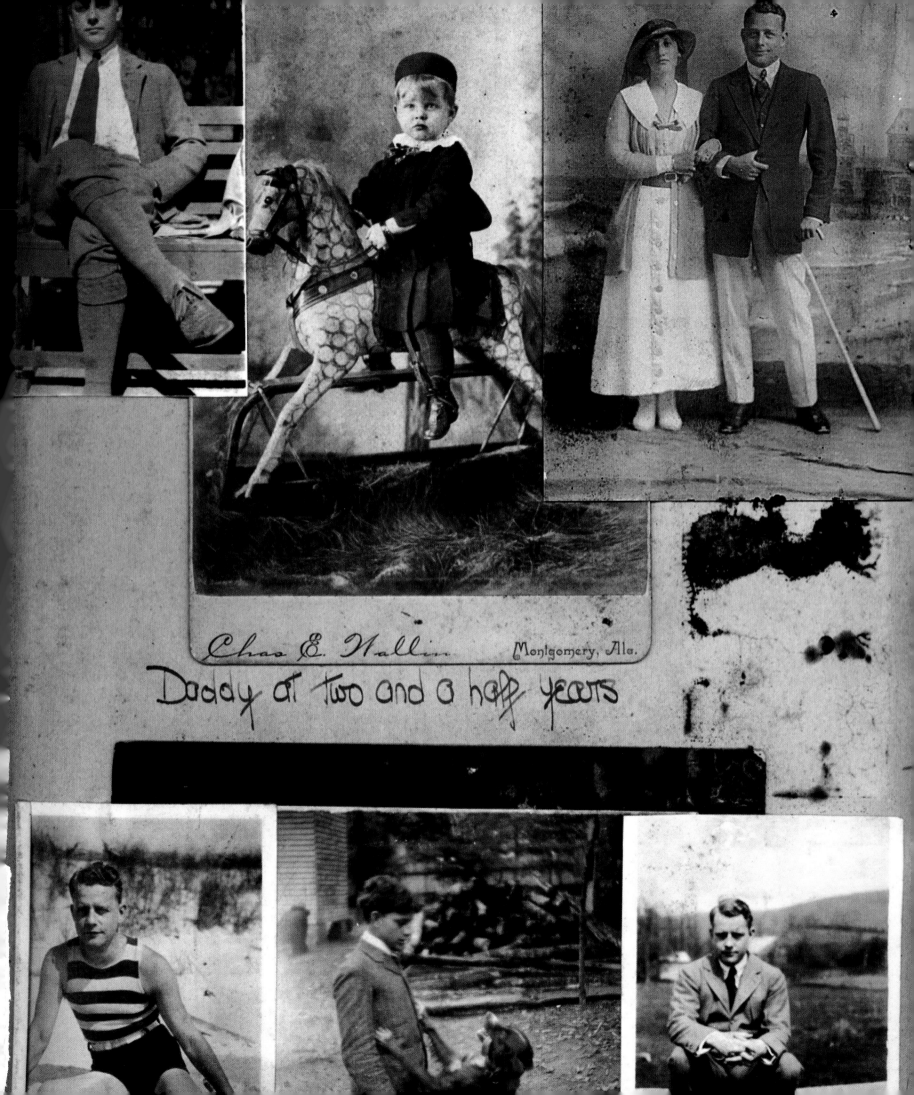

Chas. E. Wallin Montgomery, Ala.

Daddy at two and a half years

JOHN VERNOU BOUVIER

Nov. 7, 1935.

My dear Edith:

This day you have attained an age of
definite importance. It may well be regarded as
a point of departure from which your course is to
be directed to an objective the attainment whereof
will mean, spiritually and materially, a life
worthwhile.

Obviously the road will be difficult; you
will be constrained to do much pioneering work;
from time to time you will have to stop and cast
about for your compass points; you will pass through
broad plains as well as deep forests but through
its trees you will be able to see a faint glimmering
of light, this you will pursue; the course at times
will be wearisome; your feet will seem leaden; your
strength sapped but with will and determination you
will emerge and in peace, serenity and harmony occupy
the rich meadow lands of generous youth at the end
whereof your goal will have been discovered.

As ever,

Sincerely,

Grandad

To:
Miss Edith Bouvier Beale,
40 East 62nd Street,
New York City.

1935 | Letter of encouragement and inspiration written to Edie on her 18th Birthday by her grandfather, John Vernou Bouvier, Jr.

Opposite:
1935 | Portrait of Edie done by Carroll L. Wainwright.

"El Morocco's" Family Album

Opposite and following pages: 1934 | Extracts of the El Morocco family album, a place of celebrities and high society to see and be seen. Published in 1937, only a "chosen few" local and international celebrities are included. Jerome Zerbe was one of the first famous "paparazzi" photographers. In the foreword to the Family Album, American journalist Lucius Beebe states *"Given the entire antecedent social background of New York and so of America, it would still have been impossible to foresee the usurpation of the glitter scene of the most glittering city in the land by a single, and in itself, not overly resplendent hideaway in an entirely anonymous side street. Ten years ago no seer or prophet, not even that arch-astronomer Myra Kingsley could have read in the conjunctions fo the spheres the sudden and deafening explosion of Morocco across the Urban consciousness of New York....The New York scene was suddenly and in its social entirety taken over by people whose names made new and whose clothes and faces made comparative sense...Editors screamed with relief when there became available shots of you and fascination people lapping up carboys of champagne and dressed in the after dark attire of gentle-folk, and it at once became apparent that one way to become a professional celebrity was to be snapped by Mr. Zerbe. "*

Clockwise, from top left: 1/ "Topper" Carey Grant, one of the most popular of all movie stars"; 2/ Miss Edith Beale, daughter of Mr. and Mrs. Phelan Beale with Mrs. Woodward Vietor's son Jack, "who has diplomatic ambitions"; 3/ Edward Wasserman, William Randolph Hearst Jr., Mrs. George Kaufman, H. L. Menken, and Mrs. Alfred Knopf; 4/ Mr. And Mrs. Gary Cooper; 5/ David Niven and Mrs. Lewis Milestone; 6/ Ed Sullivan, Broadway and Hollywood columnist who disproves the fiction that columnists never take their wives on the rounds with them; 7/ William Randolph Hearst Jr at the right, joined the celebrating of the Marshall Hemingways first wedding anniversary; 8/ Randolph Churchill and Mrs. Harrison Williams who is always one of America's best dressed women; 9/ One who should need no introduction, Clark Gable.

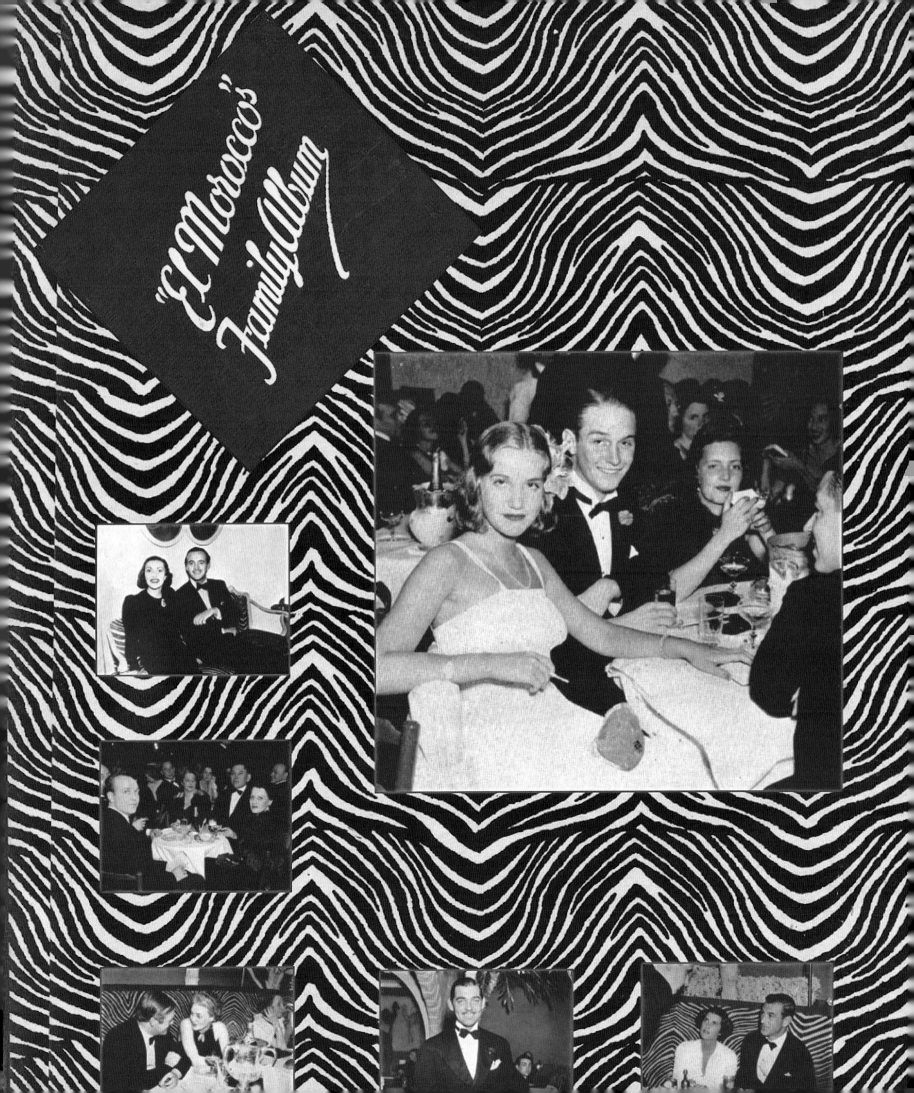

"El Morocco's" Family Album

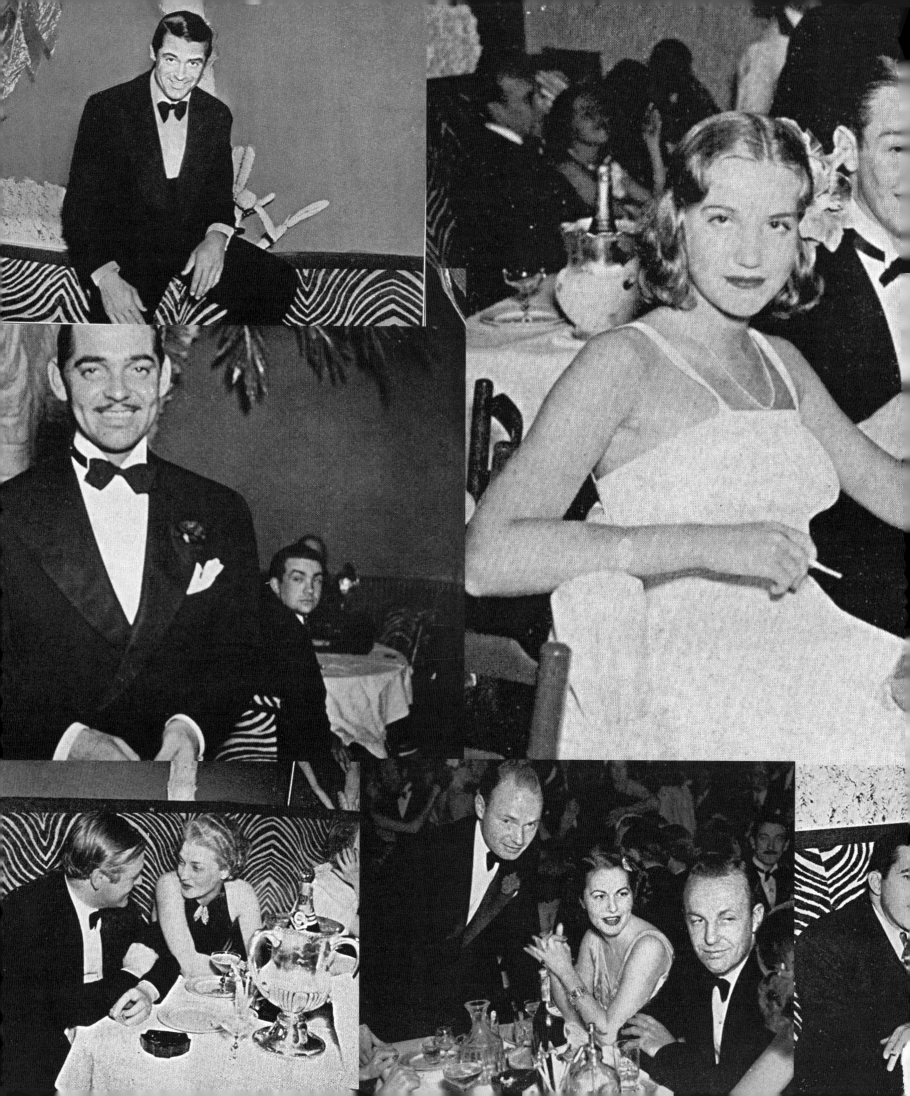

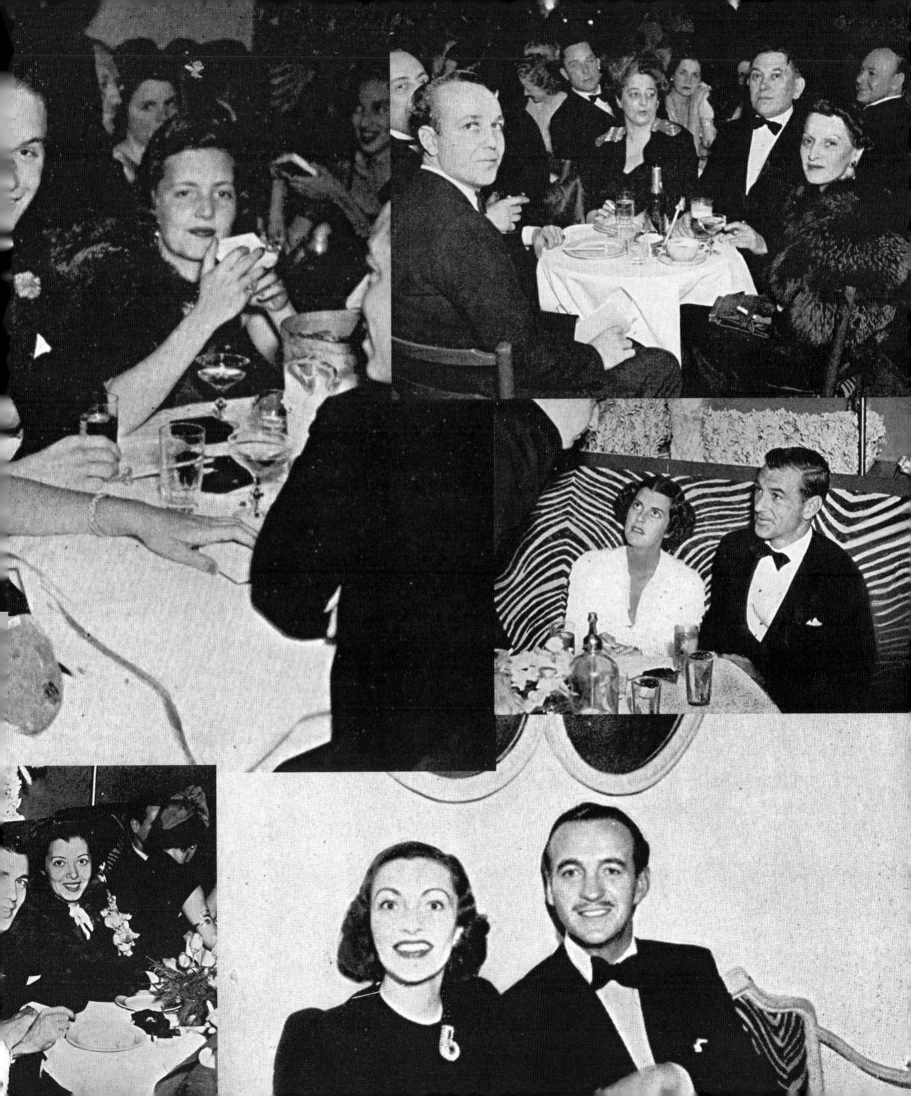

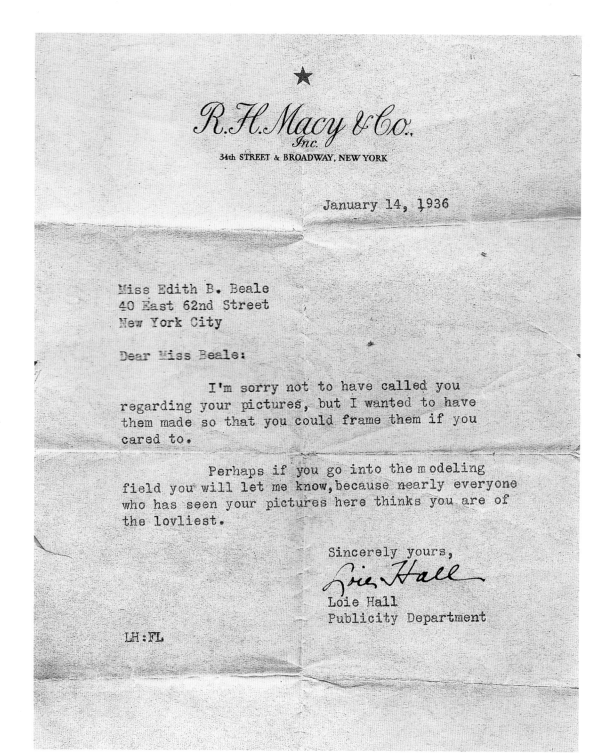

R.H. Macy & Co.
Inc.
34th STREET & BROADWAY, NEW YORK

January 14, 1936

Miss Edith B. Beale
40 East 62nd Street
New York City

Dear Miss Beale:

I'm sorry not to have called you
regarding your pictures, but I wanted to have
them made so that you could frame them if you
cared to.

Perhaps if you go into the modeling
field you will let me know, because nearly everyone
who has seen your pictures here thinks you are of
the lovliest.

Sincerely yours,

Loie Hall
Publicity Department

LH:FL

Letter from Macy's publicity department encouraging Edie's modeling career.

Opposite:
January 1936 | Edie in Debutante dress from Bergdorf Goodman. Dress made of white tulle and silver appliqué. Edith's debutante supper dance was held at the Pierre Hotel in New York.

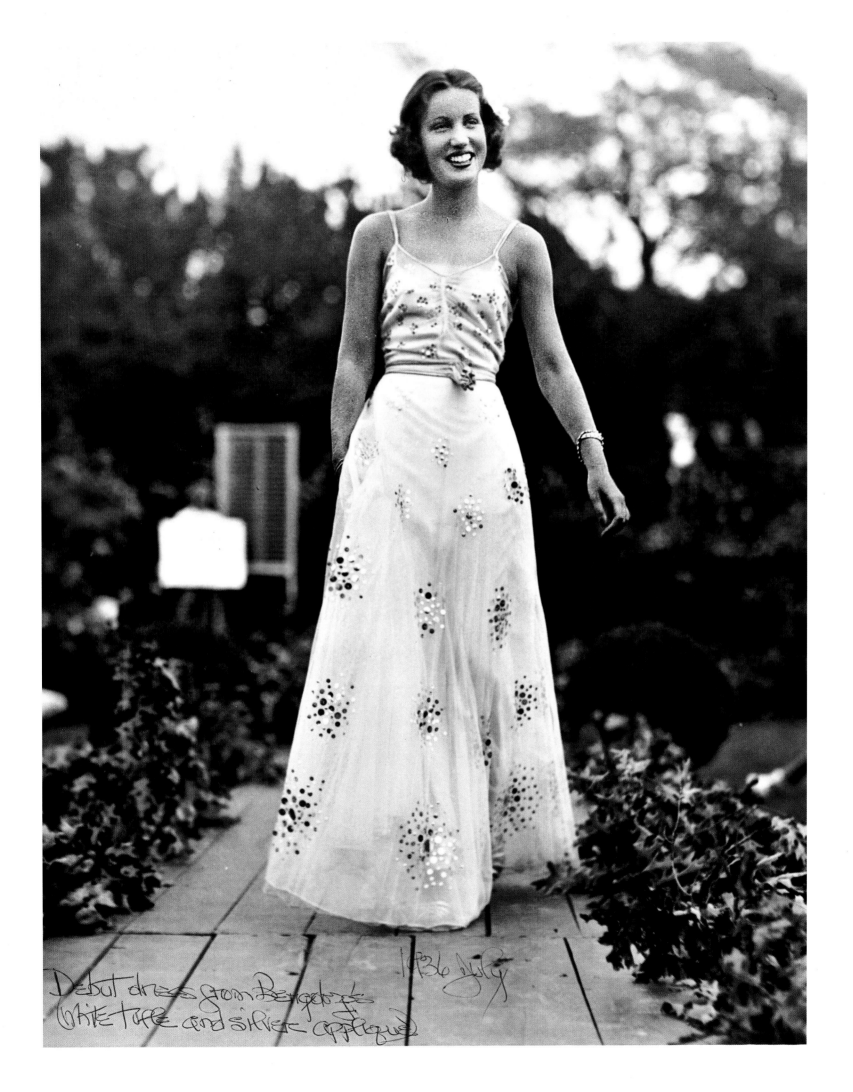

Debut dress from Bergdorfs
white tulle and silver appliqué

1936 July

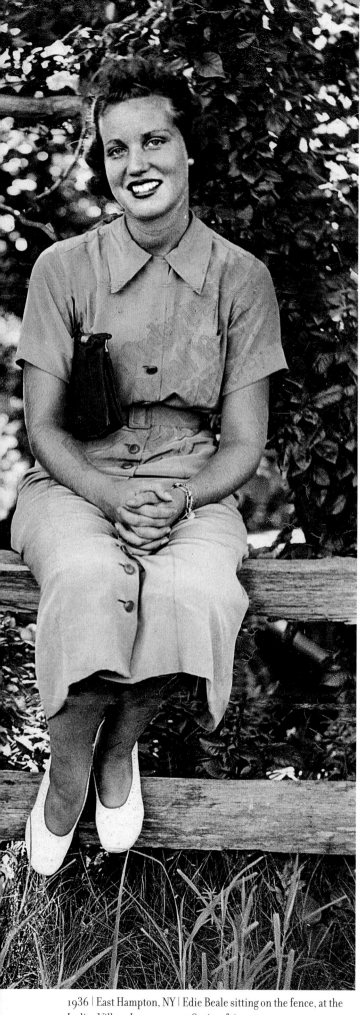

I ask for Nothing More.

I am weary of the old loves.
I am weary of the new
I am weary of this earth — with all its
 hopes untrue
The world is full of hoping
And dreams I've dreamt before
I want a dream come true. I ask for
 Nothing More.
I dreamt a silver dream once.
It faded into mist—
A dew-drop did the same once
That by the sun was kissed
I want a dream that will never fade
Silver though it be—
I want a dream hung from a star
And plucked by only me.
I want a made-to-order dream
As in the old time lore
I want a dream come true—
I ask for nothing more.

"I Ask For Nothing More"

I am weary of the old loves / I am weary of the new / I am weary of this earth –with all its hopes untrue.

The world is full of hoping / And dreams I've dreamt before / I want a dream come true- I ask for nothing more.

I dreamt a silver dream once. / It faded into mist / A dew drop did the same once / That by the sun was kissed / I want a dream that will never fade / Silver though it be / I want a dream hung from a star / And plucked by only me. / I want a made-to-order dream / As in the old time lore / I want a dream come true / I ask for nothing more.

Edith Bouvier Beale

1936 | East Hampton, NY | Edie Beale sitting on the fence, at the Ladies Village Improvement Society fair.

Opposite: 1936 | East Hampton, NY | Edie stands in front of Guild Hall.

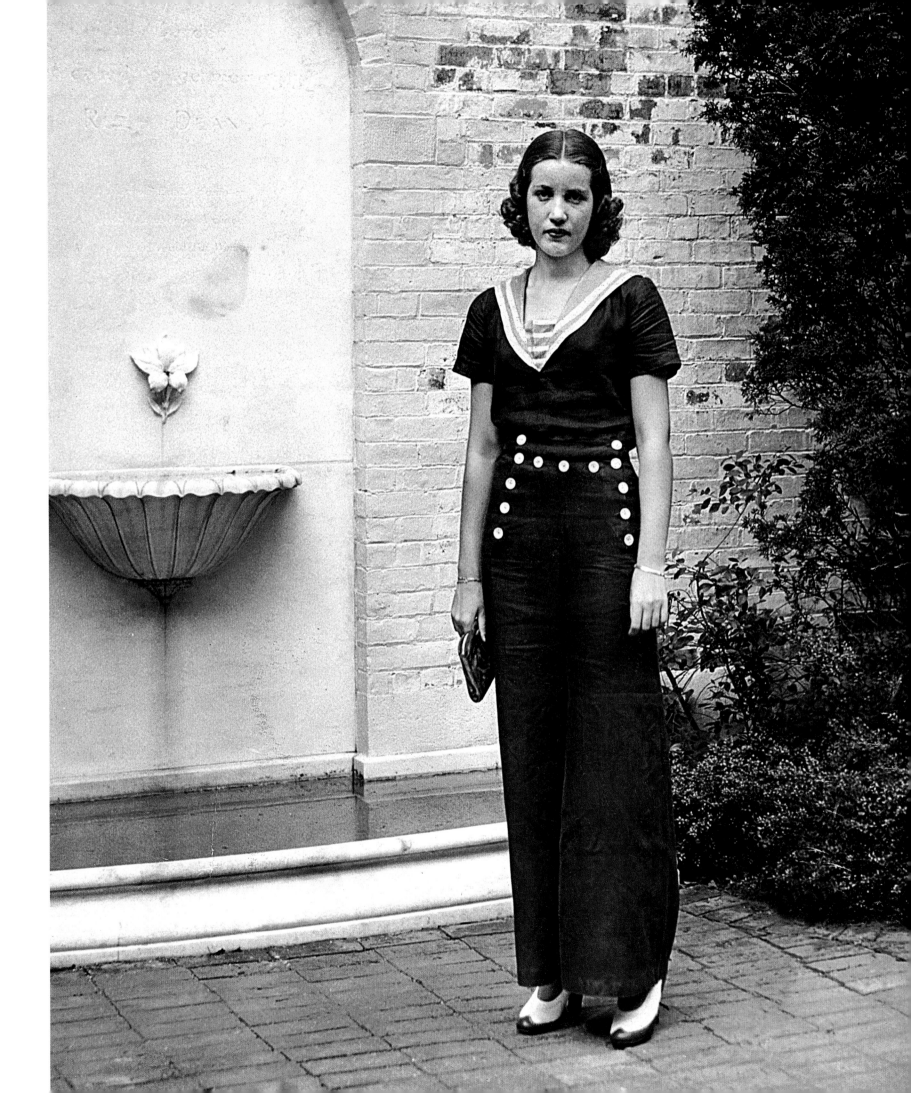

Edie displays her usual radiant smile.

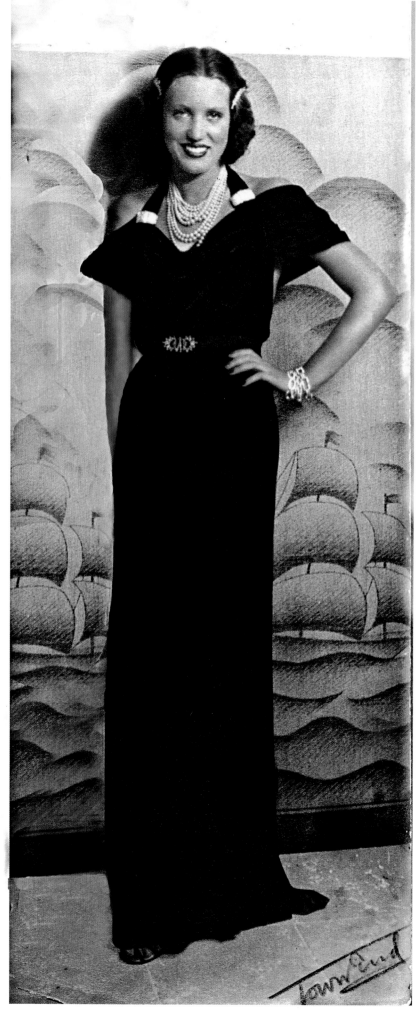

1936 | East Hampton, NY | Edie dresses for the Schuler event Labor Day. Original photograph with Edie's partner was torn off.

Opposite:
1937 | East Hampton, NY | Edie dresses with attention to detail for the Riding Club Horse Show.

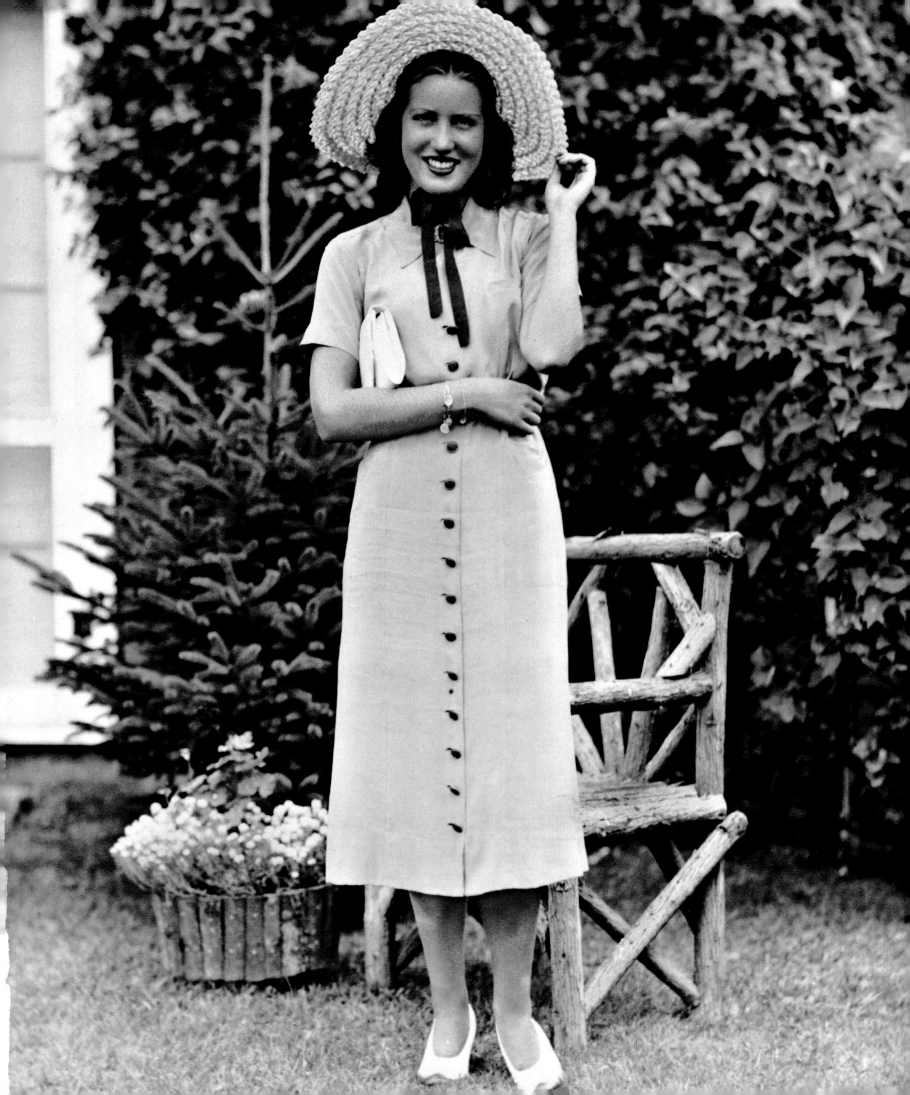

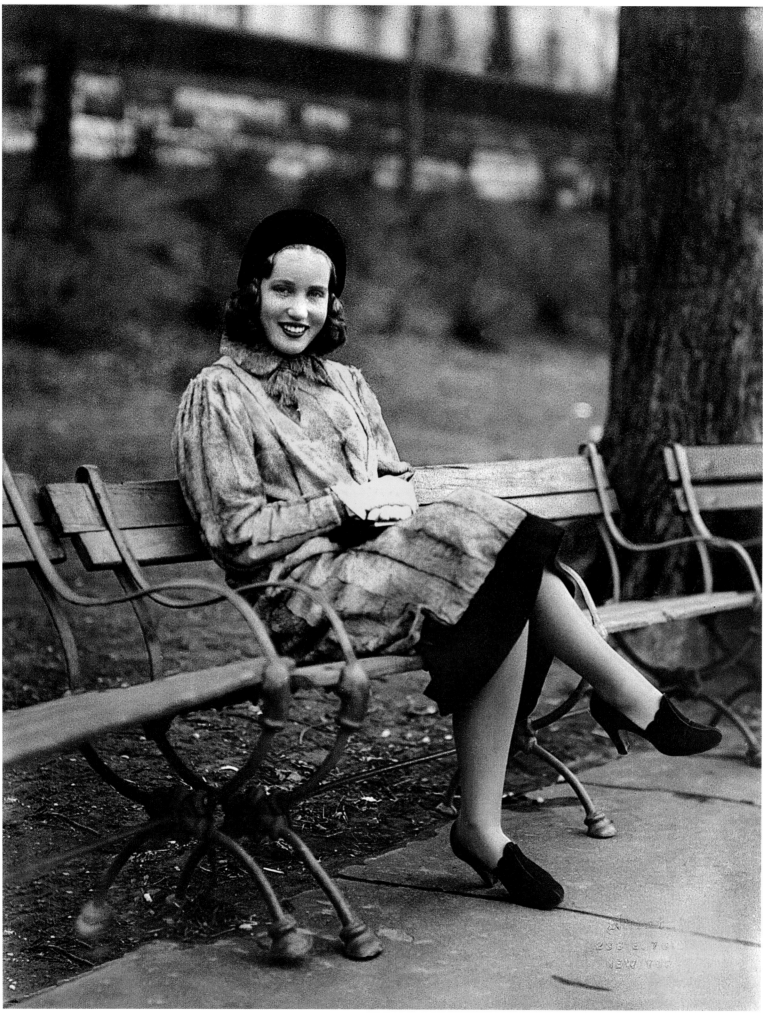

Opposite:
1937 | Central Park, New York, NY
Little Edie pictured seated in
Central Park.

1937 | East Hampton, NY | Edie
celebrates spring on the porch of
Grey Gardens.

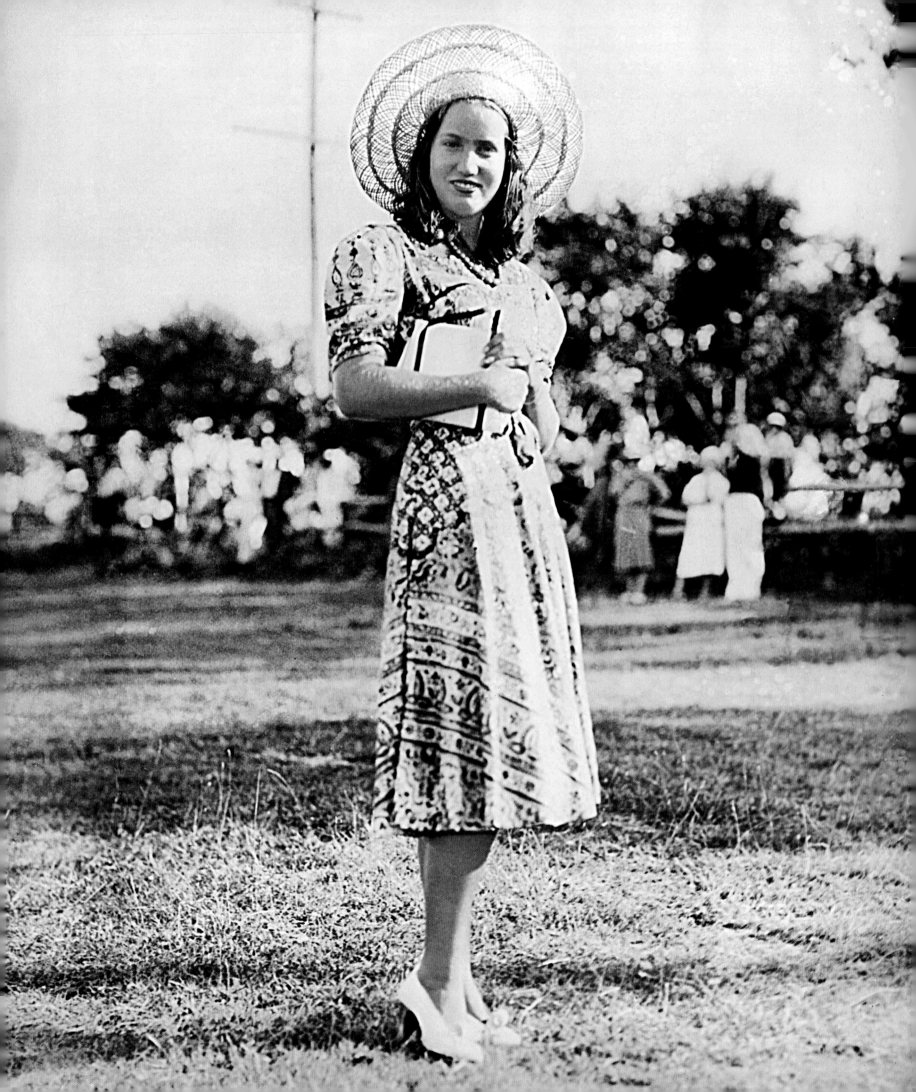

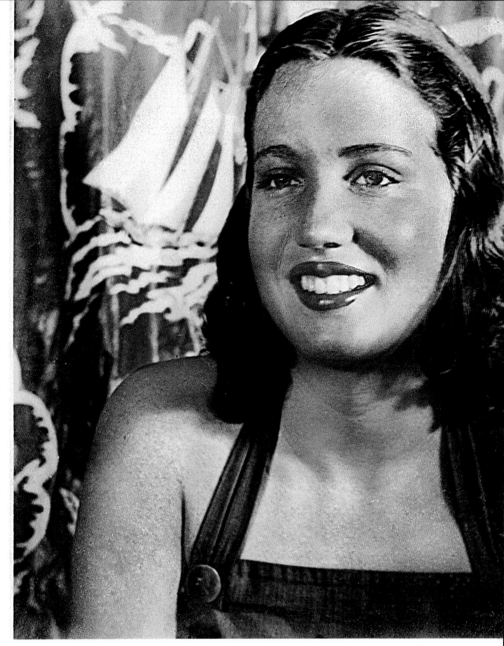

1937 | East Hampton, NY | Edie wearing a summer sun dress and showing her beautiful smile.

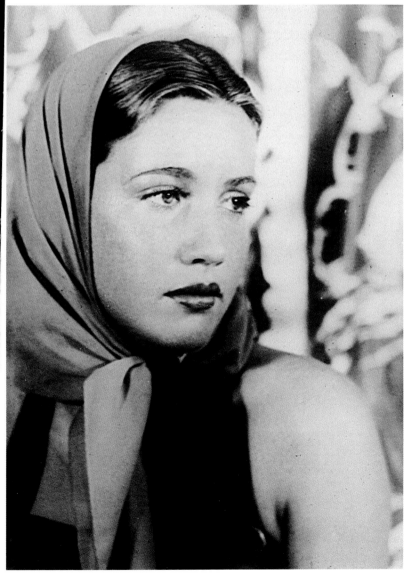

Opposite: July 1937 | East Hampton, NY | Edie smiles for the paparazzi at the LVIS summer fair.

1937 | East Hampton, NY | Edie posing showing her signature look.

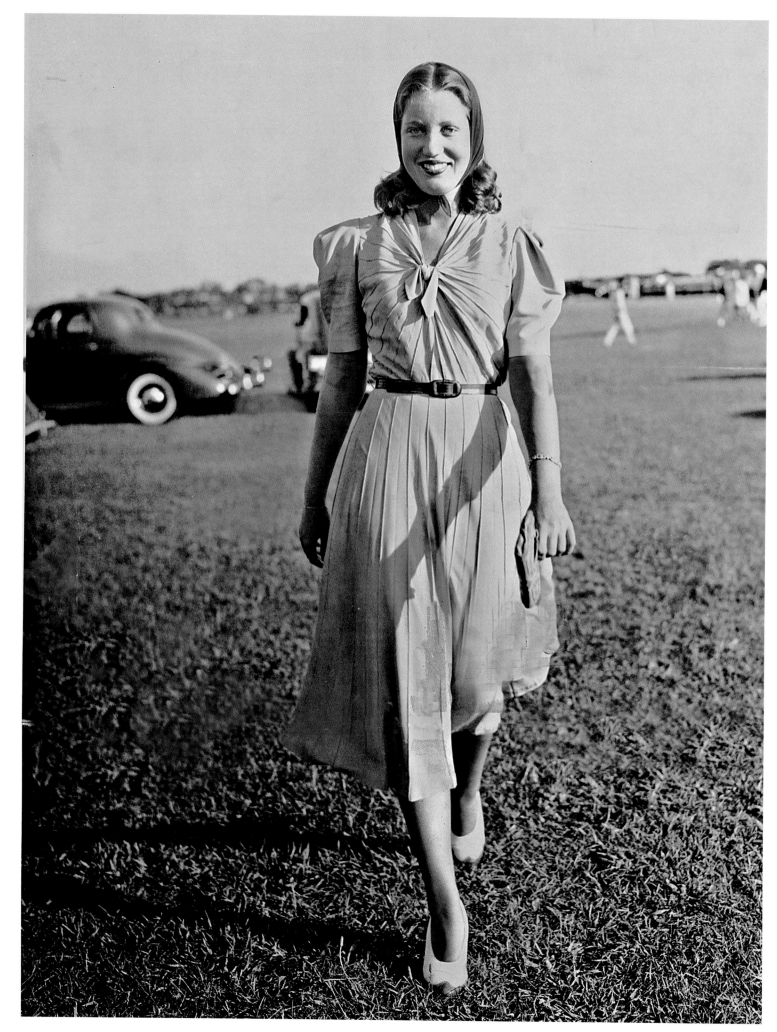

1937 | East
Hampton, NY
| Little Edie
modeling a
Maize dress
from Macy's.

102

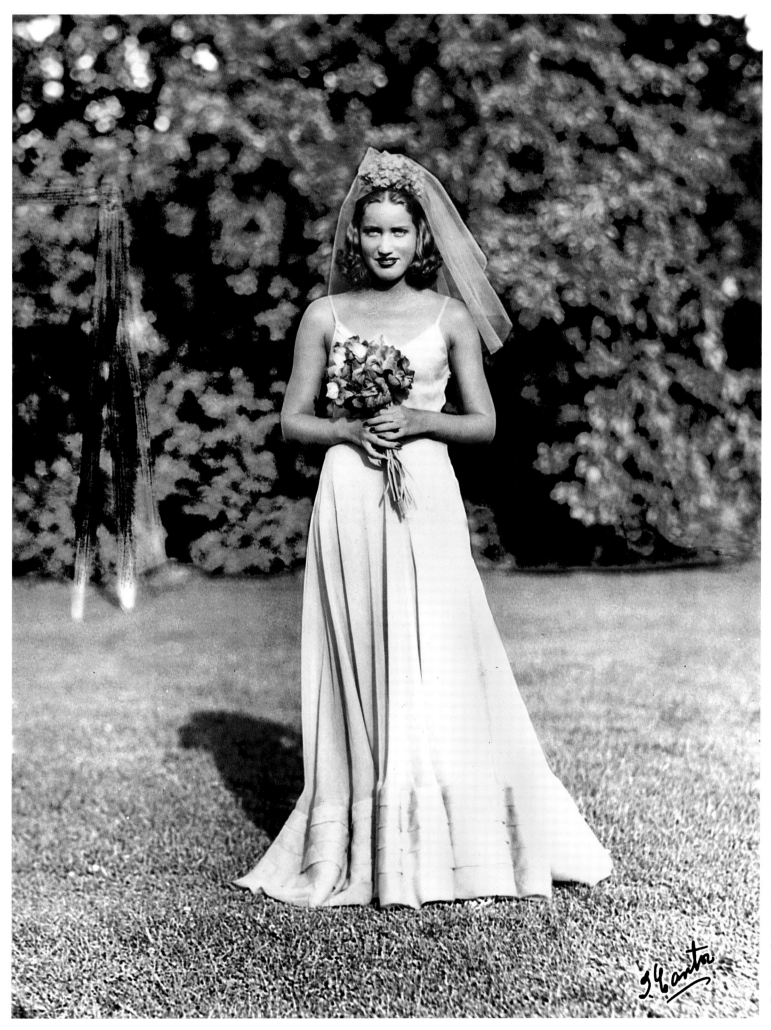

July 1937 | East Hampton, NY | Little Edie models a bridesmaid dress. "Lavender Chiffon bridesmaid dress from Rosemary Wards Wedding" as quoted by Edie on the back of print.

"Who?"

Who is the person you love with all your heart?

Who gives you cake and a juicy tart?

Who is it that watches over you and helps

With every hard task you do?

Who gives you a kiss - every morn, noon, and

night?

Who always is cheerful, and loving, and bright?

Who is the person that tucks you in bed?

Who is it that pats you on the head?

Who is it that cares for you when you are sick?

Who is the person you take medicine for without a kick?

Why! every child in America must know! it is mother

Of course - that you love so!

Above: Poem "Who?" by Edie Beale.

Opposite:
1937 | Ladies Village Improvement Society (LVIS), East Hampton, NY | Little Edie models "East Bridal Costume". "Lavender Chiffon bridesmaid dress from Rosemary Wards Wedding" as quoted by EBB on the back of photograph.

Following pages:
1938 | East Hampton, NY | Little Edie poses as "Eve" eating the apple at a fashion show at the Lady's Village Improvement Society.
1938 | East Hampton, NY | Edie in fashion show as "Miss Harvard".

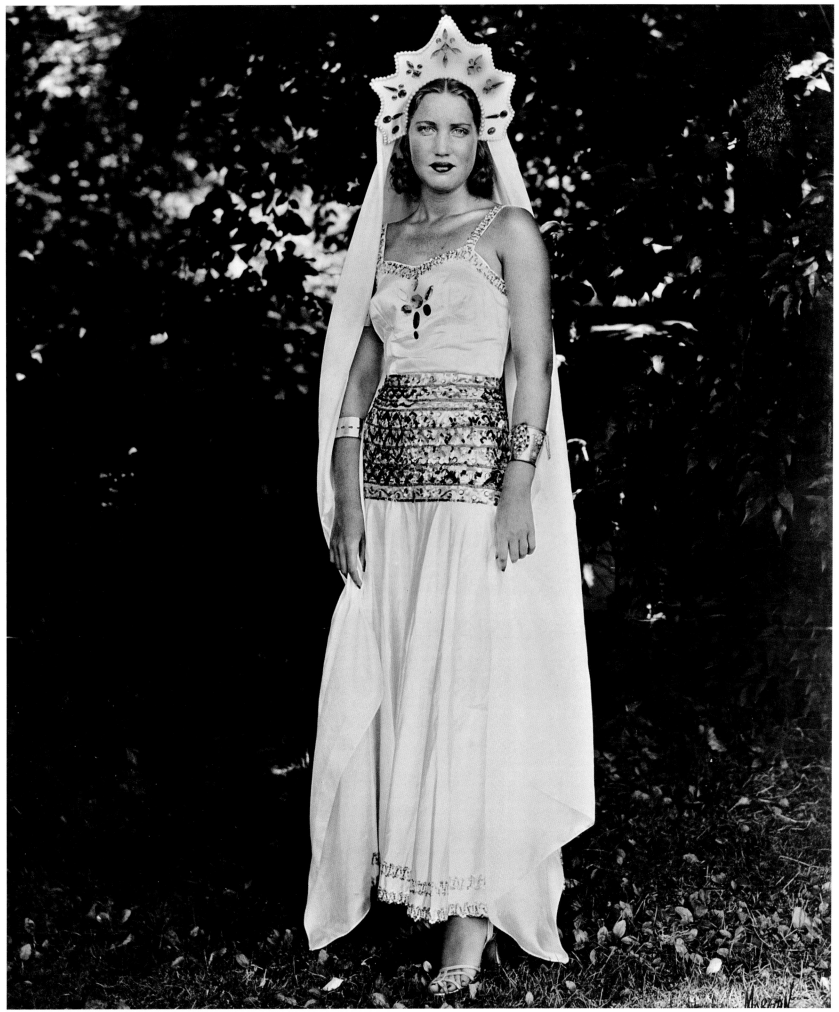

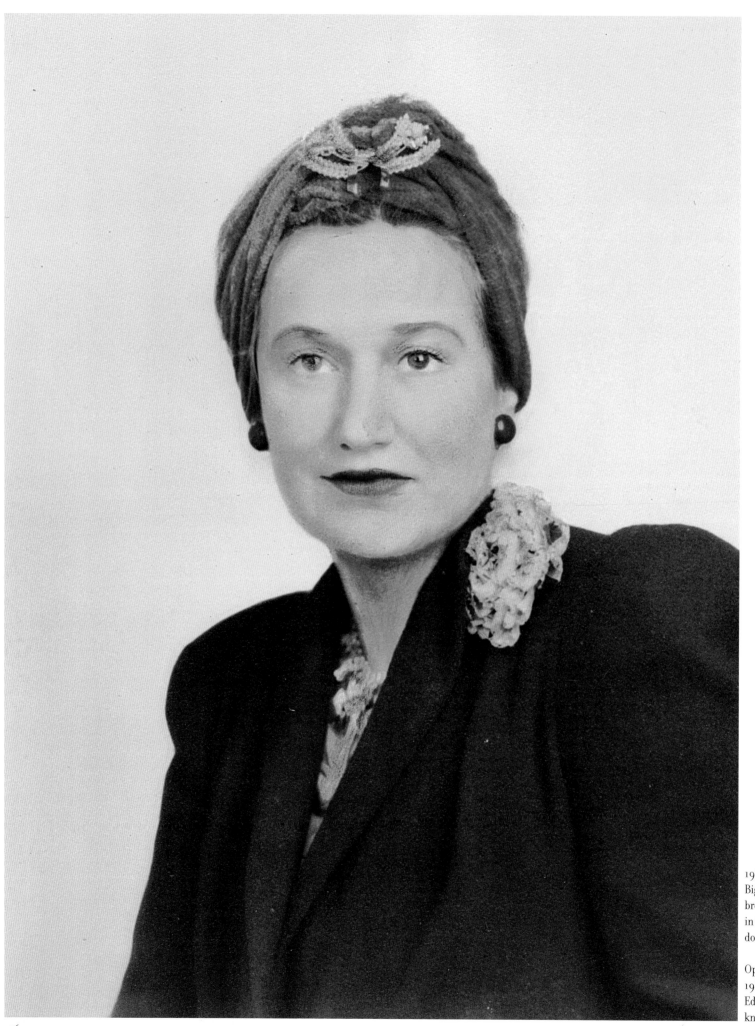

1938 | New York, NY |
Big Edie wearing famous
brooch that Edie wore
in the *Grey Gardens*
documentary.

Opposite:
1938 | New York, NY |
Edie Beale portrait by un-
known photographer.

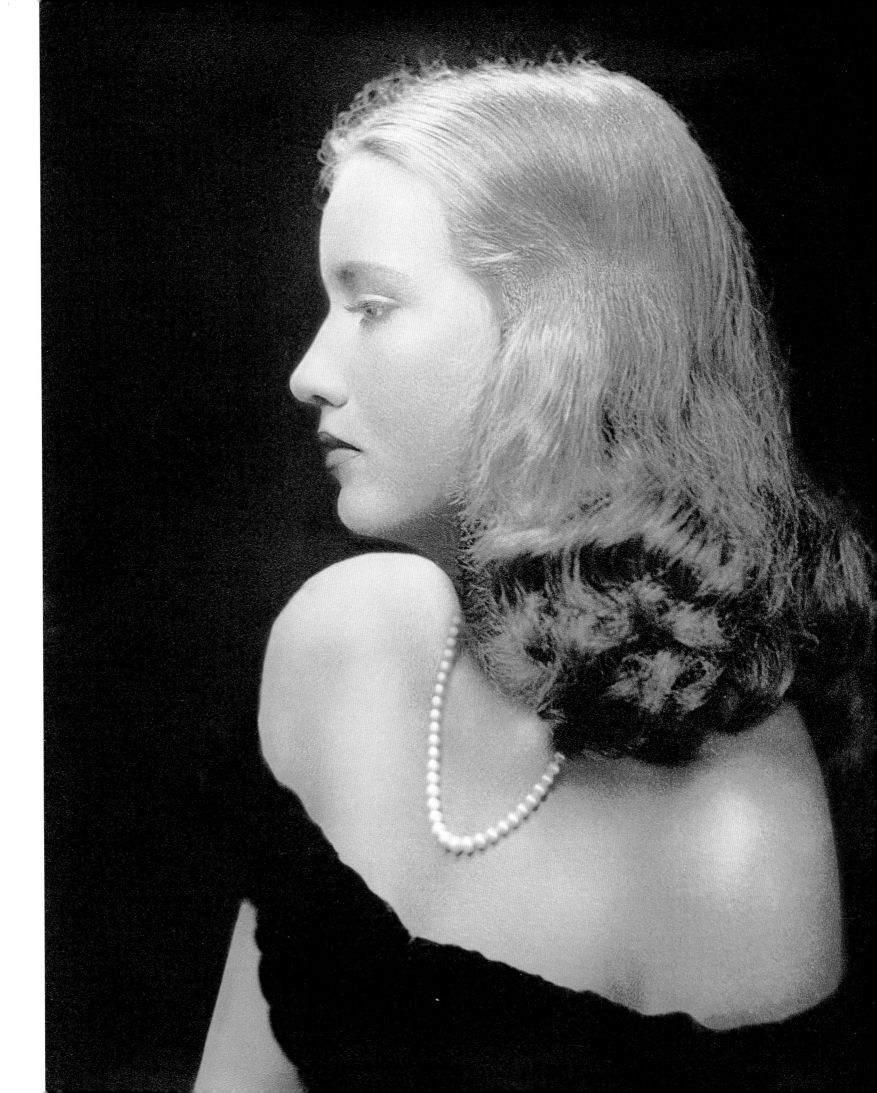

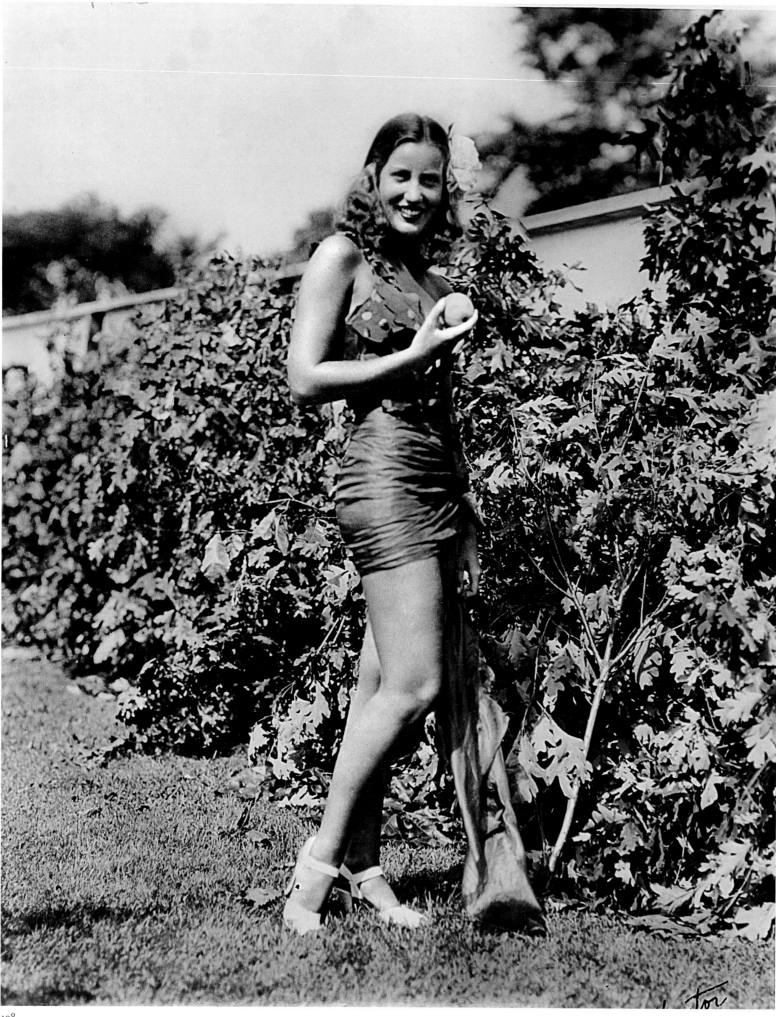

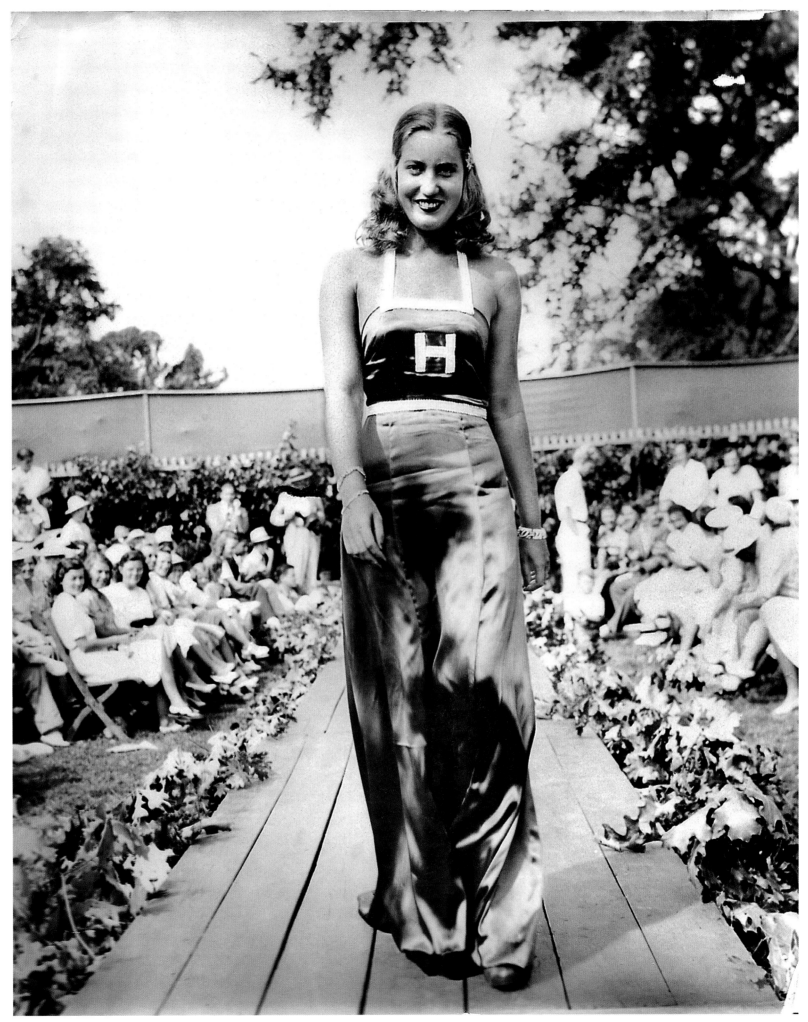

1938 | South Hampton, NY | Edie Bouvier Beale with Burt McGuire.

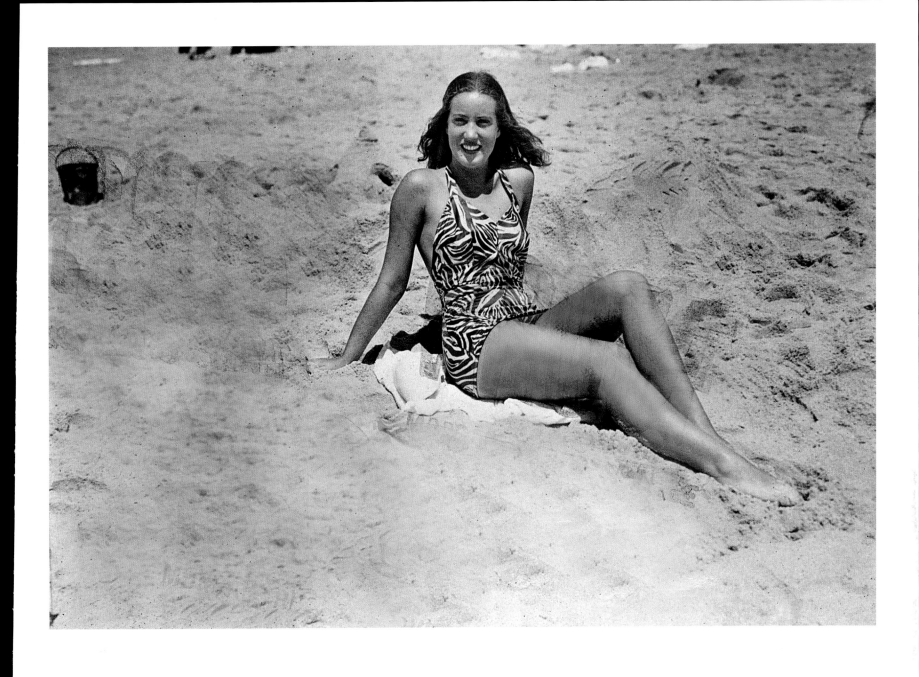

1938 | East Hampton, NY | Edie Beale poses on the beach of East Hampton wearing a zebra swimsuit.

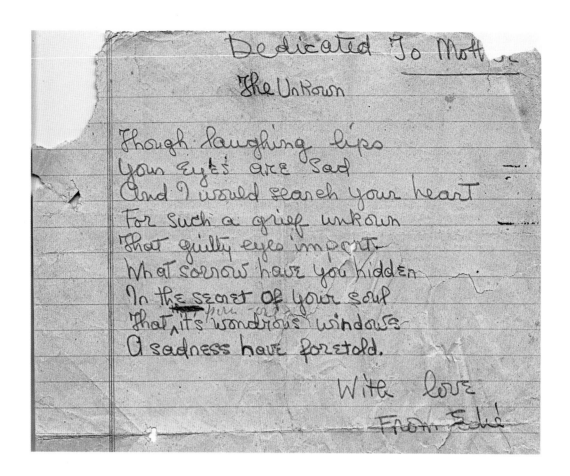

Dedicated to Mother
The Unknown

Though laughing lips
Your eyes are sad
And I would search your heart
For such a grief unknown
That guilty eyes impart.
What sorrow have you hidden
In the secret of your soul
That it's wondrous windows
A sadness have foretold.

With love
From Edie

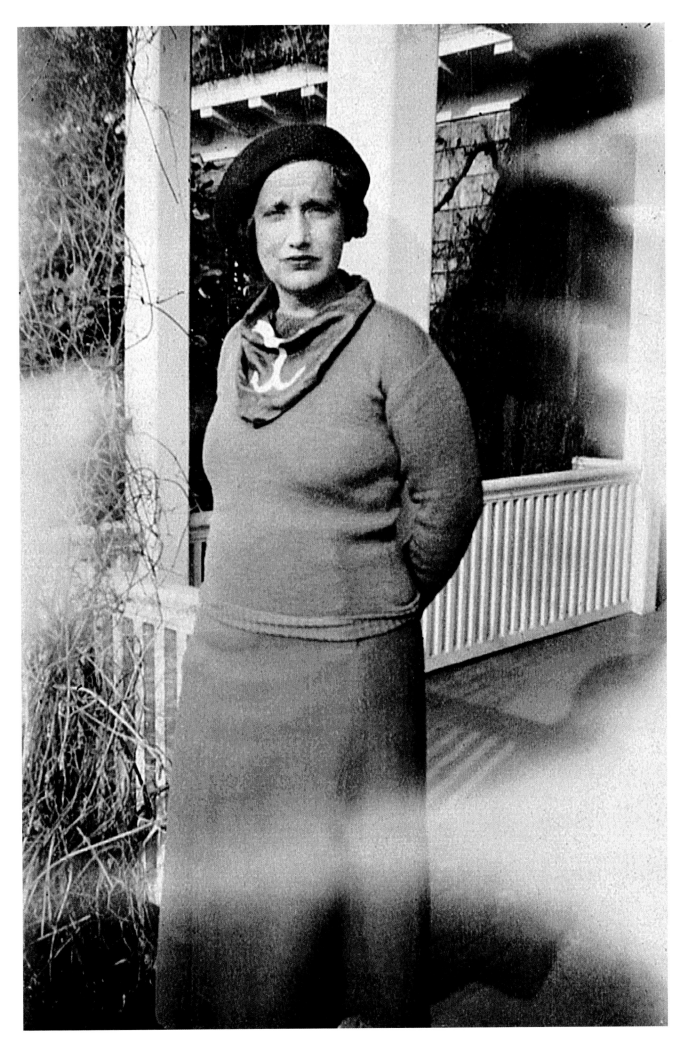

1938 | Grey Gardens, East Hampton, NY | Big Edie poses in front of grey Gardens wearing a beret and neck-scarf.

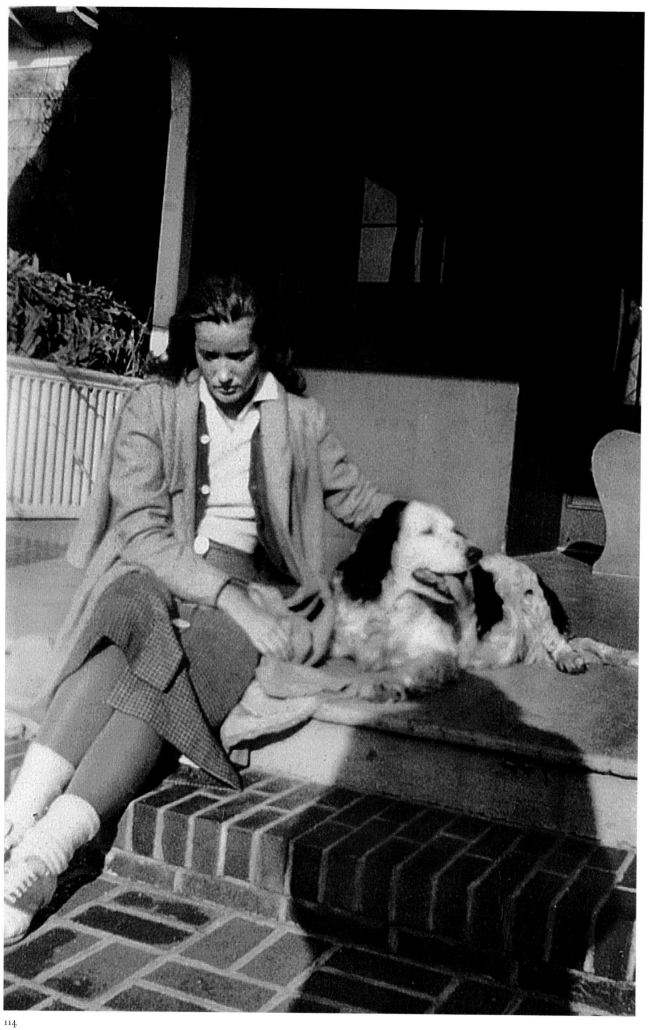

1938 | East Hampton, NY | Little
Edie pictured with Spot on the stoop
of Grey Gardens.

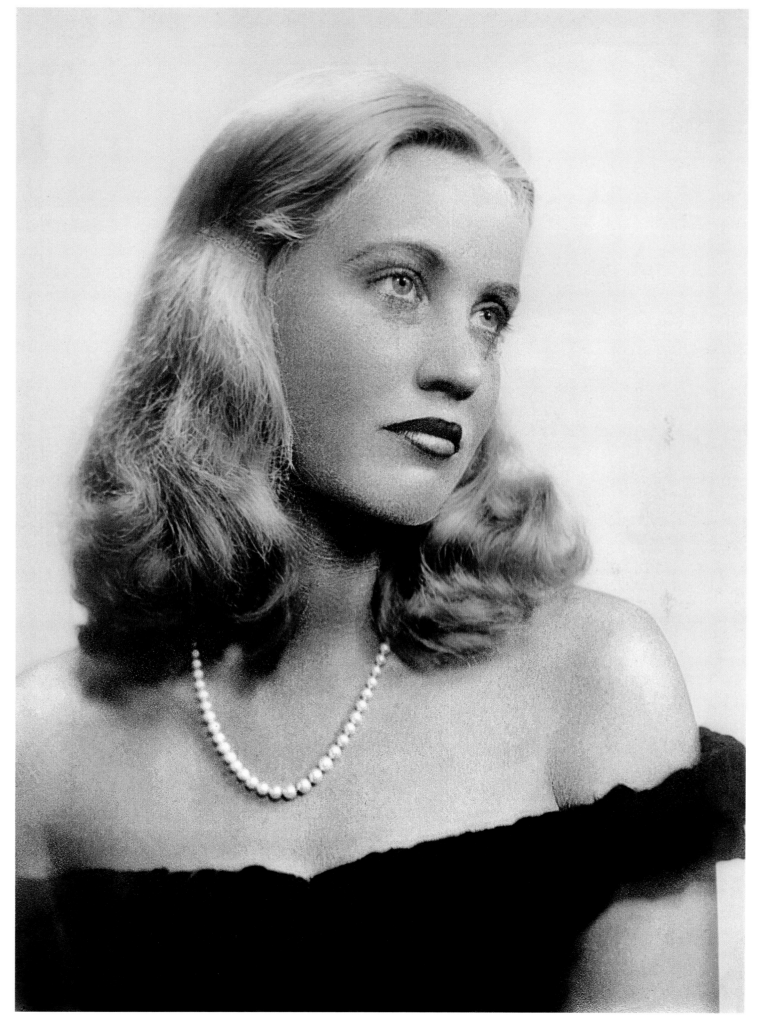

938 | Bachrach
trait of Edie.

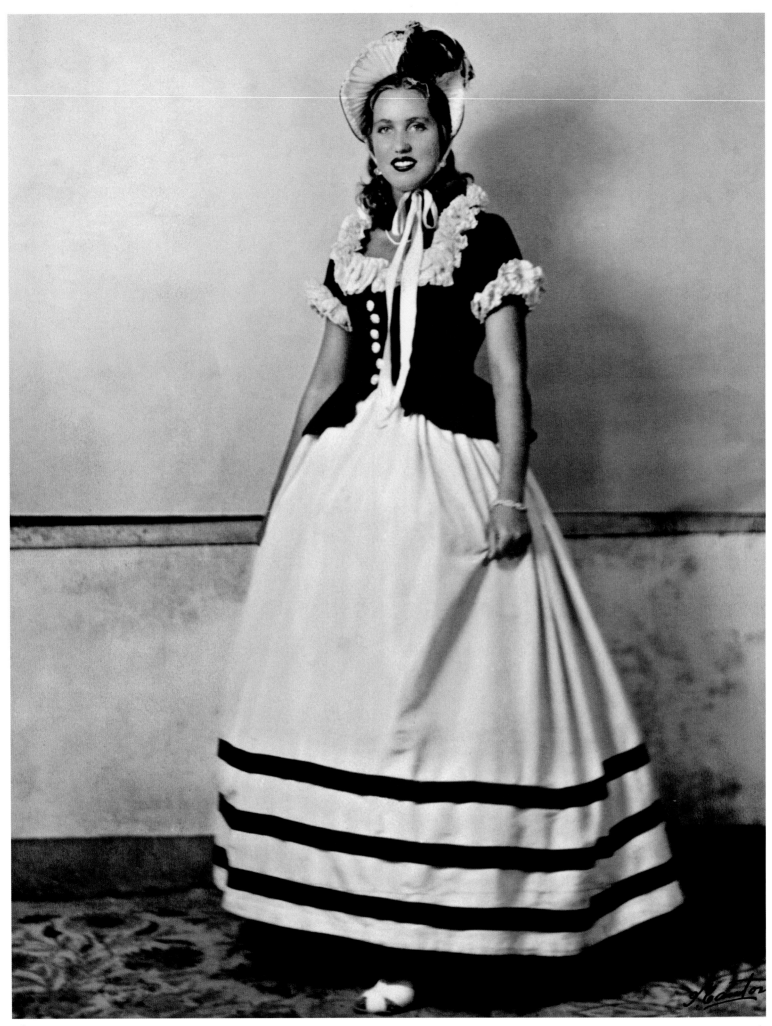

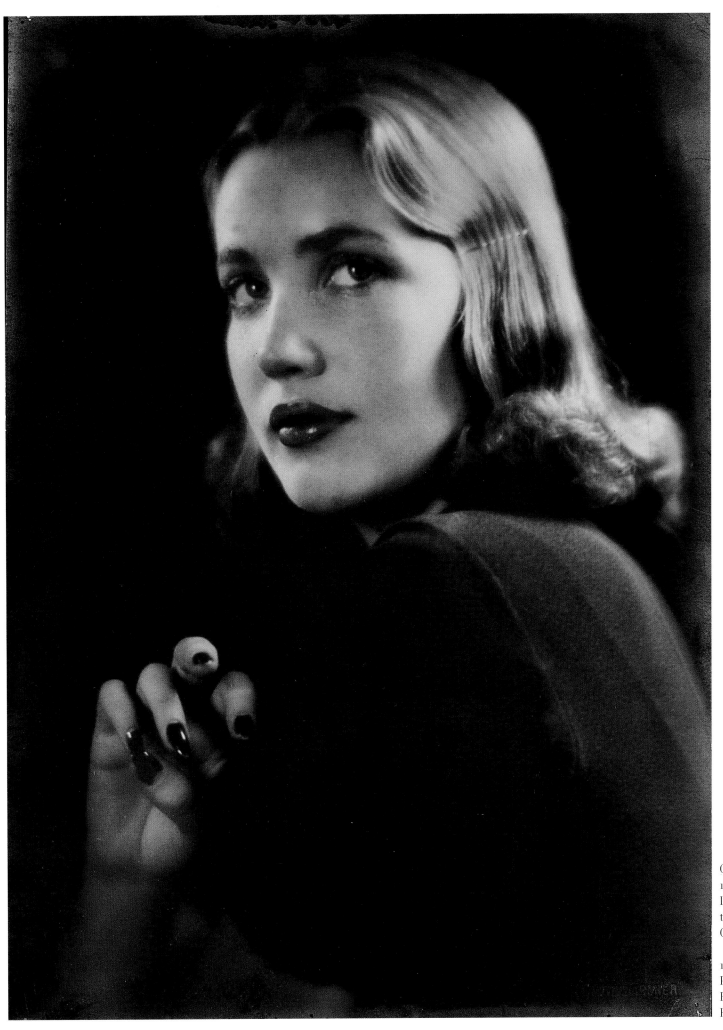

Opposite:
1939 | Hampton, NY |
Labor Day, "Gone with
the Wind" Maidstone
Club Dance.

1939 | New York, NY
Portrait of Edith Bouvier
Beale taken at the Plaza
Hotel.

117

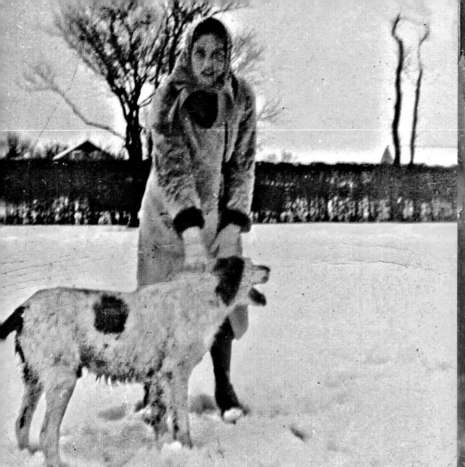

1940 | East Hampton, NY | Little Edie poses with Spot in snowy yard of Grey Gardens wearing her mother's pony skin fur coat.

Air Photo of
"Grey Gardens"
in the 1920's
East Hampton

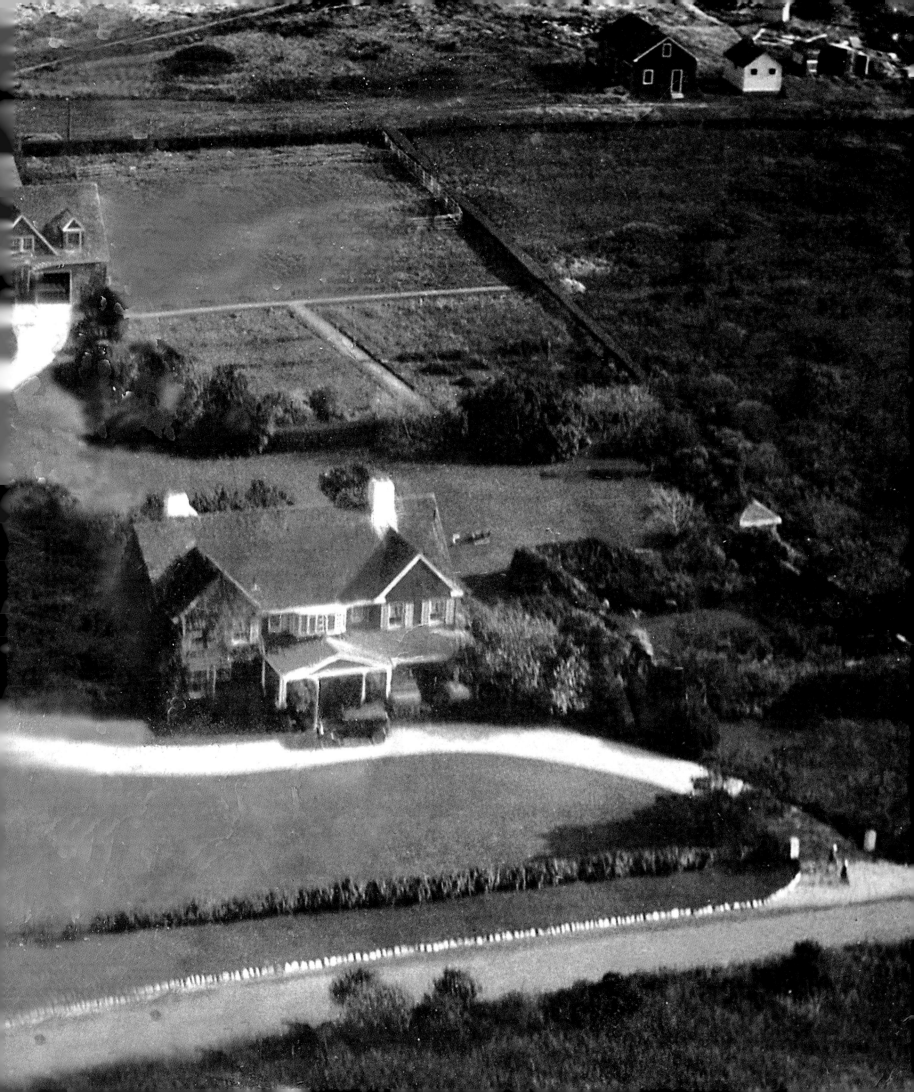

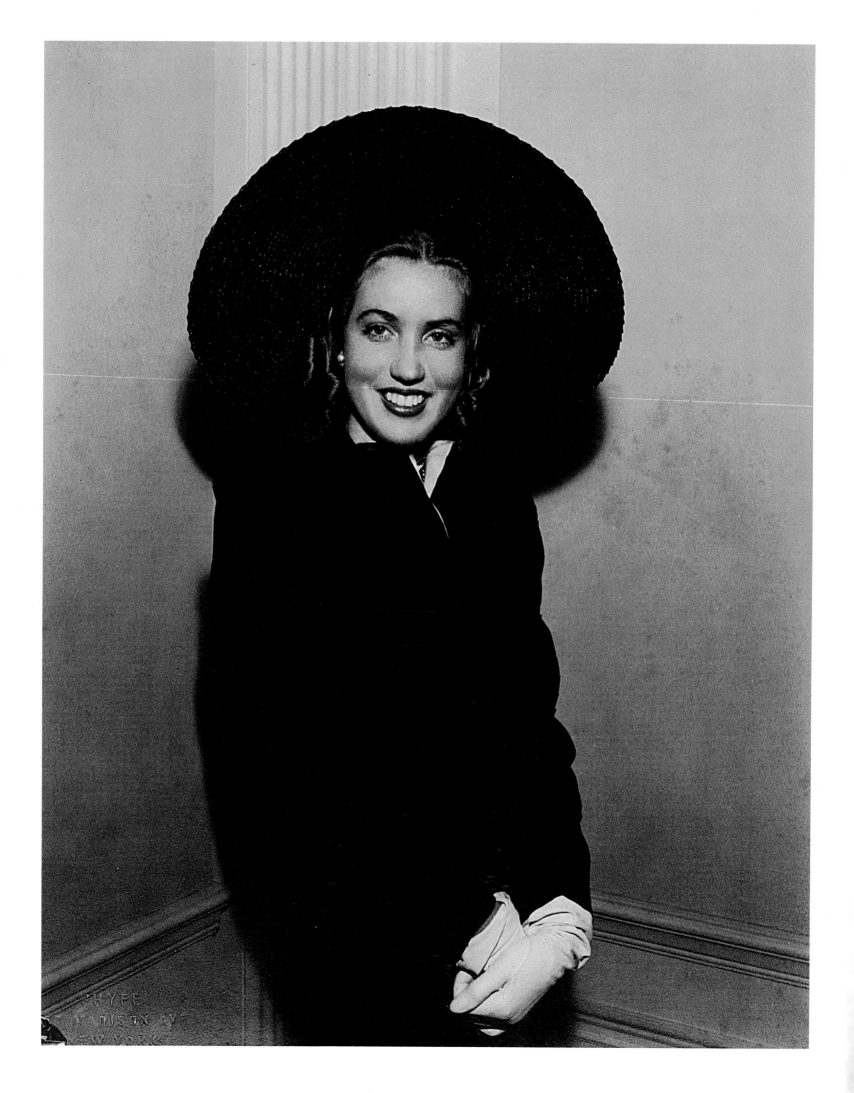

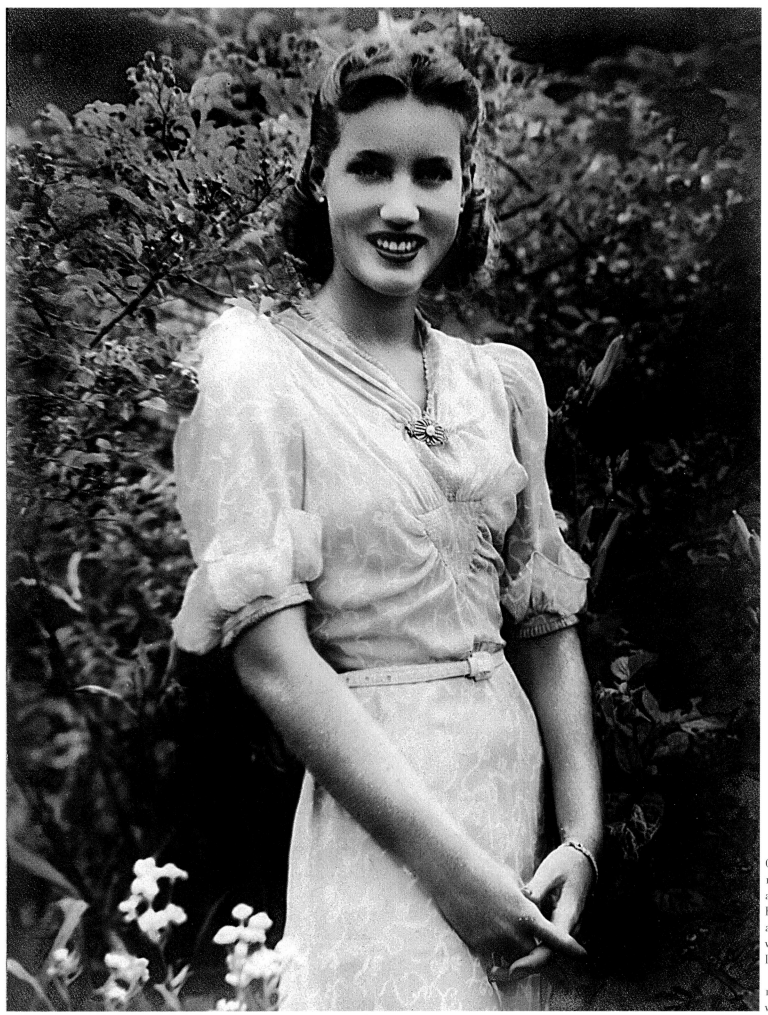

Opposite:
1940 | Edie at "Hamshire House" for a friends' wedding (Dick Lunn).

1940 | Edie in white dress.

121

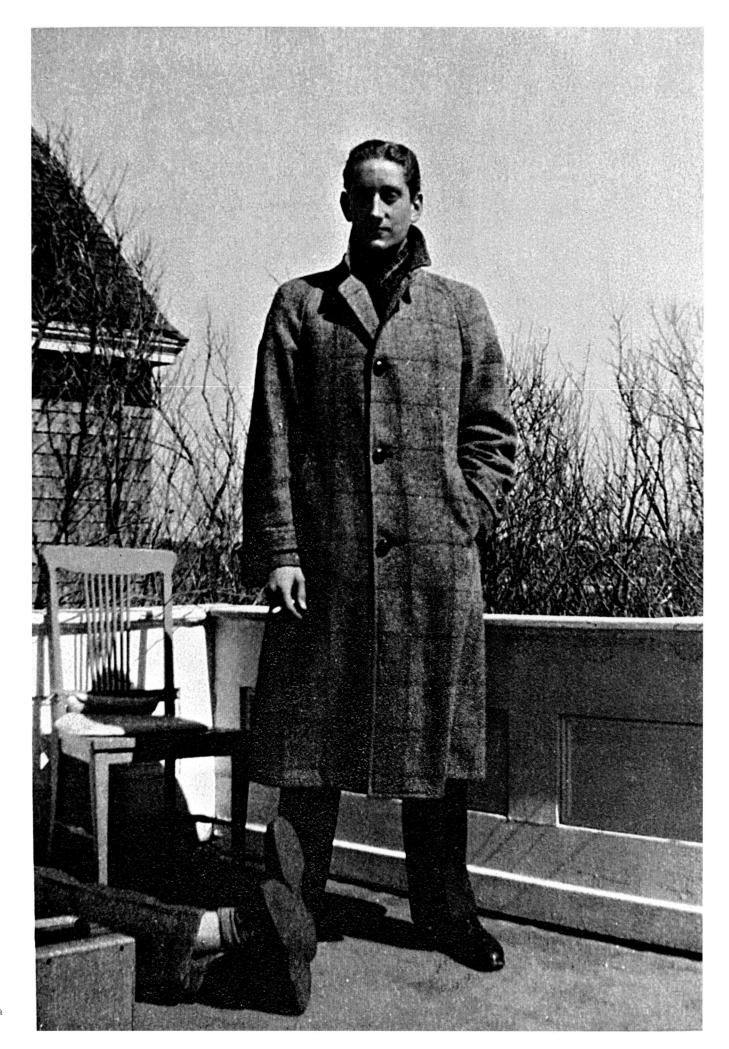

1940 | East Hampton, NY
| Bouvier Beale (Buddy)
poses in a handsome coat at
Grey Gardens while taking a
smoking break.

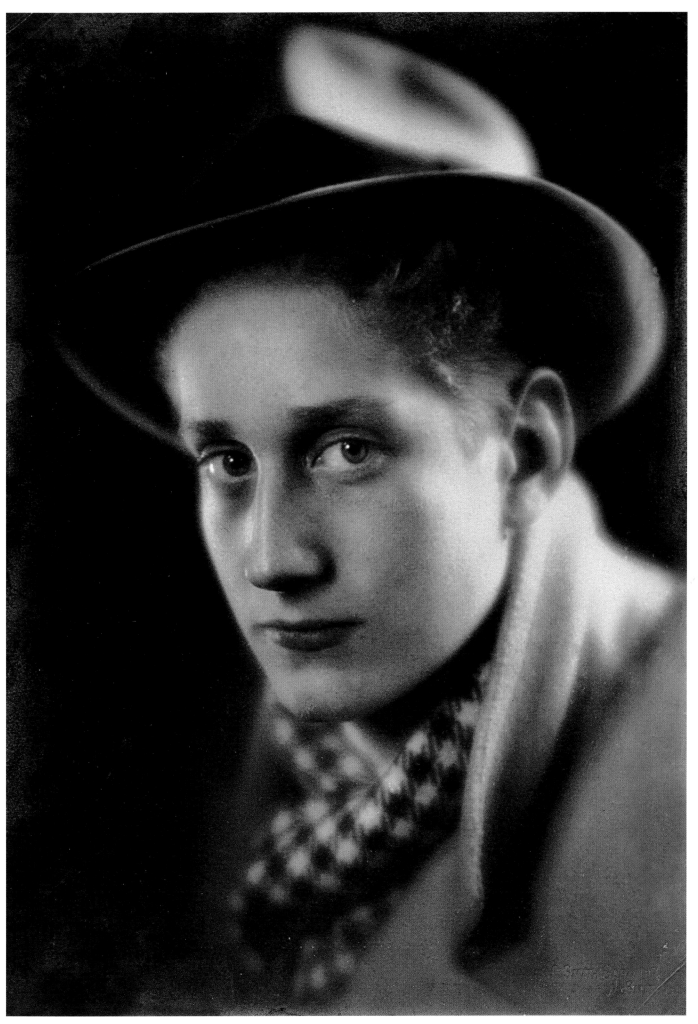

1940 | Bouvier Beale (Buddy) looking very sophisticated.

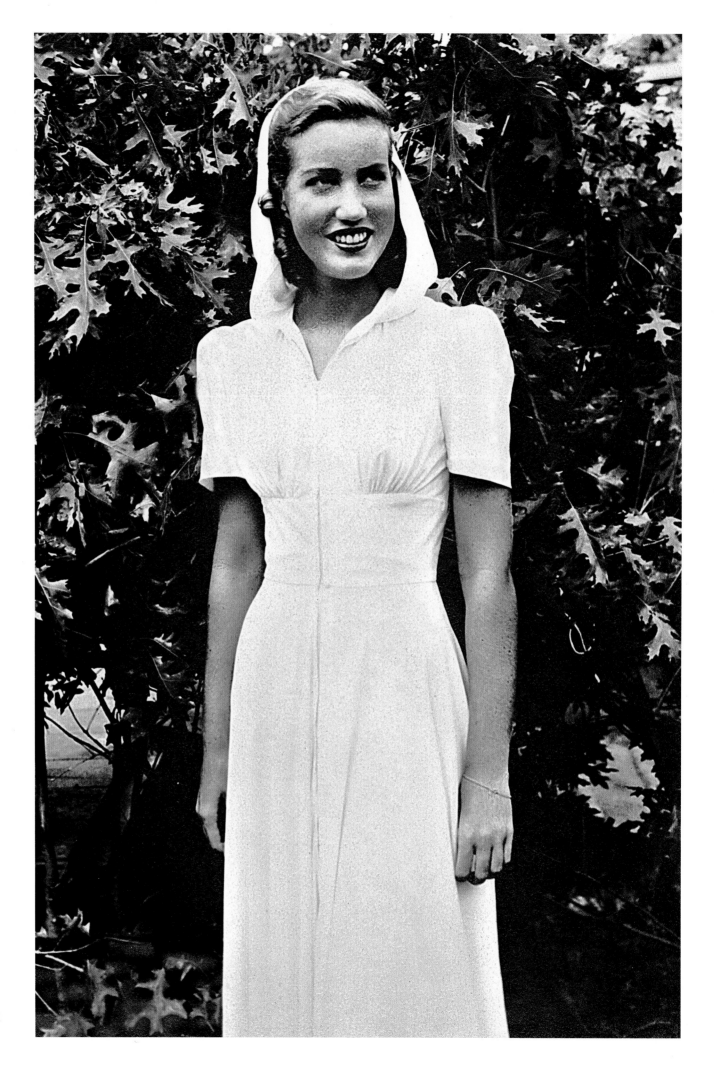

1940 | Edie looking beautiful and
angelic in her very white dress.

124

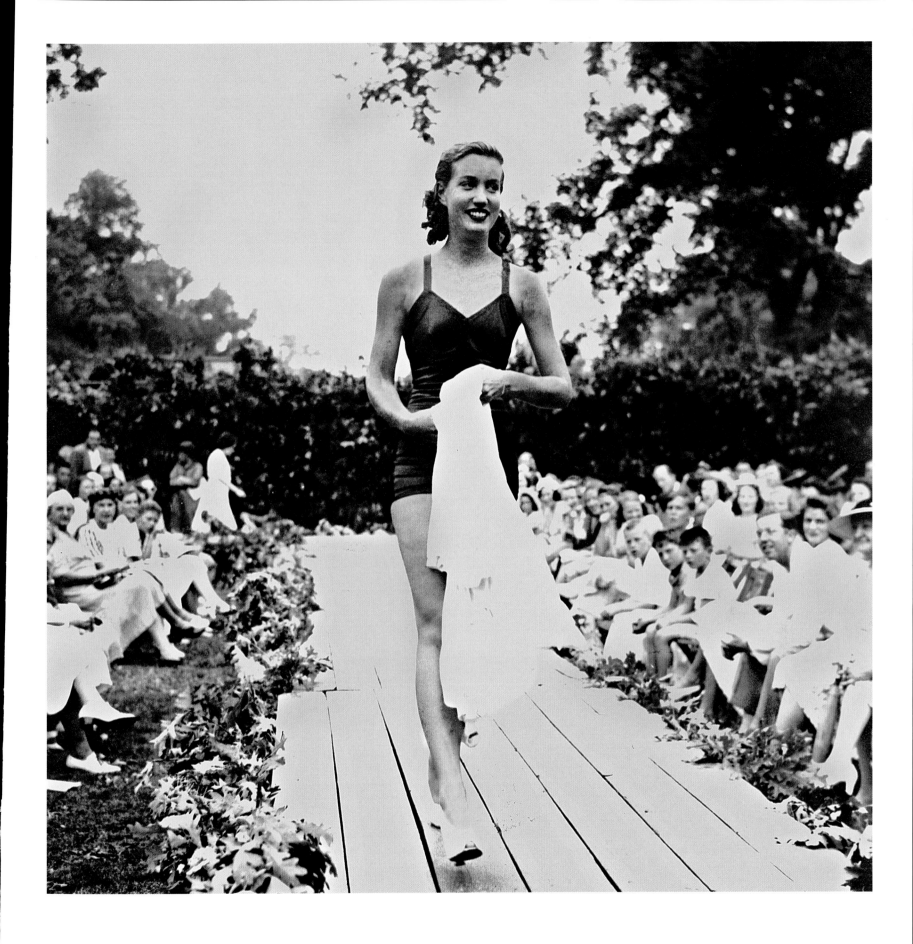

1940 | East Hampton, NY | Edie pictured modeling at the Lady's Village Improvement Society Fashion Show.

"Decision"

"For years I pondered the weighty matter
Is he young enough?
Rich enough?
Should he be fatter?
What about his family?
Does he like dogs?
And thisa and thata ---

but now thank heaven
all debate is finished
at twenty-eight it is true
any pair of pants will do."

Edith Bouvier Beale, 1945

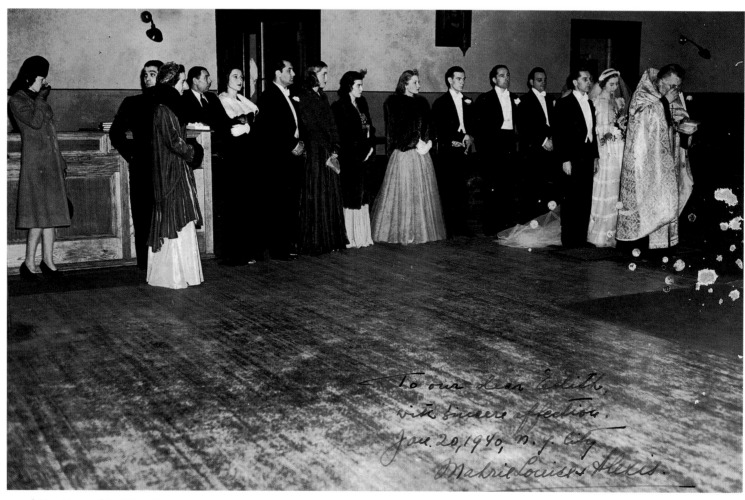

To our Dear Edith,
with sincere affection.
Jan. 20, 1940, N. y. City.
Mabel Louise Hicks.

1940 | Edie attends a friends' wedding.

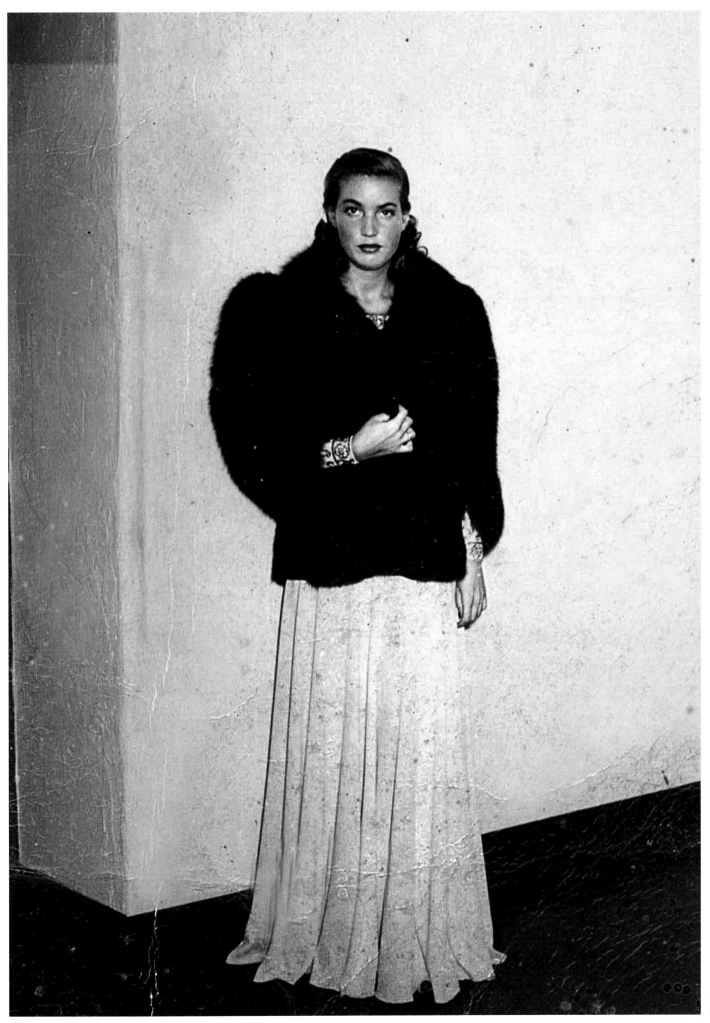

1940 | Edie Dressed for a soirée.

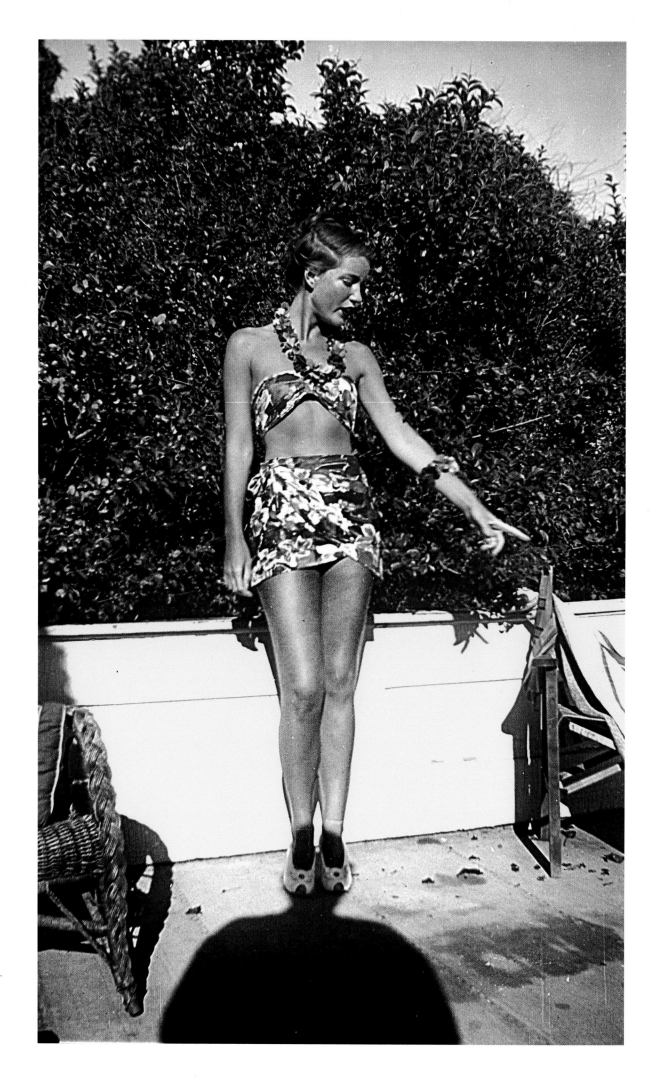

1941 | East Hampton, NY | Little Edie poses in a floral two-piece swimsuit, looking very tropical on the porch of Grey Gardens.

Opposite:
1941 | Edith Beale, a vision in white.

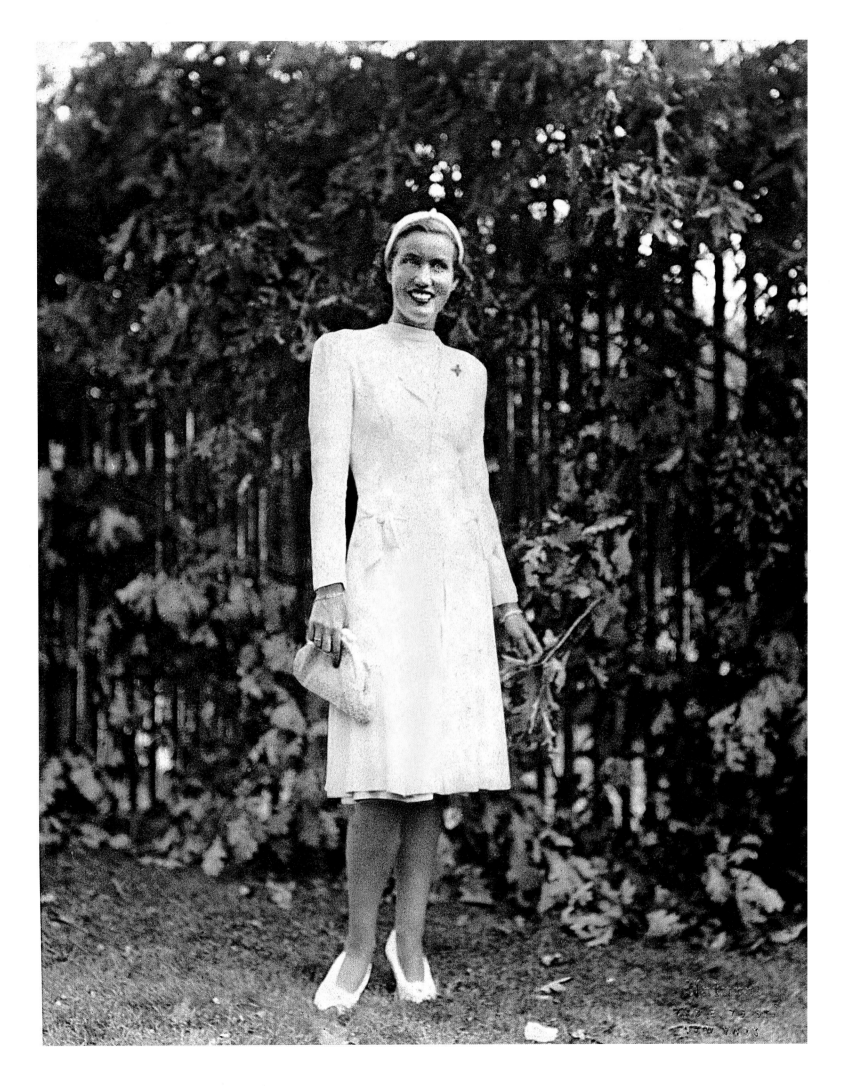

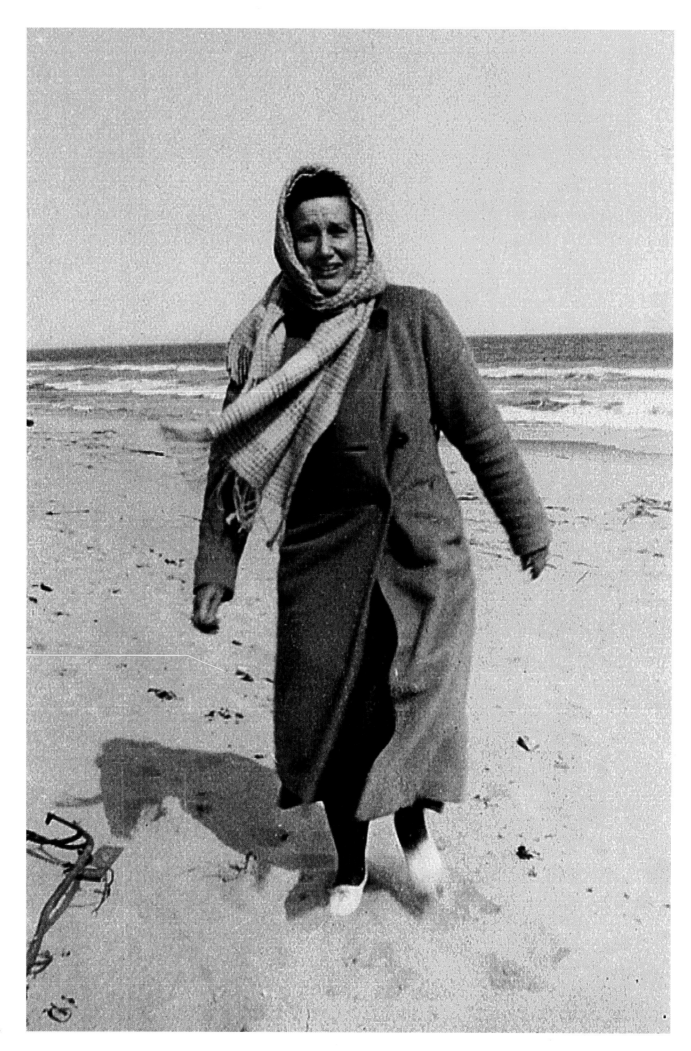

1938 | East Hampton, NY | Big Edie
pictued walking on Georgica Beach.

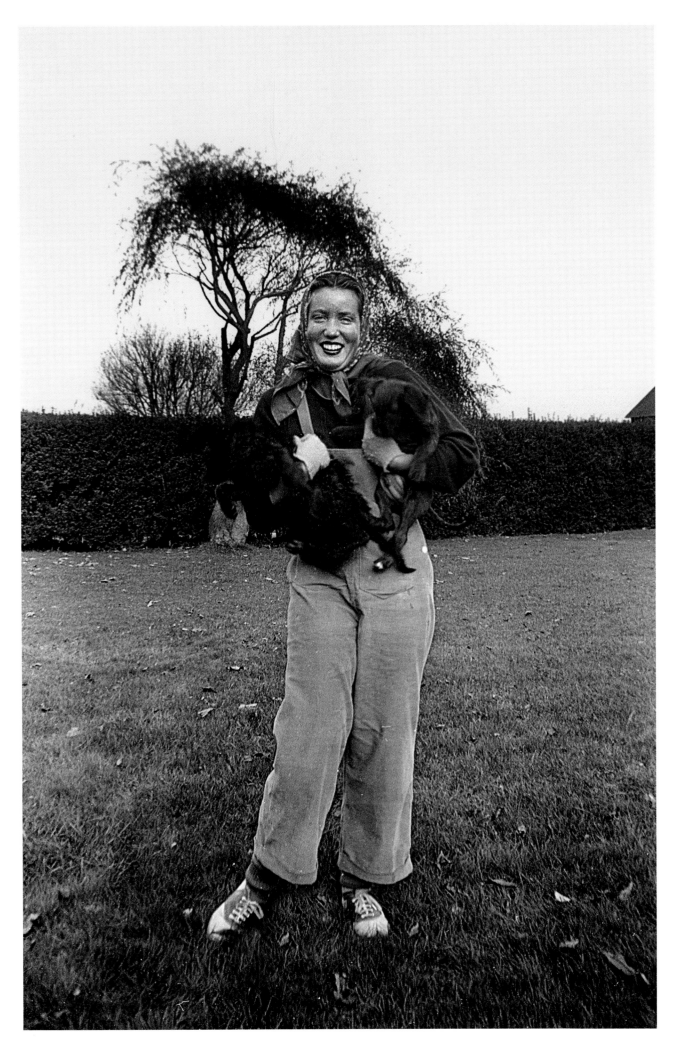

1942 | Grey Gardens, East Hampton, NY | Edie pictured holding her dogs in the yard of Grey Gardens.

131

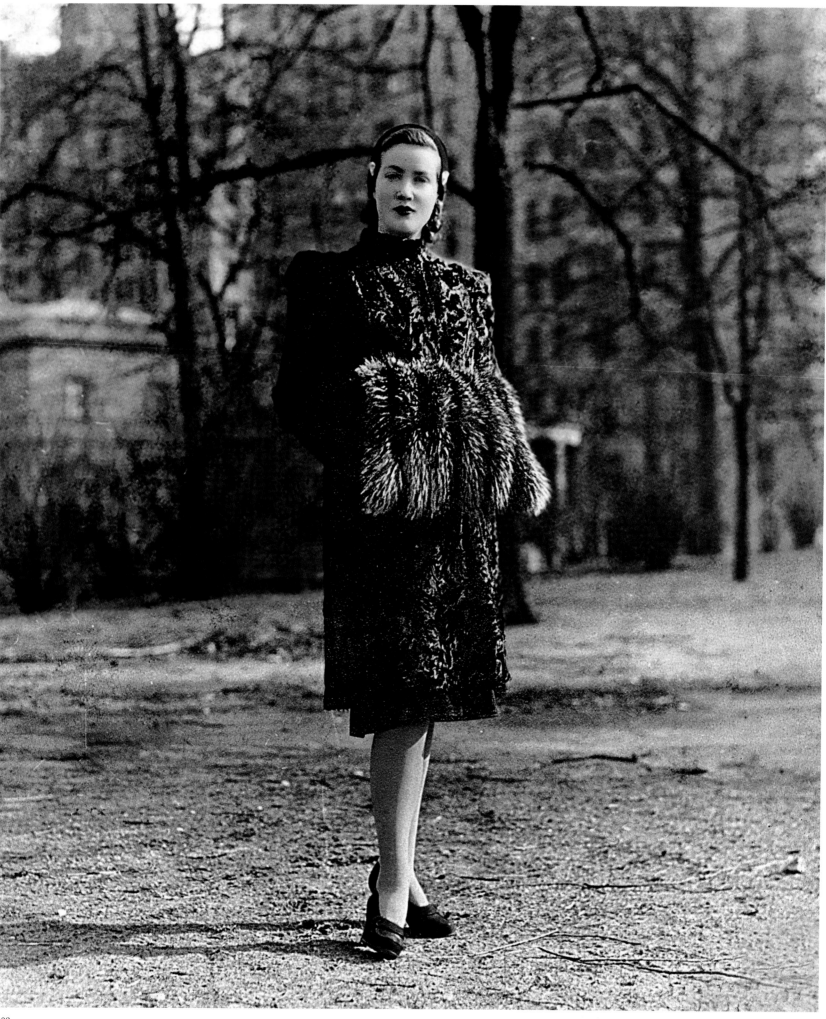

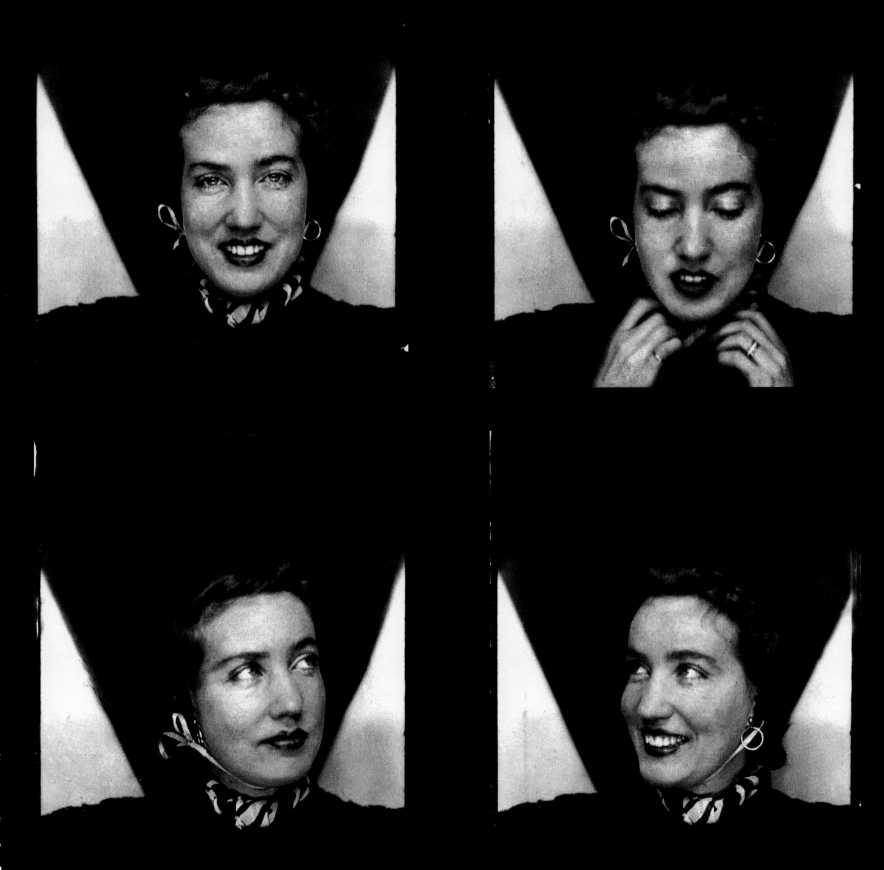

Opposite:
1945 | Edie dressed to kill in Central Park.

1942 | Series of stylish but casual snapshots of Edie.

1944 | East Hampton, NY | Spot, the Beale's pet Dalmatian, pictured in the yard of Grey Gardens.

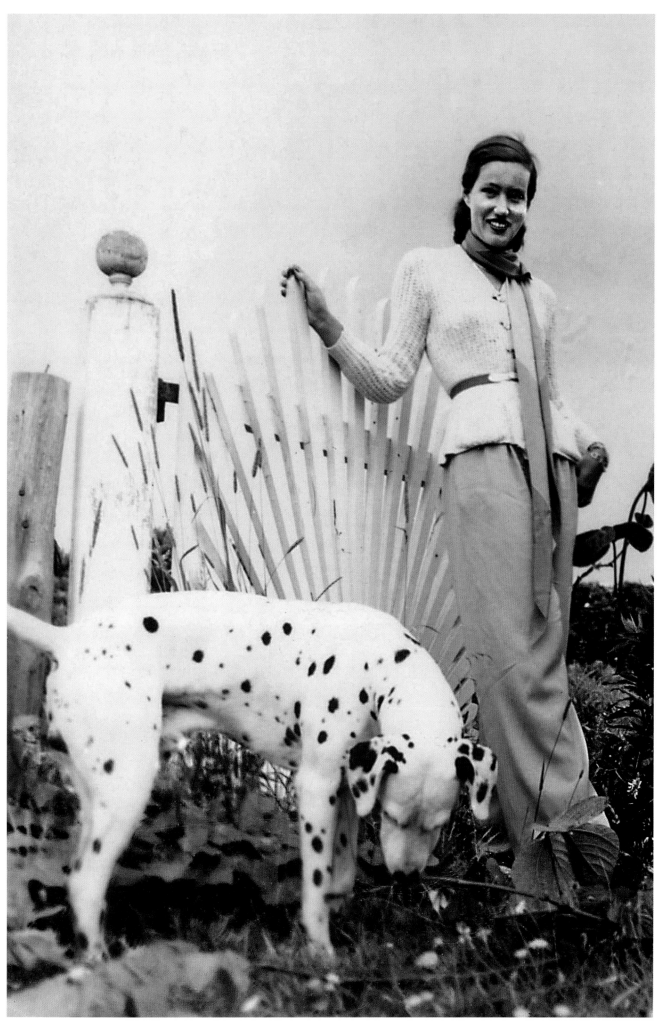

1940 | Photo of Edie at Grey Gardens with Spot - Oceanside.

Following pages:
1938 | East Hampton, NY | Big Edie poses in front of Grey Gardens.

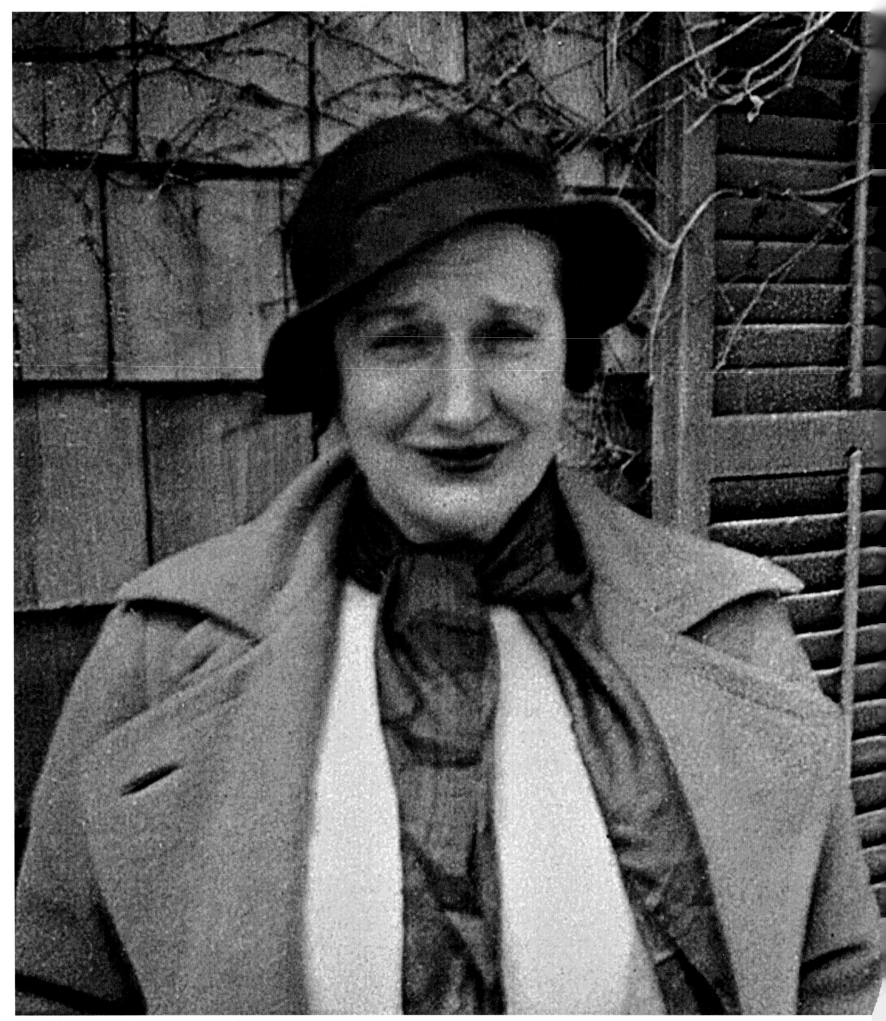

"Mother is alone at East Hampton. She needs the help any woman her age is entitled to -- not mentioning the fact that she performs the labor of a workman stoking a coal stove several times a day to keep warm. (...)

Help for her state of emergency - for that is what her life is - if one may call it a life - should come from the rightful source - not from her daughter who gave not wisely but too well, but from her own kin who with a little effort of imagination on their part could have put themselves in her position(...)."

May 7, 1948
Letter from Edith to uncle Jack,
father of Jackie.

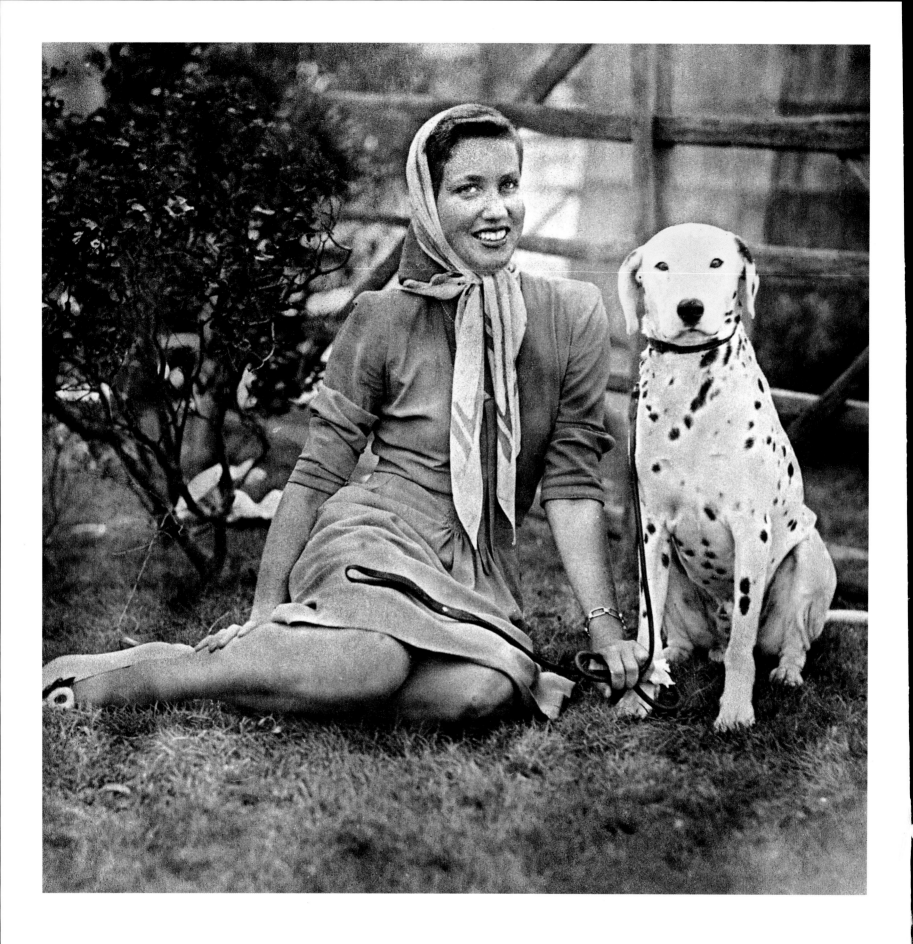

1944 | Edie with Spot.

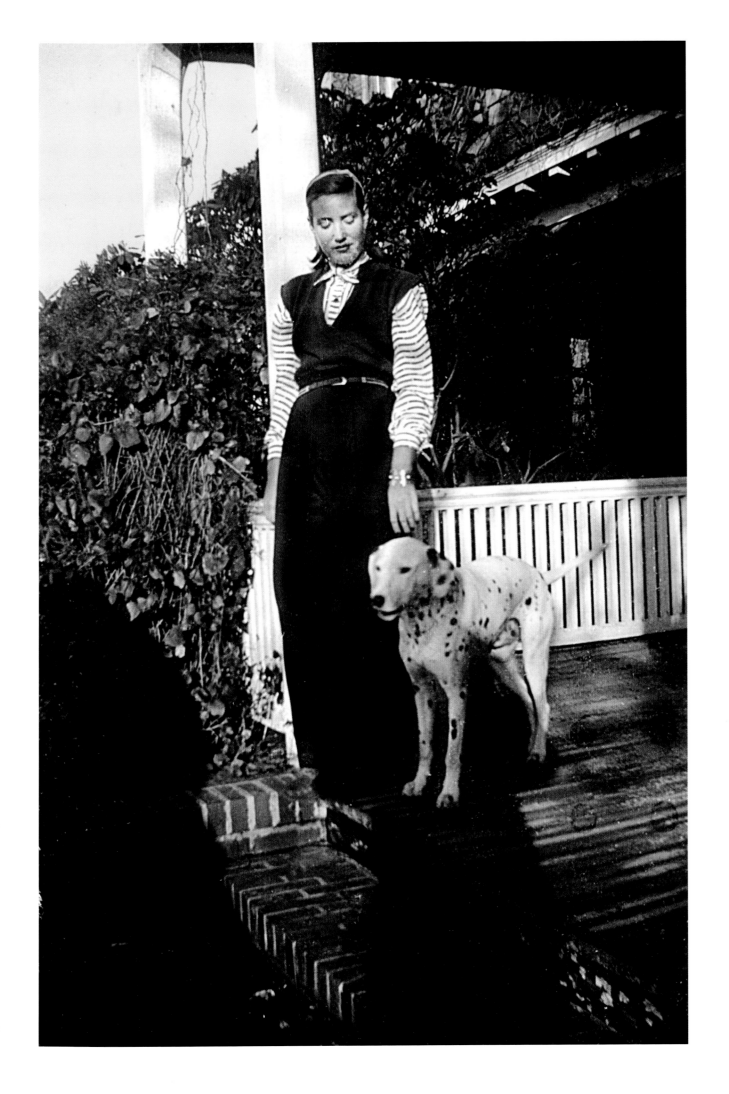

1944 | East Hampton, NY |
Little Edie poses with Spot in
front of Grey Gardens.

"Born Anew"

"One day I loved
And hoped to find
Reciprocation of its kind
But the man I chose
Was not for me---
Bitter, cold, unyielding he
He had suffered once
And was not free
Heart still wrapped in self-misery
Closed to all, and to me
Curious that I who had suffered once
Was, through pain, born anew."

Edith Bouvier Beale, 1945

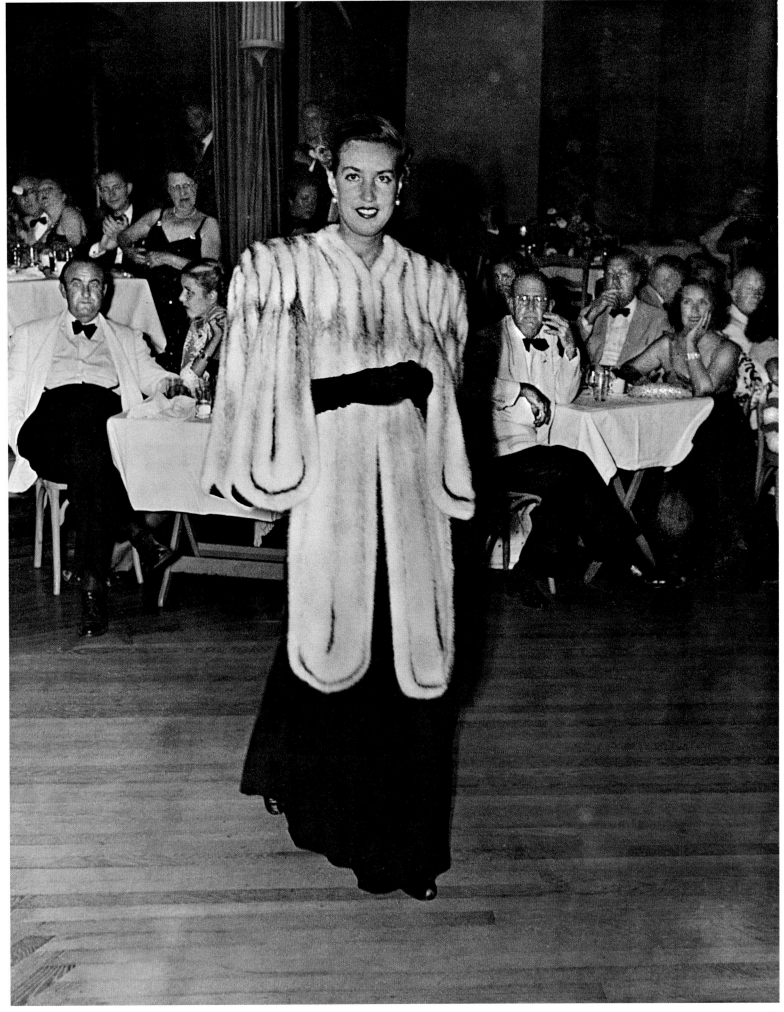

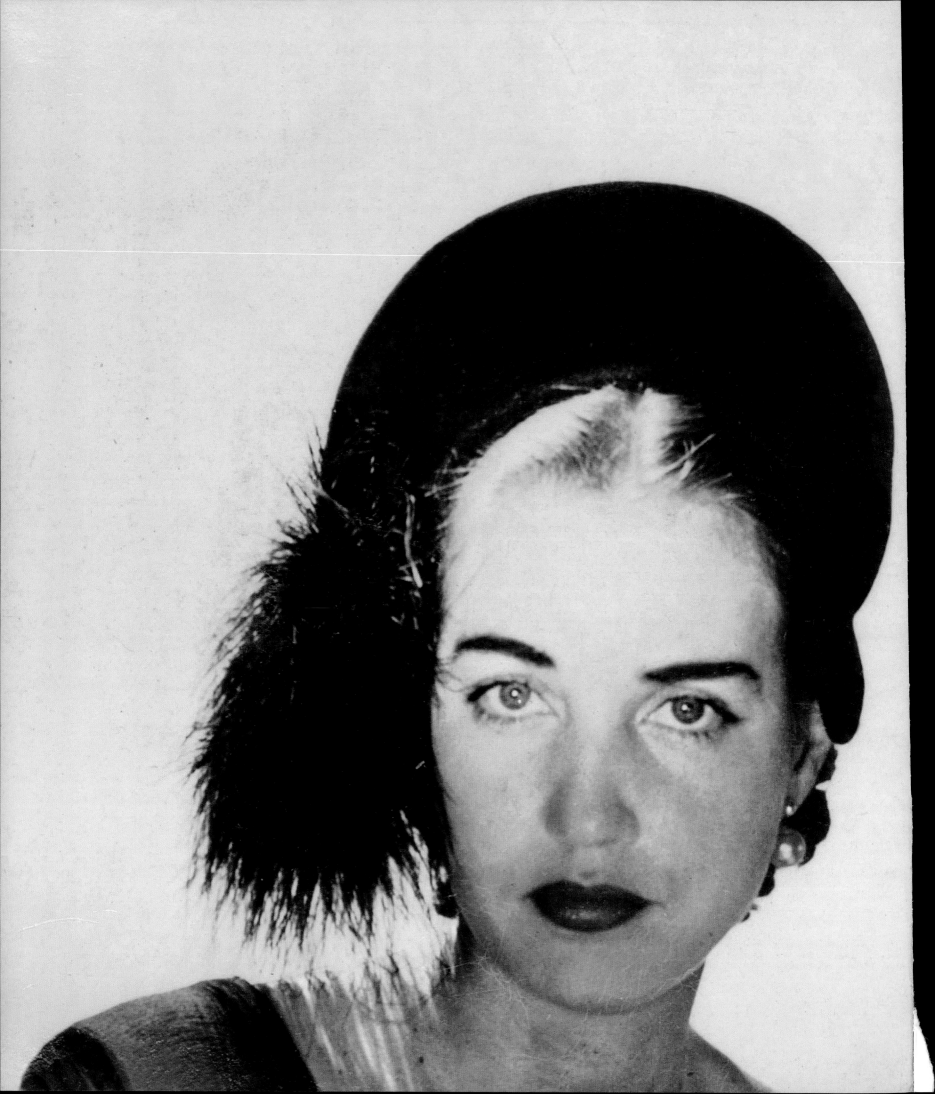

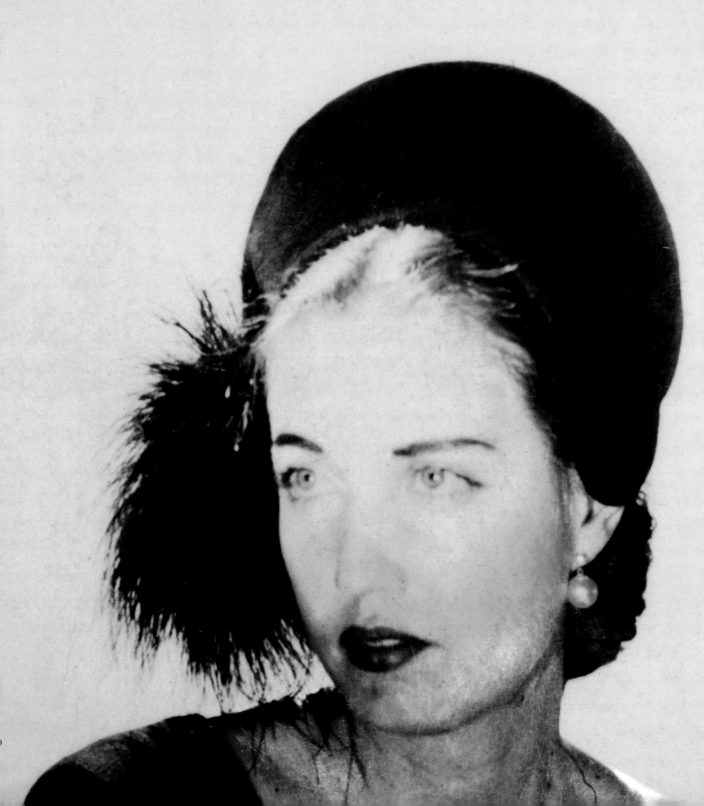

1948 | New York, NY | Studio
portraits of Edie.

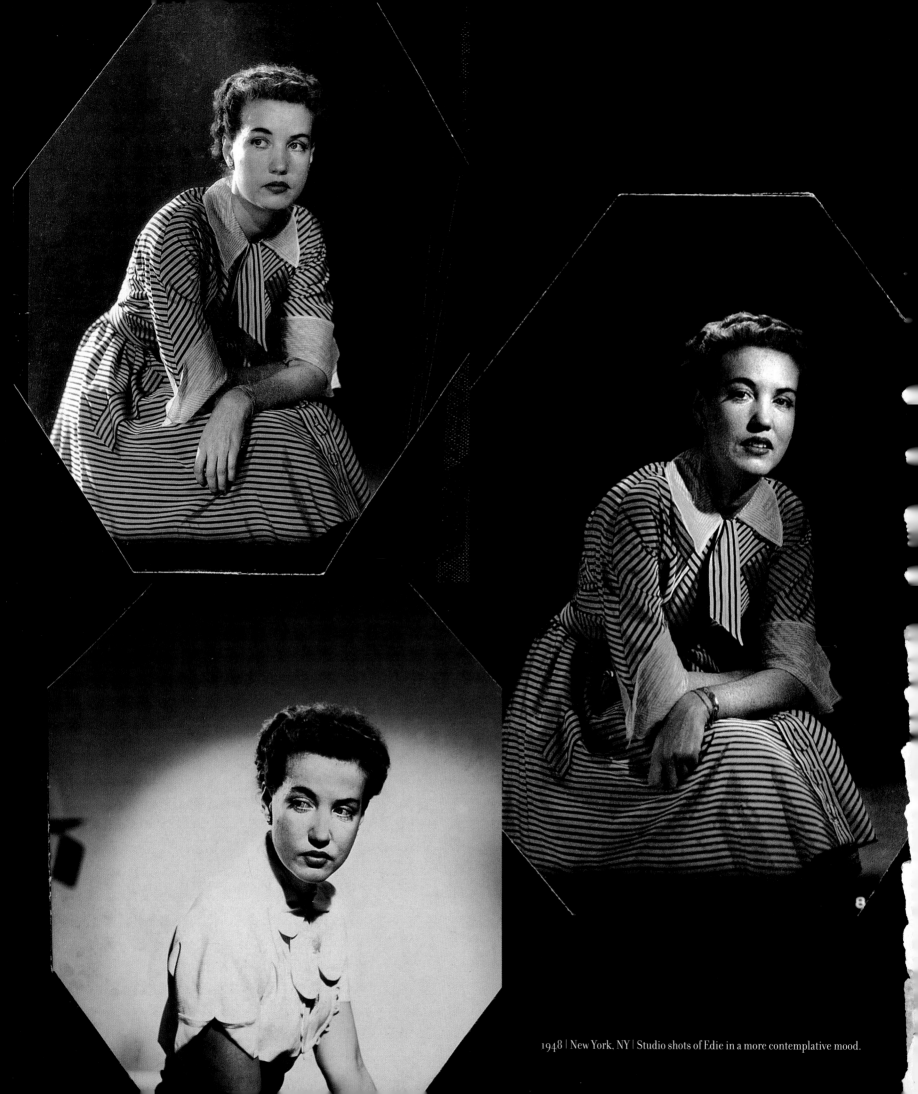

1948 | New York, NY | Studio shots of Edie in a more contemplative mood.

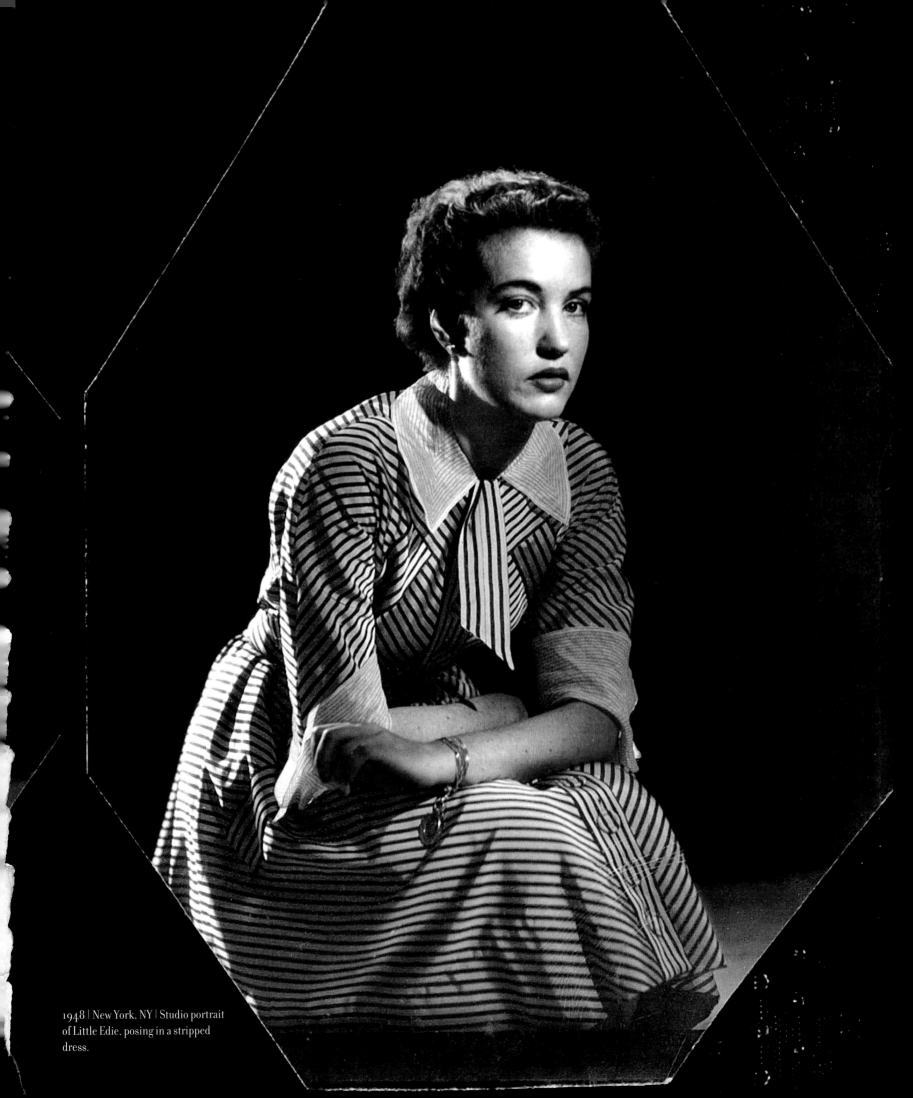

1948 | New York, NY | Studio portrait of Little Edie, posing in a stripped dress.

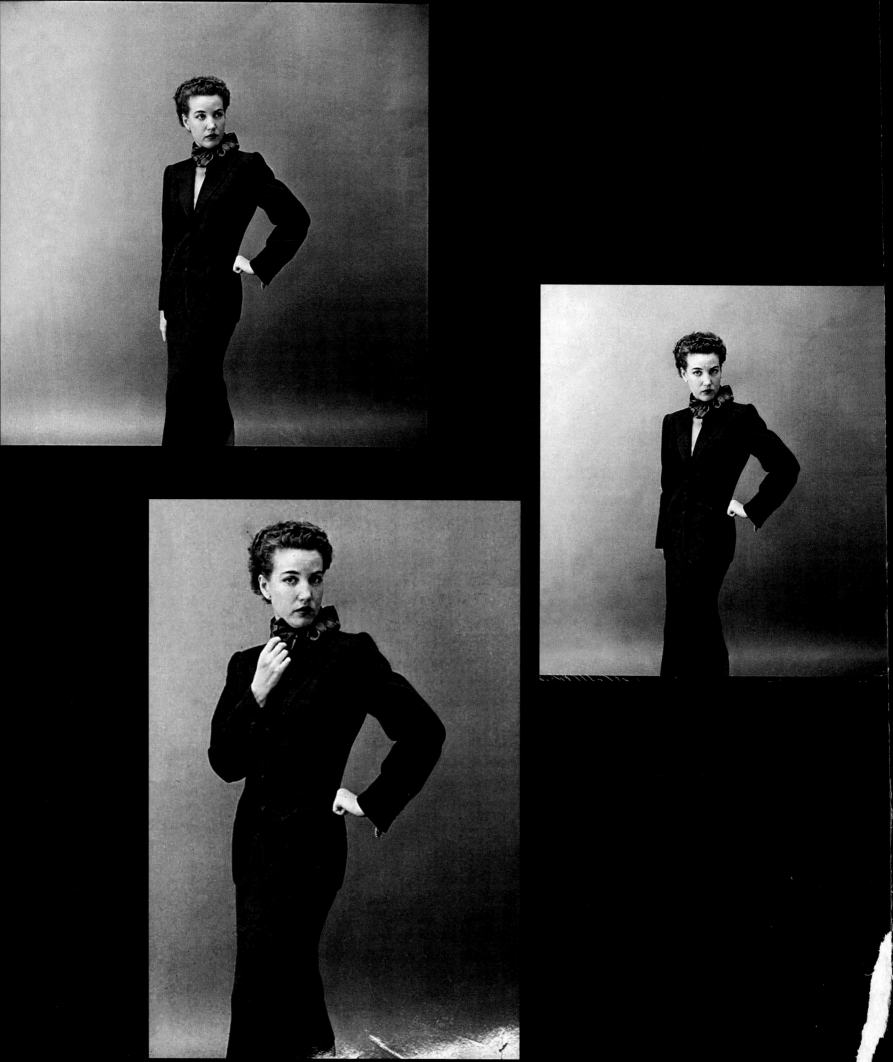

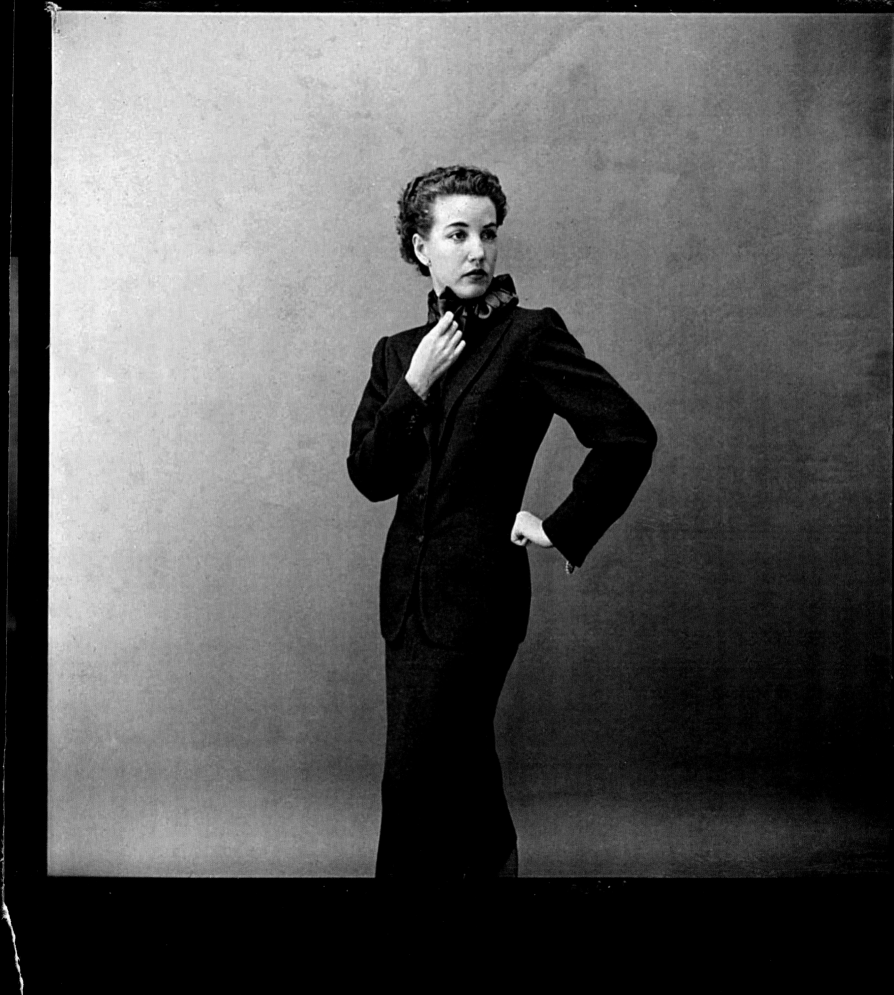

Studio photographs of Edie in a professional looking suit.

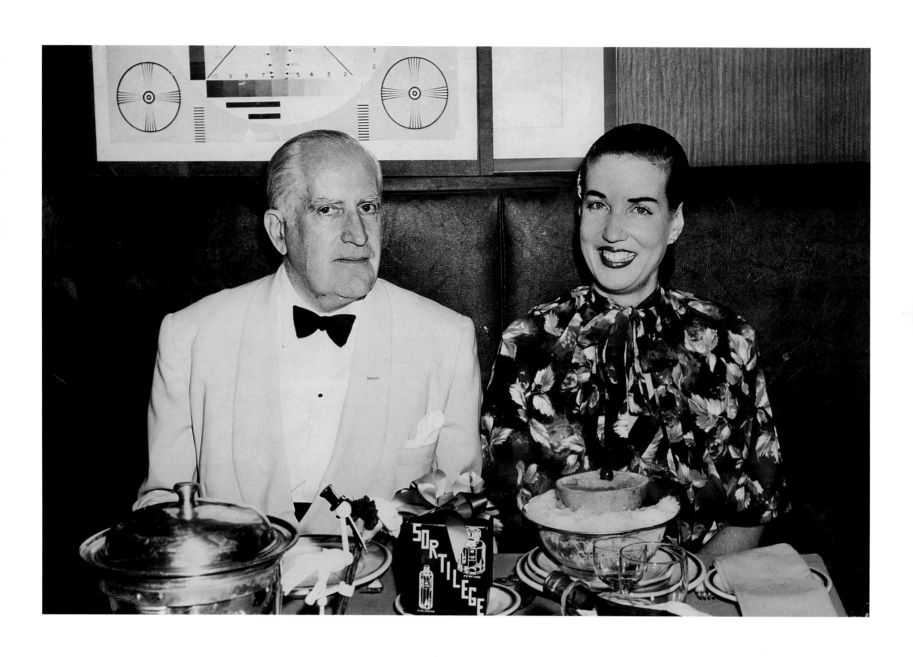

1951 | Edie and her father Phelan at the Stork Club.

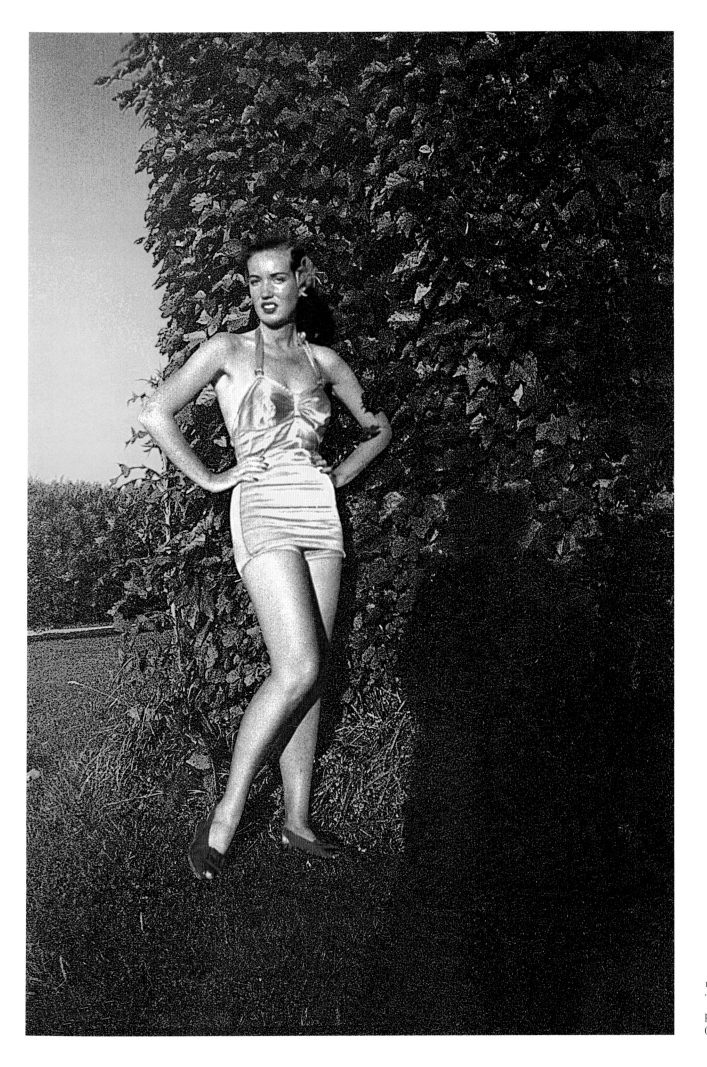

1951 | East Hampton, NY |
"Beale Body Beautiful": Edie
posing in front of hedges at Grey
Gardens.

149

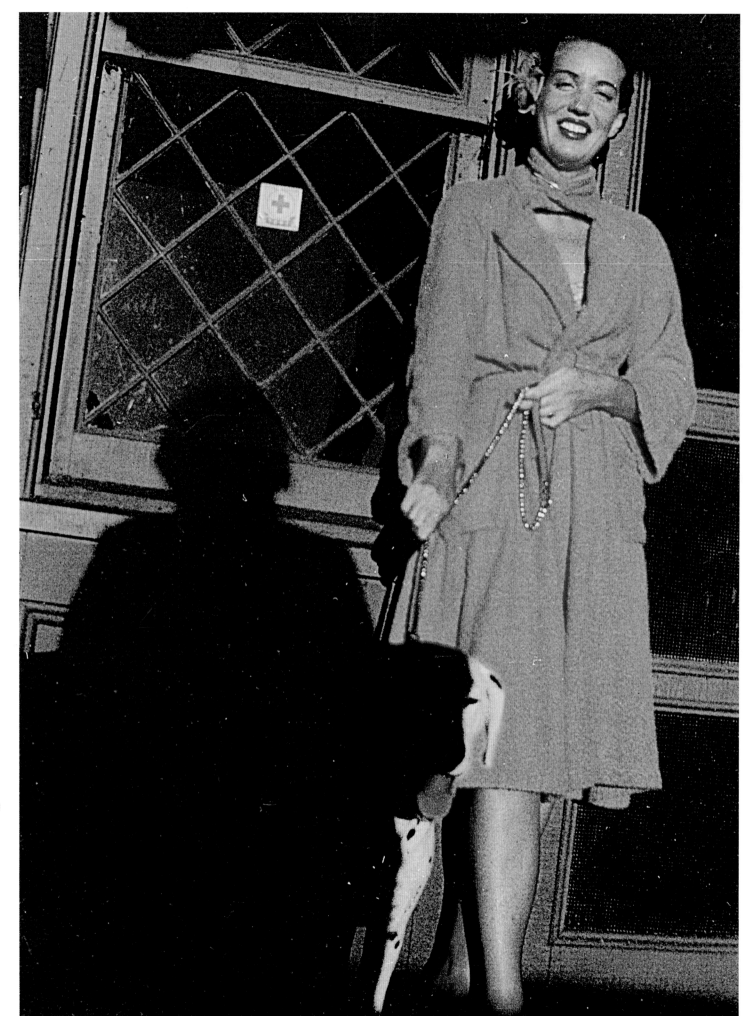

1951 | East Hampton, NY | Little Edie poses in an orange swimsuit and sarong with Spot in front of Grey Gardens.

Opposite:
1951 | East Hampton, NY | Little Edie poses in front of Grey Gardens in Asian-inspired costume.

150

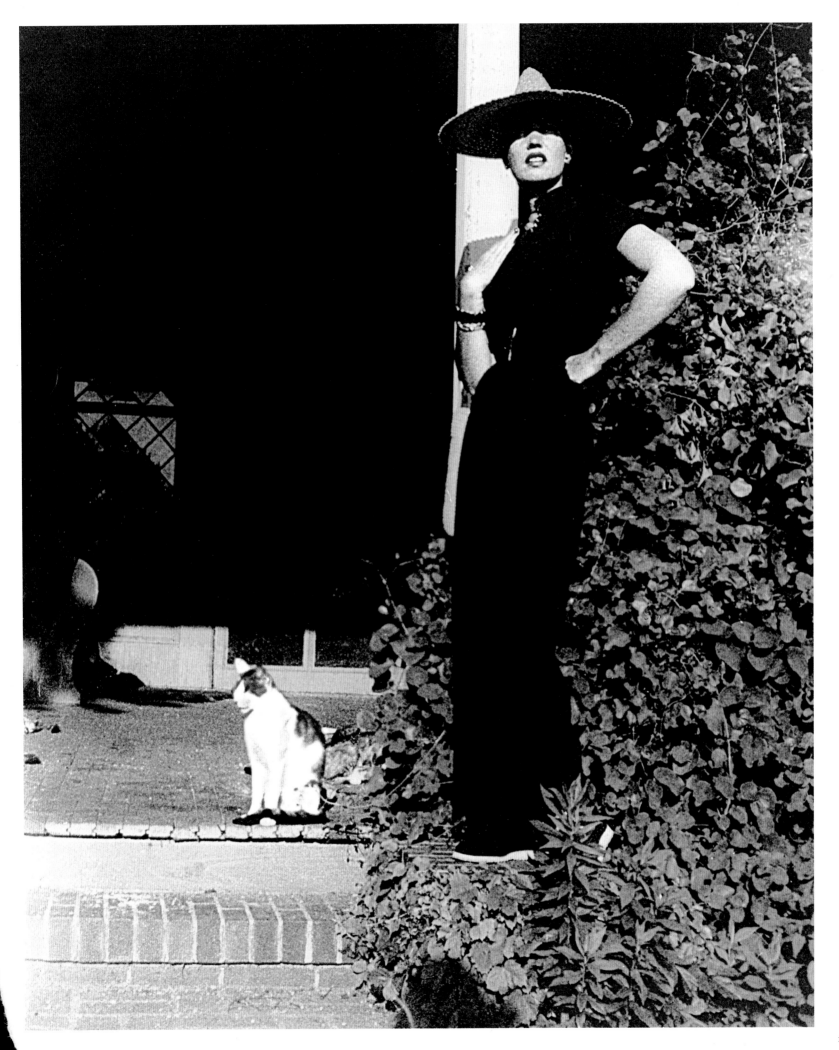

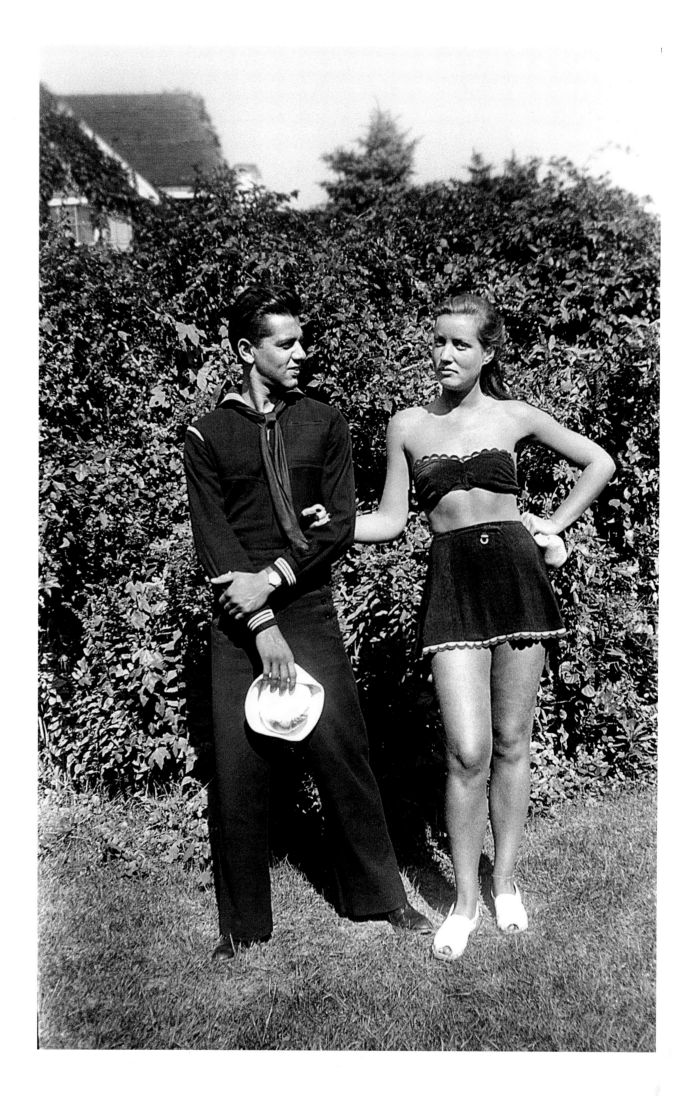

1942 | East Hampton,
NY | Boyfriend Johnny
Robinson, former fiancé,
comes to visit Edie at Grey
Gardens after being away
at sea. Edie broke this
engagement.

152

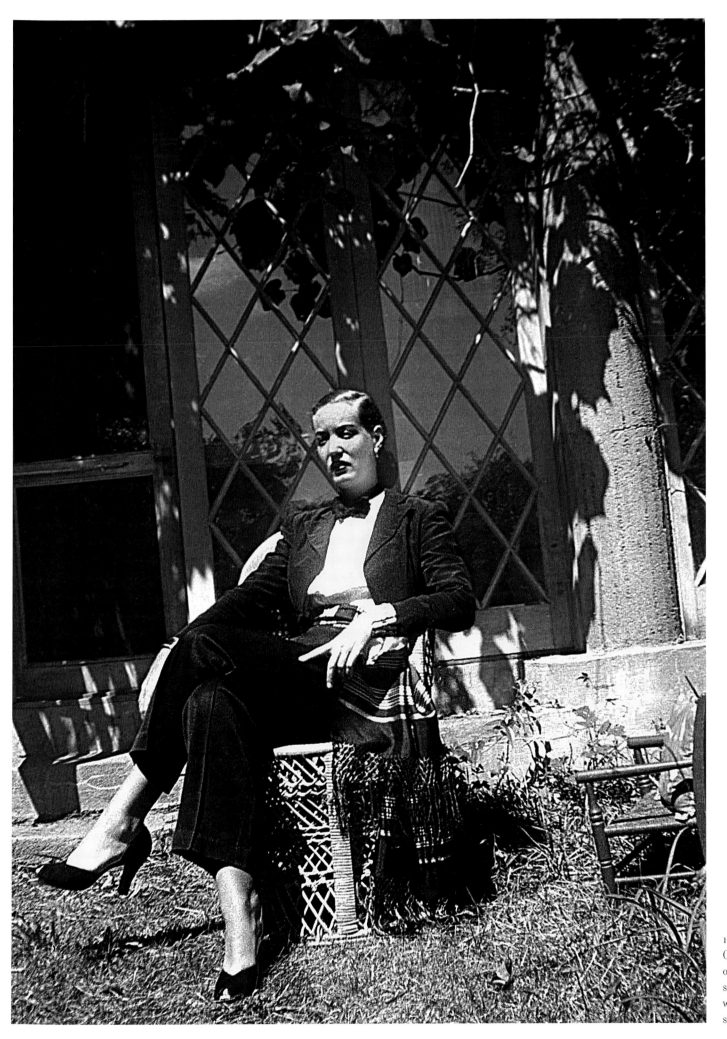

1951 | Edie at Grey Gardens, once again ahead of the curve fashion-wise, sports a bold striped sash with a conservative pants suit.

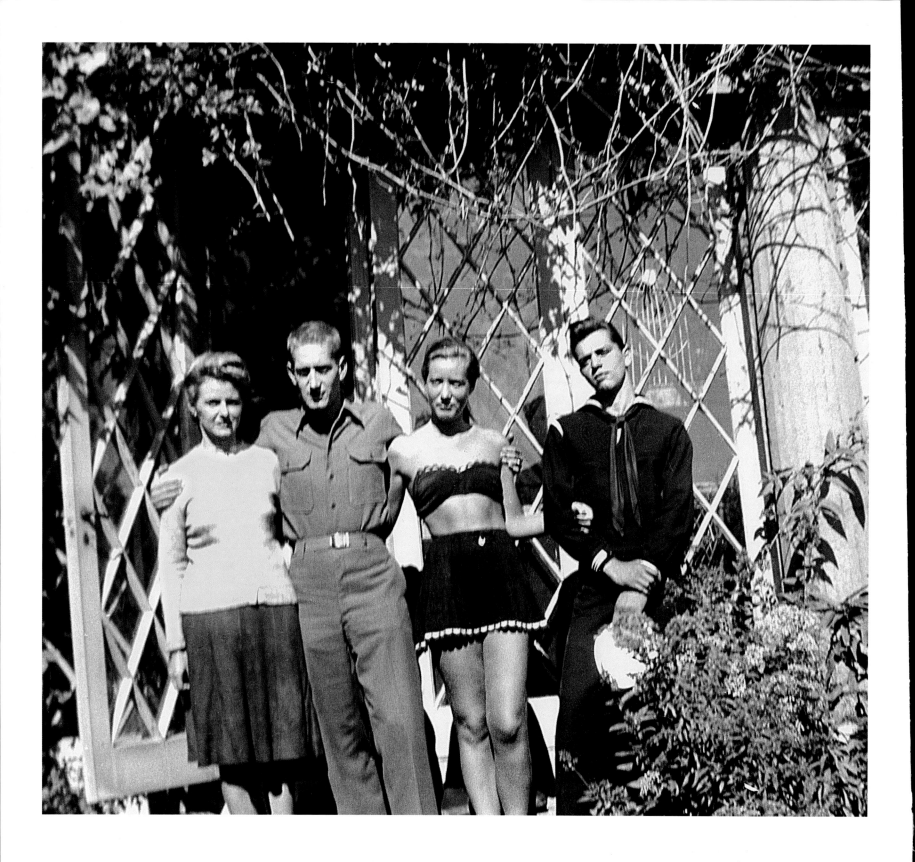

1942 | Grey Gardens, East Hampton, NY | Edie and Johnny Robinson pose with Edie's brother Buddy and his bride Katharine.

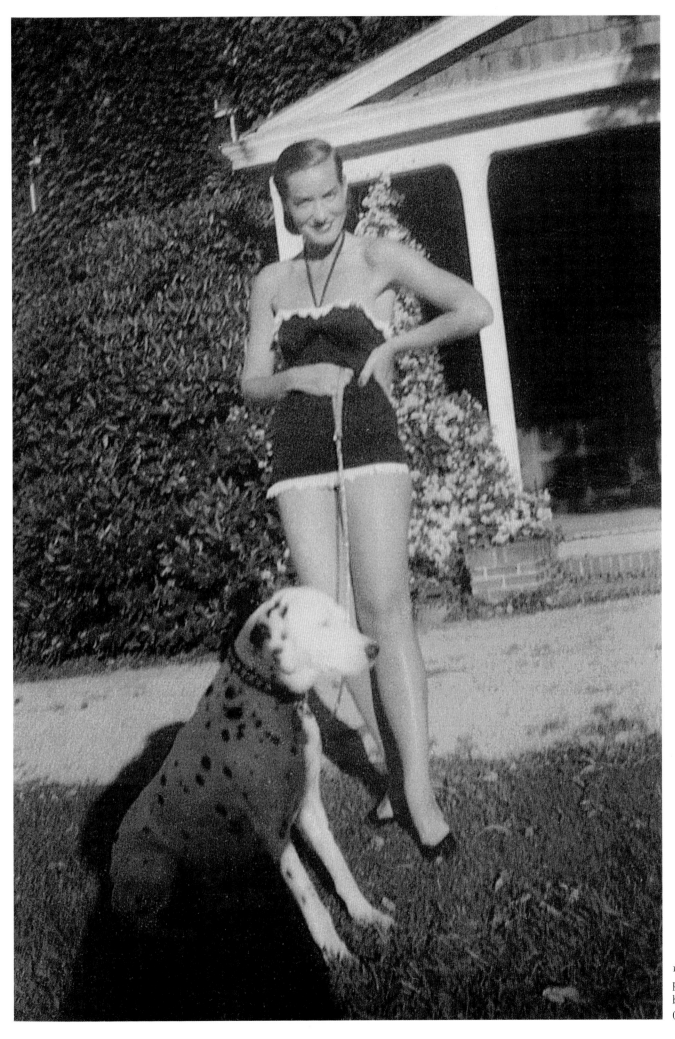

1951 | East Hampton, NY | Little Edie poses, wearing a black and white bathing suit, with Spot in front of Grey Gardens.

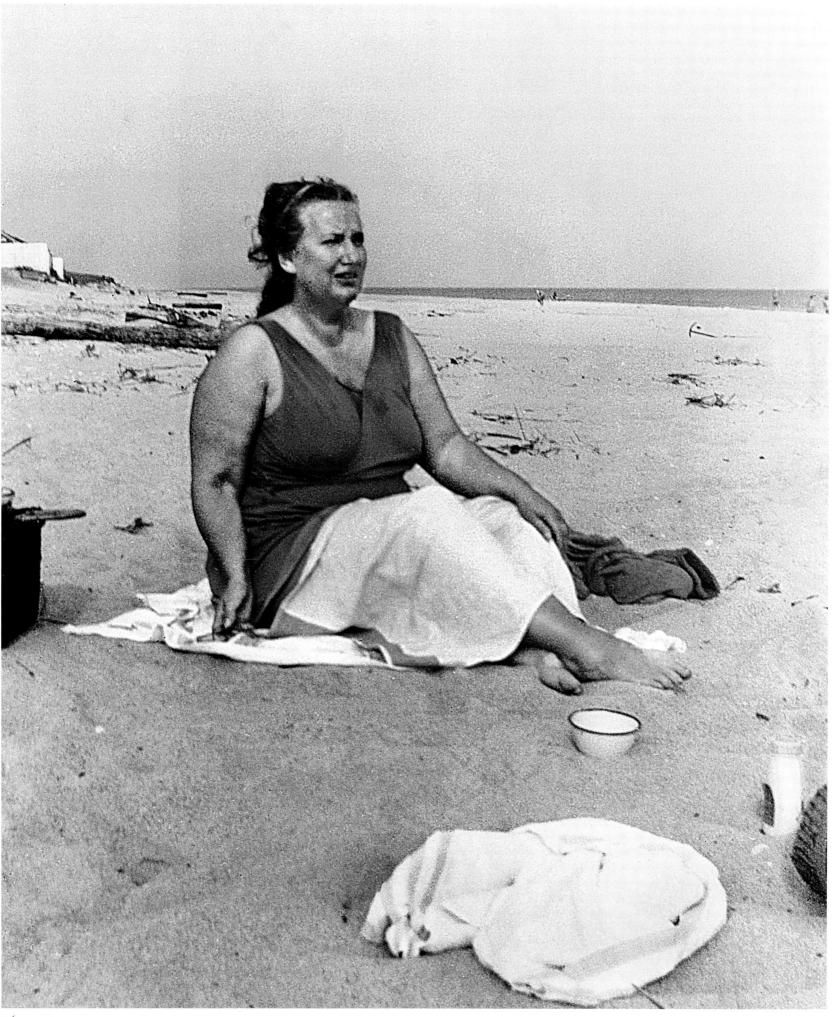

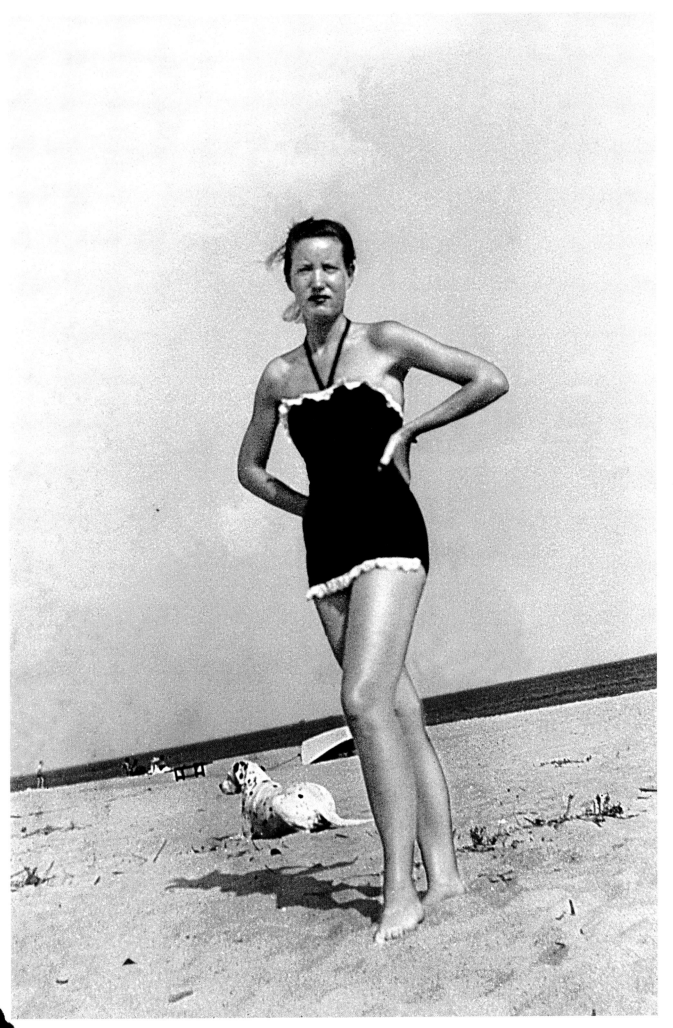

Opposite:
1951 | East Hampton, NY | Big Edie
pictured lazing on the beach.

1951 | East Hampton, NY | Little Edie
poses on the beach in East Hampton
wearing a black and white swimsuit.

Following pages:
East Hampton, NY | "A Heavy Surf":
Vintage Postcard of East Hampton,
found Little Edie's scrapbook.

A Heavy Surf. East Hampton, N. Y.

The Sea

Within me pounds the tumult of the sea
The moan and crash of breakers
And their plea
Resounding, never ceasing, their dull pound
Increasing to ever torture me.
I hear the weary whisper of the tides
As they sigh agains the shore
Their sigh ever fleeting
My sigh oft repeating
A sigh that leaves me nevermore.
But their whispers dim-
On barren rocks the rollers surge
Their dull thunders echo, now loud, now low
As they sing their ancient durge.
Oh sea forever pounding-
Oh sea —and — wind- and sky
Will you never cease your wailing-
Will within me ever sound your cry?

Edith Bouvier Beale

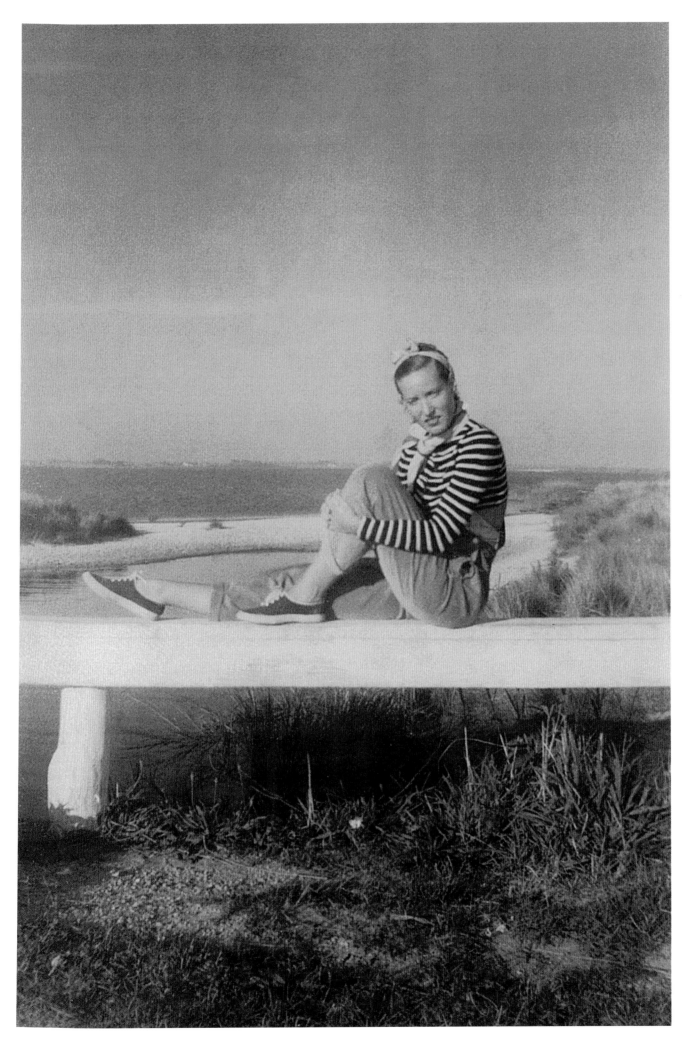

1951 | East Hampton, NY | Little
Edie poses at Georgica Beach.

161

"Two roads diverged in yellow wood
and pondering one I took the other

and that made all the difference."

Robert Frost

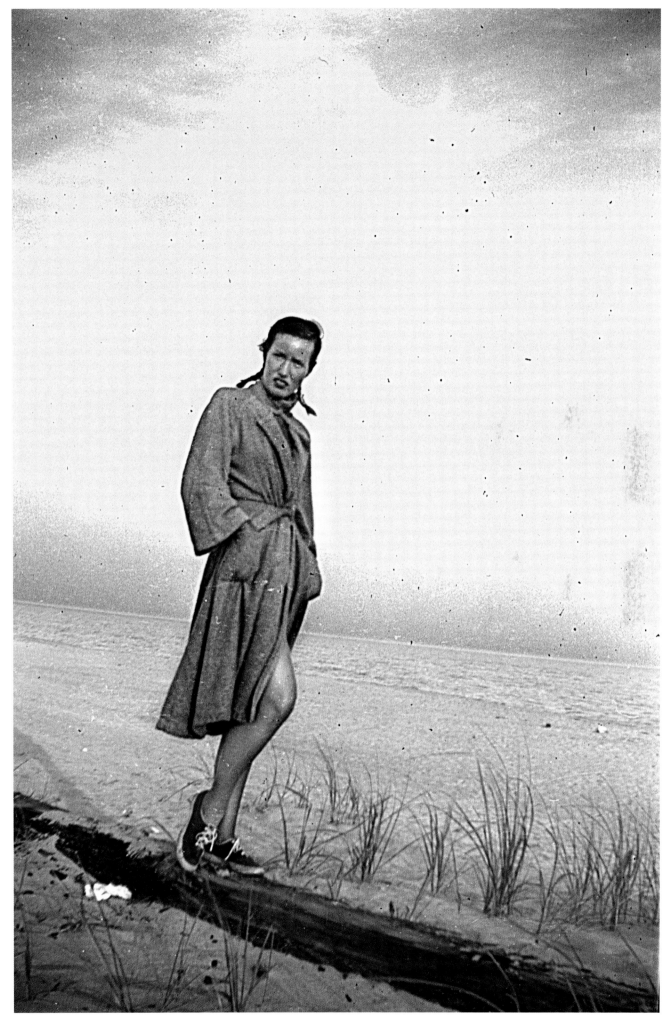

1951 | East Hampton, NY | On Georgica Beach, Edie with hair braided walking on the beach- a favorite place for Edie.

On July 29, 1952,
Edith returned to live
with her mother
in the East Hampton estate,
Grey Gardens.

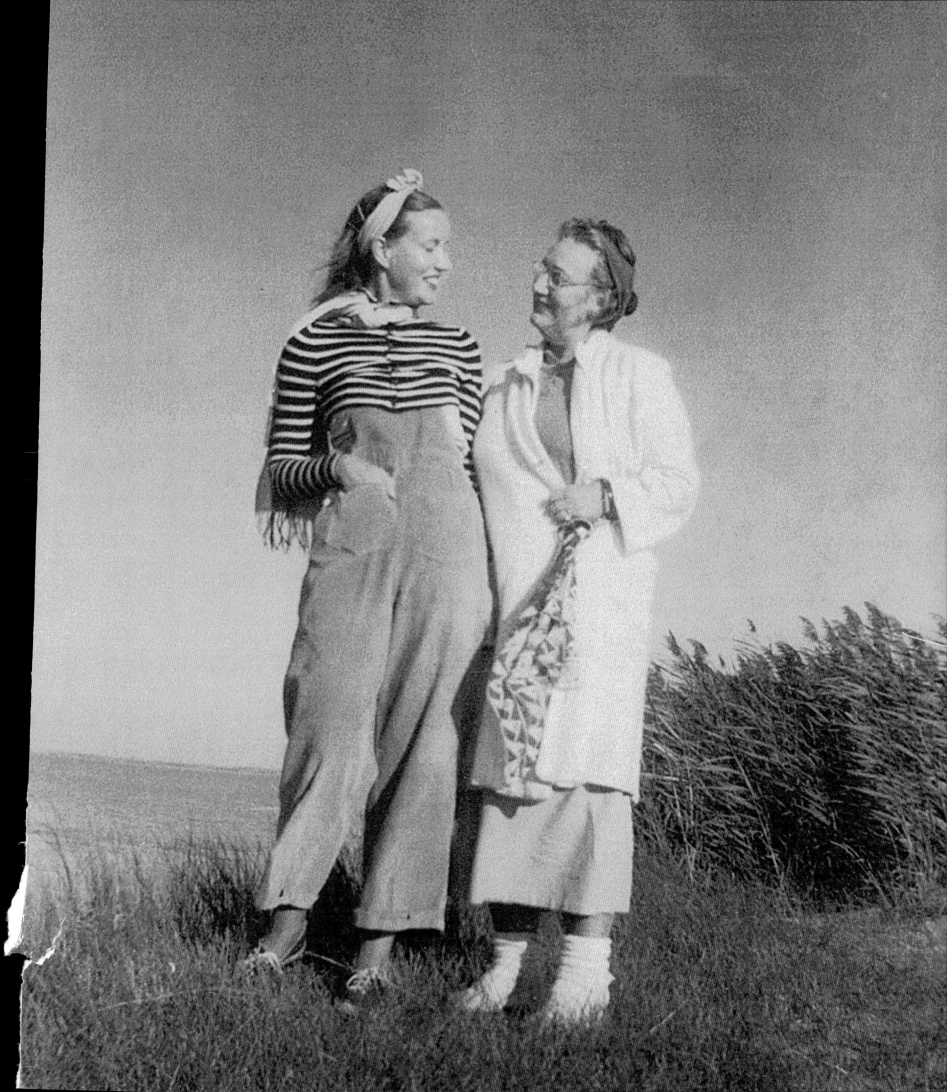

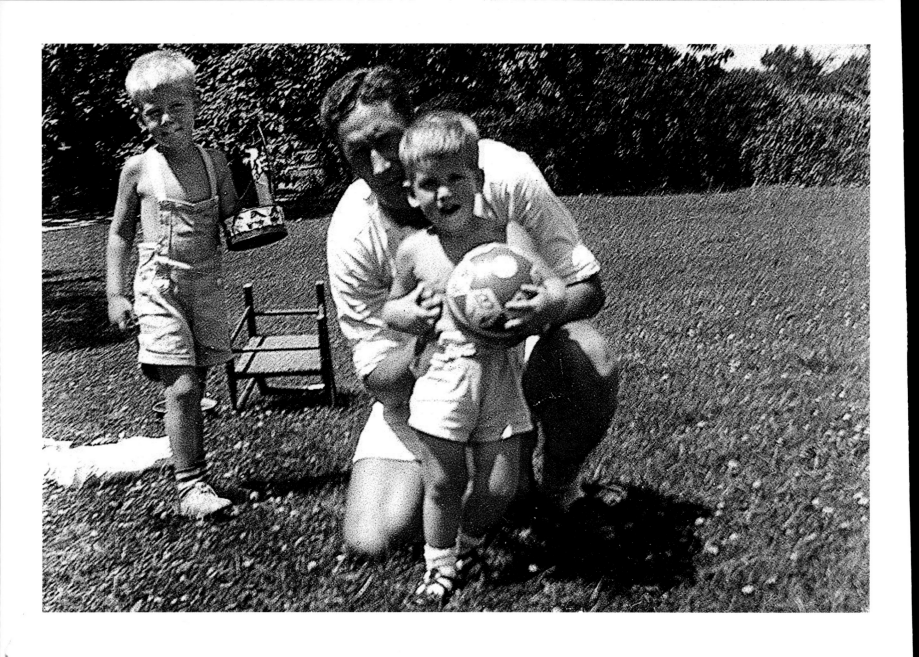

1952 | East Hampton, NY | Bouvier (Buddy) Beale visits Grey Gardens with his two sons Bouvier (left) and Nicholas Ridgely.

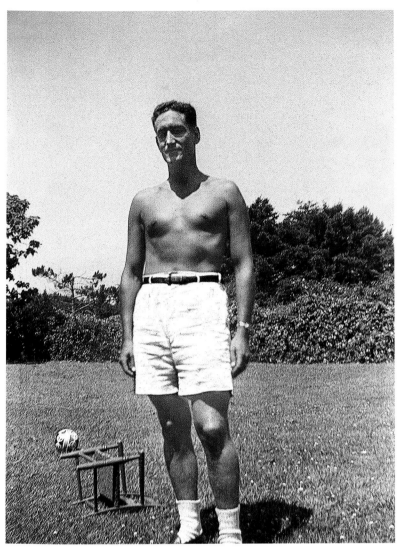

1952 | East Hampton, NY | Bouvier (Buddy) Beale visits his family at Grey Gardens.

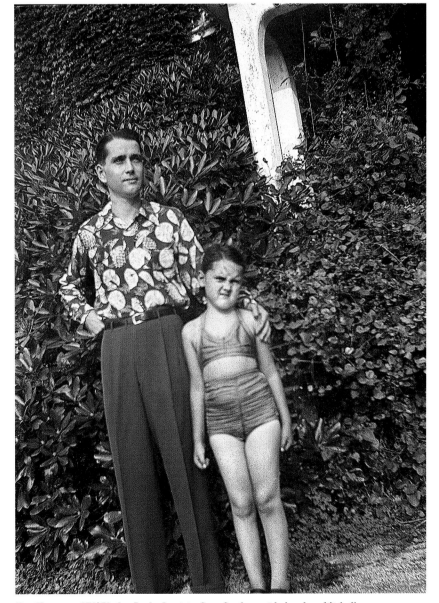

East Hampton, NY | Phelan Beale, Jr. visits Grey Gardens with daughter Michelle.

Destiny

By what orderly fate do people mate?
With careful hands they seem to choose
lives in wich they'll never loose -
And order destiny about -
Catherine marries Henry
Who has the same friends as she
Both were bred together
In unrecognized monotony.
Richard marries the daughter of the man
Who can best further his business plan
And Alice and John's families declare
There never was a better pair
to carry on their ancestral clan.
Such well ordered choosing is not for me
I am marked for what is to be
Out of the years
Out of eternity
Written in the sands of time
Is the fate to be mine.

Edith Bouvier Beale

IMPASSE

It would be rush to give in

And let you know I love you so

Yet I'll lose you if I tarry

So I'm afraid we'll never marry.

Edith Bouvier Beale

1952 | East Hampton, NY | Little Edie pictured holding a cat in the yard of Grey Gardens.

MR. AND MRS. HUGH DUDLEY AUCHINCLOSS

REQUEST THE HONOUR OF YOUR PRESENCE

AT THE MARRIAGE OF MRS. AUCHINCLOSS' DAUGHTER

JACQUELINE LEE BOUVIER

TO

THE HONORABLE JOHN FITZGERALD KENNEDY

UNITED STATES SENATE

ON SATURDAY, THE TWELFTH OF SEPTEMBER

AT ELEVEN O'CLOCK

SAINT MARY'S CHURCH

SPRING STREET

NEWPORT, RHODE ISLAND

Invitation to Jacqueline Bouvier's 1953 wedding with John F. Kennedy.

RECEPTION

FOLLOWING THE CEREMONY

HAMMERSMITH FARM

NEWPORT, RHODE ISLAND

THE FAVOUR OF A REPLY IS REQUESTED

PLEASE PRESENT THIS CARD AT

SAINT MARY'S CHURCH

ON SATURDAY, THE TWELFTH OF SEPTEMBER

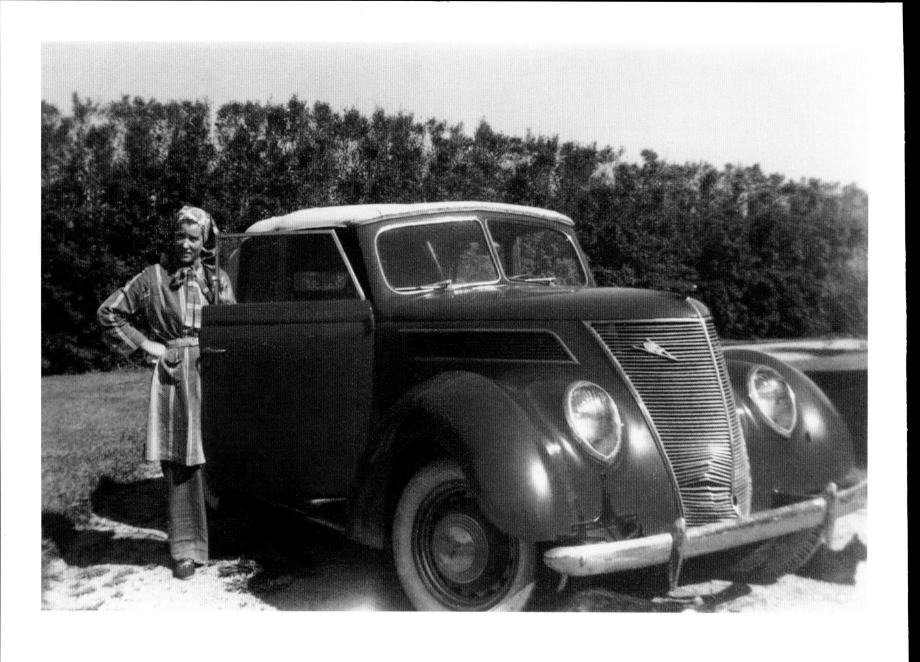

1954 | East Hampton, NY | written on back of photograph by Edith Beale "Had the 1937 Ford V8 painted after selling the garage (half the place) in Spring of 1954.

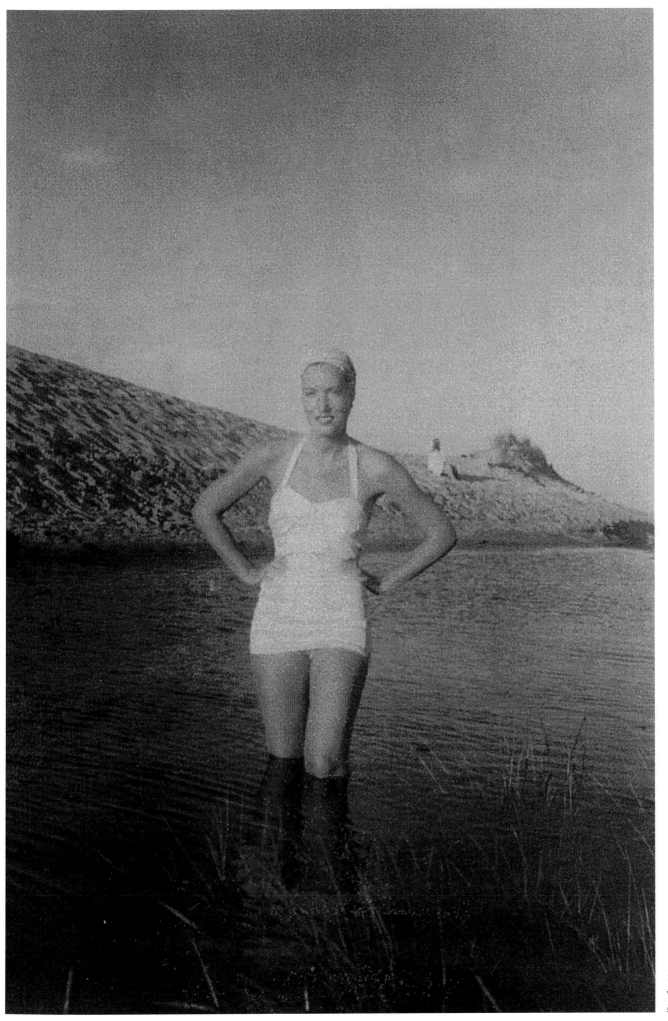

1954 | East Hampton, NY | Little Edie wades in the waters wearing a white swimsuite.

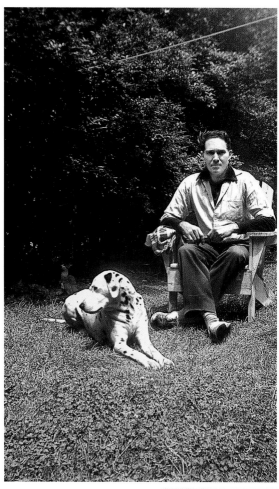

1954 | East Hampton, NY | Gould
visits the Edies at Grey Gardens.

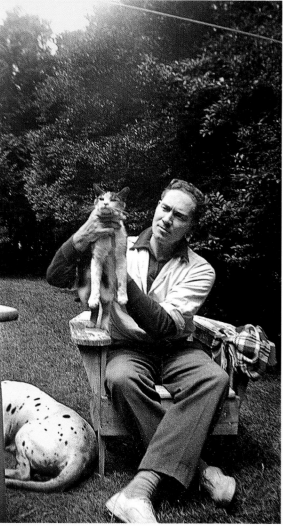

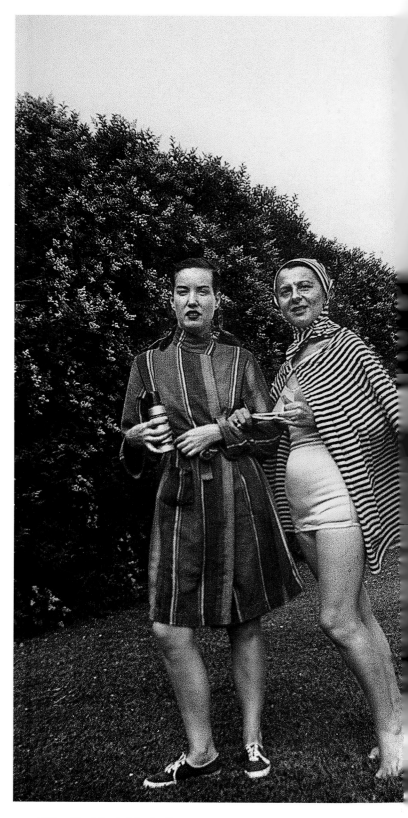

1952 | Edie with a friend of the family.

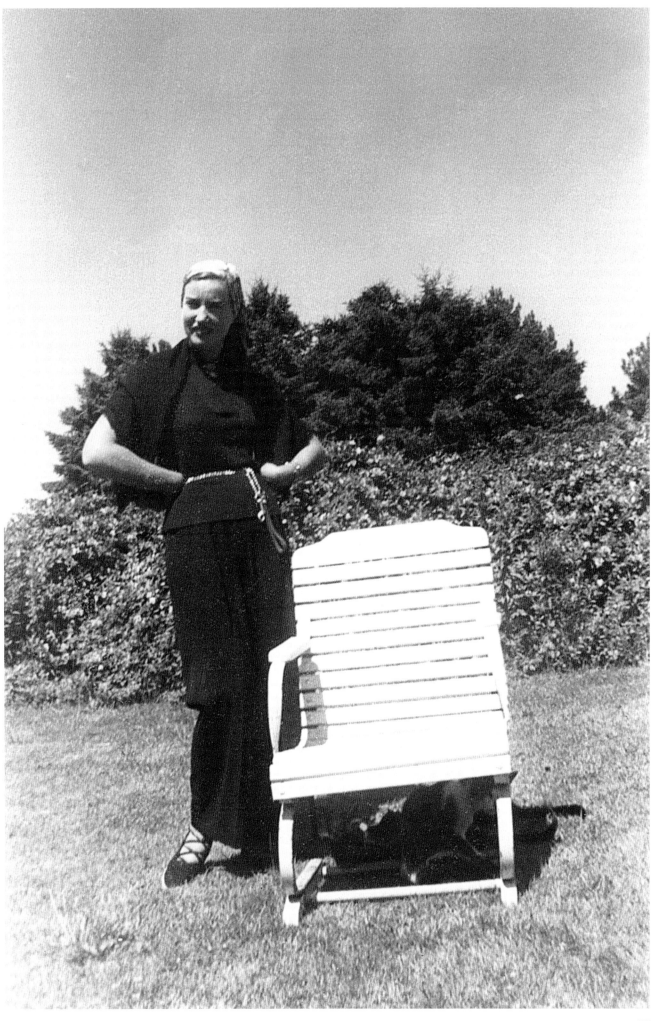

1954 | East Hampton, NY | Little Edie poses in the yard of Grey Gardens.

1954 | East Hampton, NY | Edie looking very mysterious with Spot on the porch of Grey Gardens.

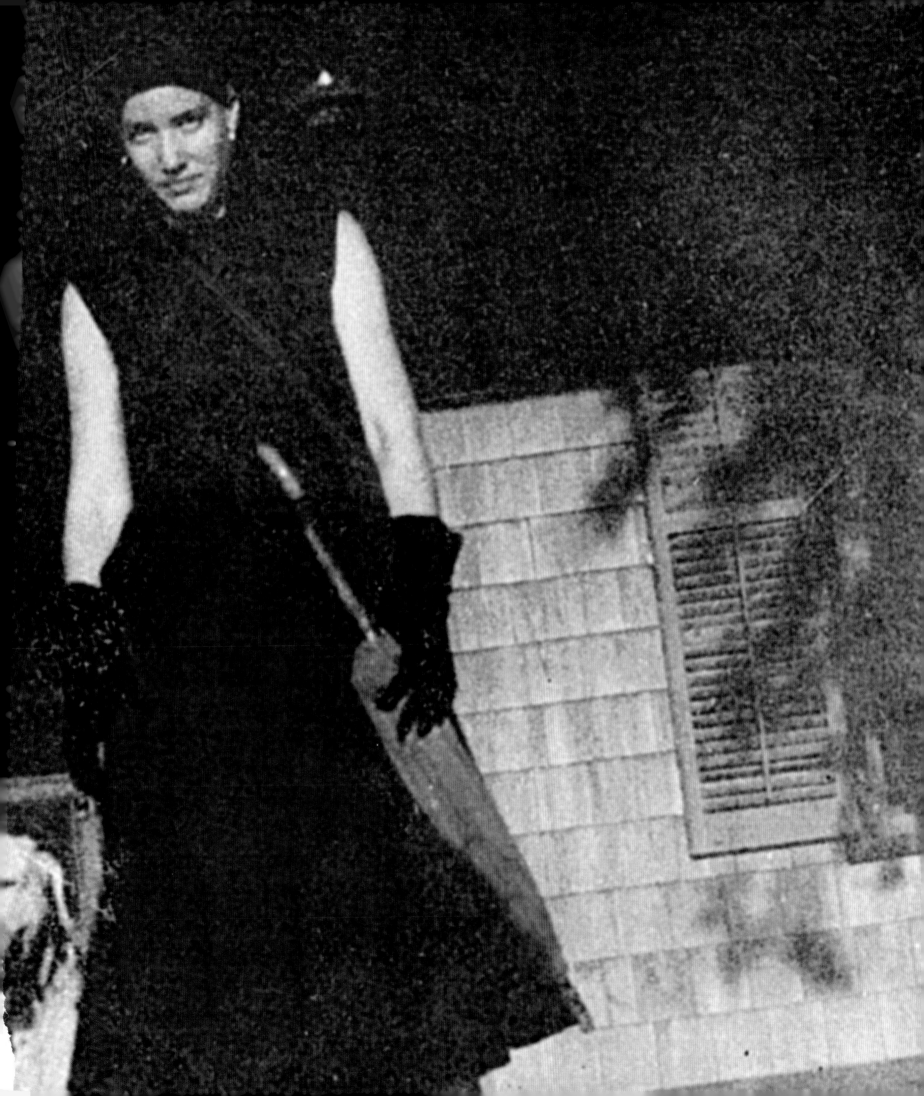

WESTERN UNION

1202

The filing time shown in the date line on telegrams and day letters is STANDARD TIME at point of origin. Time of receipt is STANDARD TIME at point of destination

NUMBER	RECEIVED BY	CHECK
		DL PD CHG PHONE EASTHAMPTON 343

Dated TDSH EAST HAMPTON NY FEB 8 1954 310P

To J V BOUVIER

DELIVER DONT PHONE 125 EAST 74 ST NEWYORK NY

STILL WAITING FOR MY MONTHLY CHECK. SEND IMMEDIATELY. URGENT.

TERRIBLY COLD AND DANGEROUS HERE FOR ME; MUST ARRANGE TO COME TO CITY.

MR MOYLAN AND MR SCHENCK DEMAND MONEY OWED. THEY WILL NOT WAIT UNTIL

MIDDLE OF MARCH WHEN CASE IS SETTLED. REGRET NOW THAT I COOPERATED SO

SERIOUSLY WITH MR DAYTON; YOU SHOULD HAVE PAID BILL BEFORE DAYTON

GOT IN HERE. IF I HAD BEEN SMART I WOULD HAVE INSISTED UPON IT.

PLEASE ACT IMMEDIATELY; THIS IS MY SEVENTH WINTER HERE.

PLEASE UNDERSTAND.

EDITH.

1954 | Telegram to John Vernou Bouvier, the executor of the Bouvier Estate.

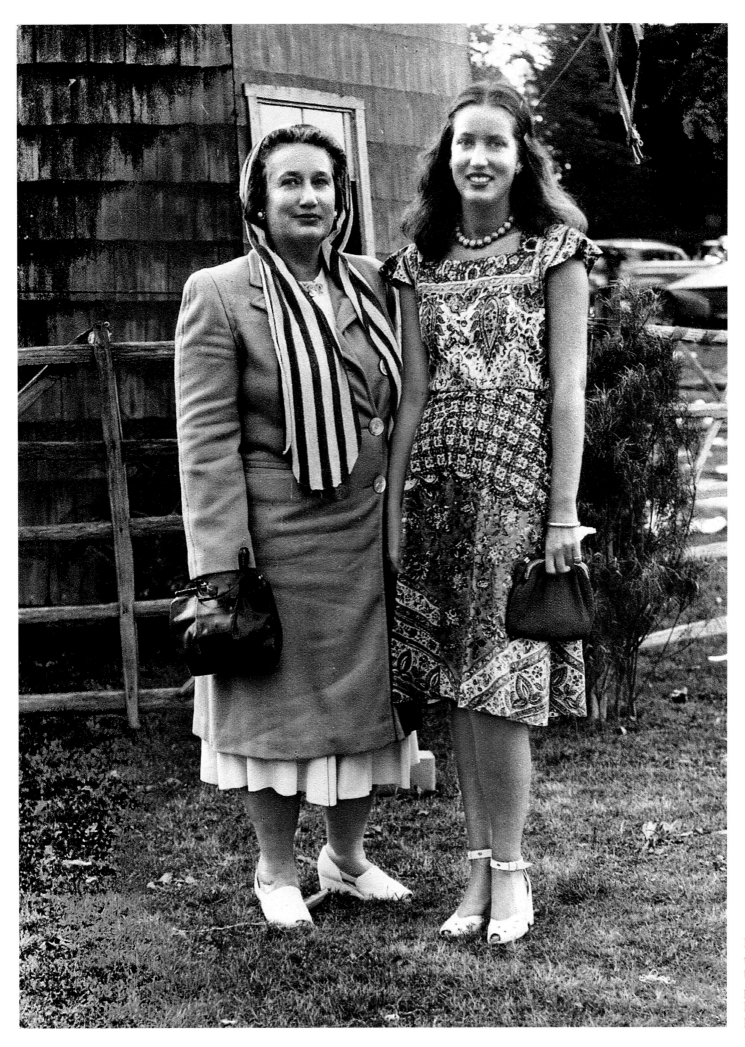

East Hamp-
tons, NY |
Undated
picture of
Little and Big
Edie.

Grey Gardens in wintertime.

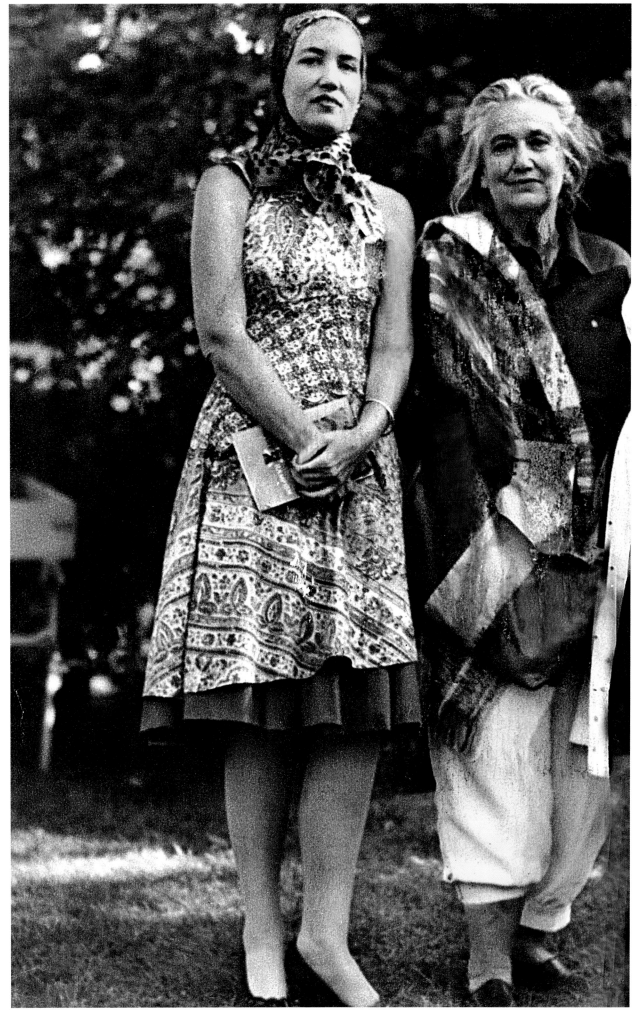

1962 | East Hamptons, NY | Little and Big Edie pose together at the Lady's Village Improvement Fair. Mother and daughter together as always through the years. Little Edie is still wearing the same dress 24 years later (cut to fit her).

May – 1964

*How tragic
and how
glorious is
the passing
of time!*

Grey Gardens

How tragic and how glorious
Is the passing of time!
Grey Gardens

Edith Bouvier Beale May 1964

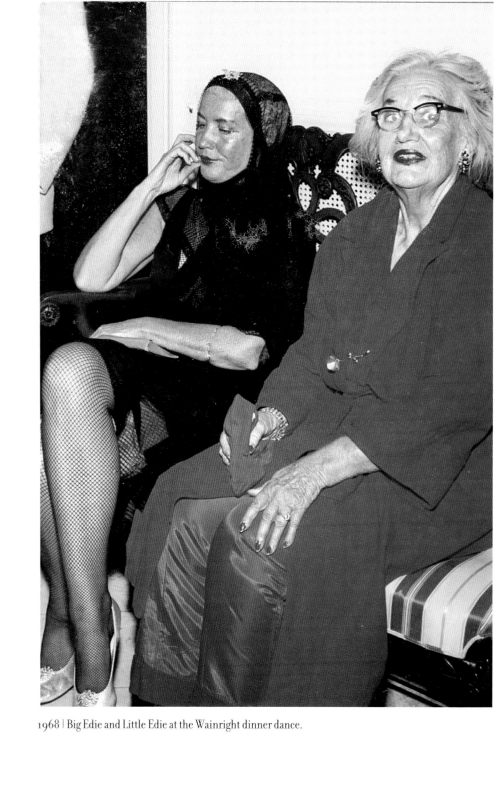

1968 | Big Edie and Little Edie at the Wainright dinner dance.

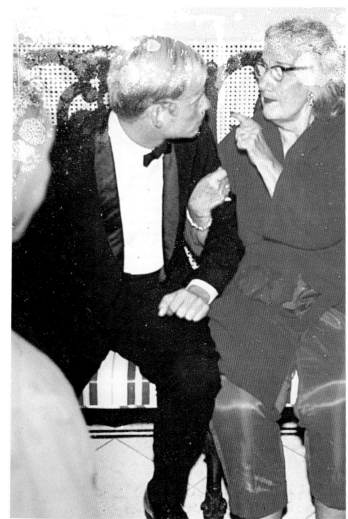

1968 | Edith Bouvier Beale and her grandson Bouvier Beale Jr. at the Wainwright Dance.

Dearest Aunt Edie and Dearest Edie-

Here I am up in the air -after just having said goodbye to you on the phone. I will miss talking to you both every night so much. Do you know what Lee and I will be eternally grateful to you for all our lives? ------The way you welcomed us back into the family.

We never left it-in our deepest hearts- all of our nostalgia is for those sunny days when all the cousins were growing up in East Hampton---and there were the great trees at Lasata to shelter us----and you, Aunt Edie, would come in and sing a beautiful song to us----then Michel Bouvier and Phelan and Edie were so glamourous---and Scottie Scott was so bad and would get us into trouble which we adored.

Then life, and marriages, geography, sad things happening, all take you away from each other- you live in different cities, different countries, and you lose touch.

Some relatives make it difficult to re-establish contact. They sound huffy- and say where have you been all these years? Which they have every right to say.

But you don't know what a joy it is to talk to you both after such a long time--- and have it be as if all the past were just yesterday-- all your love and gaeity and solicitude.

I've kept much more in touch with our other relatives- and they make me think of what Bernard Berenson said about people - they fall into 2 classes; Life- Enhancing, or Life-diminishing.

In the Life-Enhancing category, I put Daddy and both of you, and Miche- and Scottie and Shella- the aunt and cousins I always loved the most. I guess we were all on the same wave length- which probably means a bit eccentric- but it is so beautiful to be able to pick up the thread of love again- as if it were yesterday.

I love all the others too- but they aren't as much fun to be with as both of you- and I love Buddy- he tried to do for you what (page 3) he thought was best – and he tired hard. He just has another vision of what life is. I know that loving you, he thought what made him happy would make you happy- and he wouldn't have been happy staying on at "Grey Gardens"- so that is why he tried so hard to find you a house anywhere else in the world.

So don't be mad at him. You have taught me, Aunt Edie, and Edie to be so charitable to everyone, you tell me to call Aunt Maude and Aunt Shella about their operations- you ask if Lee is tired or if Ari's arthritis is all right. All you do is radiate love.

Except to the people who made the raids (which I don't blame you for) and to Buddy- but you must know that he was so earnestly trying to do what he thought was the best. It is just more rigid- but isn't it beautiful that his sons love you both so much?

Thank you , Aunt Edie, for introducing them to me on the telephone. I loved their voices – full of kindness and honour- like the expressions of John and Caroline in the picture that I sent you- loving and a little bit irreverent.

Aunt Edie- you are now the Joyenne of the family- you have to introduce all these cousins to each other. Don't you think a Halloween party might be a great time? And introduce Ari to all his in-laws- you are his favorite!

We could have Beale boys, Miche's JV, Caroline and John, maybe even Scottie and Shella's children if they don't live too far away. They could cook hamburgers for us all, and carve pumpkins for the windows, then we could all go out and scare the neighbors.

And I have one other idea for you. I think you should get a watchdog for protection- and do you know what breed I think it should be? A Bouvier des Flanderes. Daddy gave us one once- and poor Mommy had to put up with it in a New York apartment (after they were divorced) growling at the mailman etc. But they are great dogs- and as you are the last Bouviers living in East Hampton, don't you think that would be rather touching? They are the most loyal and affectionate dogs to their masters- and protect them from harm.

Do you know the book by Thomas Wolfe " You Cant Go Home Again", meaning you can't recapture your past? It is the most moving book and I always felt that way, that Lee and I could never find again the roots we knew. But you changed all that- Aunt Edie and Edie, so I thank you with all my heart- for welcoming us home again- to you.

With all my love Jackie, xo

June 25 1972

Dearest Aunt Edie
Dearest Edie —

Here I am up in the air — after just having said goodbye to you on the phone —

I will miss talking to you both every night so much —

Do you know what Lee and I will be eternally grateful to you for all our lives? — the way you welcomed us back — into the family —

We never left it — in our deepest hearts — all our nostalgia is for those summer days when all the cousins were growing up in Easthampton — and there were the great trees at Lasata to shelter us — and you, Aunt Edie, would come in and sing a beautiful song to us — then Michel Bouvier and Phelan and Edie were so glamorous — and Scottie S. was so bad and would get us all into trouble — which we all loved —

Then life, and marriages, geography, sad things happen — all take you away from each other — You live in different cities — different countries, and you lose touch.

away —

ve pumpkins for the windows — then
out + scare the neighbors —

And I have one other idea for you — I think you should get a watchdog for protection — and do you know what breed I think it should be? — a Bouvier des Flandres. Daddy gave us one one — and poor Mummy had to put up with it in a New York apartment (after they were divorced) growling at the mailman etc — but they are great dogs — and as you are the last Bouviers living in Easthampton, don't you think that would be rather touching — They are the most loyal and affectionate dogs to their masters — and protect them from all harm —

Do you know the book by Thomas Wolfe "You Can't Go Home Again" — It is the most moving book — meaning you can't recapture your past? — that Lee and I could never find again — But Edie and Ed

he Tighe was best — + he tried hard — he just has another vision of what life is. I know that loving you, he thought that what made him happy would make you happy — and he wouldn't have been happy staying on in "Grey Gardens" — so that is why he tried so hard to find you a house anywhere else in the world — S. don't be mad at him — You have taught me, Aunt Edie, and Edie — to be so charitable to everyone — You tell me to call Aunt Maude and Aunt Stella about their operations — you ask if Lee is tired or if Aris's arthritis is all right — all you radiate to people is love — except to the people who made the sails (which I don't blame you for) — and to Buddy — but you must know he was so earnestly trying to do what he thought was best — He is just more rigid — but isn't it beautiful that his sons love you both so much?

Thank you, Aunt Edie for introducing them to me on the telephone — I loved their voices — full of kindness and humour — like the expressions of John + Caroline in the picture I sent you — loving and a little bit irreverent.

Aunt Edie — you are now the doyenne of the family — You have to introduce all these cousins to each other — Don't you think a Halloween party might be a great time? And introduce Aris to all his in-laws — you are his favorites! contact — they been all these years? — which

say —

but you don't know what a joy it is to talk to you both after such a long time — and have it be as if all the past was just yesterday — all your love and gaiety and solitude.

I've kept much more in touch with our other relatives — They make me think of what Bernard Berenson said about people — they fall into 2 classes — Life-enhancing or life-diminishing —

In the life-enhancing category, I put Daddy, and both of you — and Michele — and Scottie and Stella — the aunt and cousins I always loved the most — I guess we are all on the same wave length — which probably means being a bit eccentric — but it is so beautiful to be able to pick up the thread of love again — as if it was yesterday —

February 8 1977

Dearest Edie –

I am thinking about you tonight and I just wanted to send you all my love and tell you that the service you arranged for Aunt Edie was so beautiful and so moving. She would have been so pleased, and so proud of you.

We are all thinking and caring about you, and I hope you will keep in touch and let us know if we can cheer you in the low times or help in any way.

Goodnight dear Edie – and much love –

Jackie

188

Edie in 1979 after the sale of the house.

1978 | Grey Gardens | Edie in front of the library window.

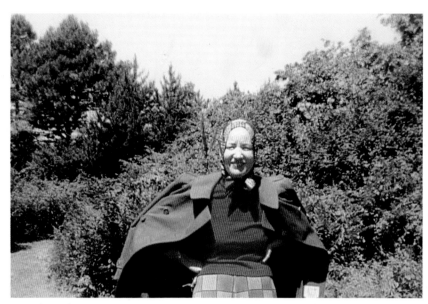

1978 | Edie at Grey Gardens.

"In the end I conquered,

for I found a greater thing than the hills.

My spirit rests in fields beneath the windy skies

where lies the wanderer's peace."

Edith Bouvier Beale, "The Wanderers Peace" (excerpt)